BALLPARKS
THEN & NOW

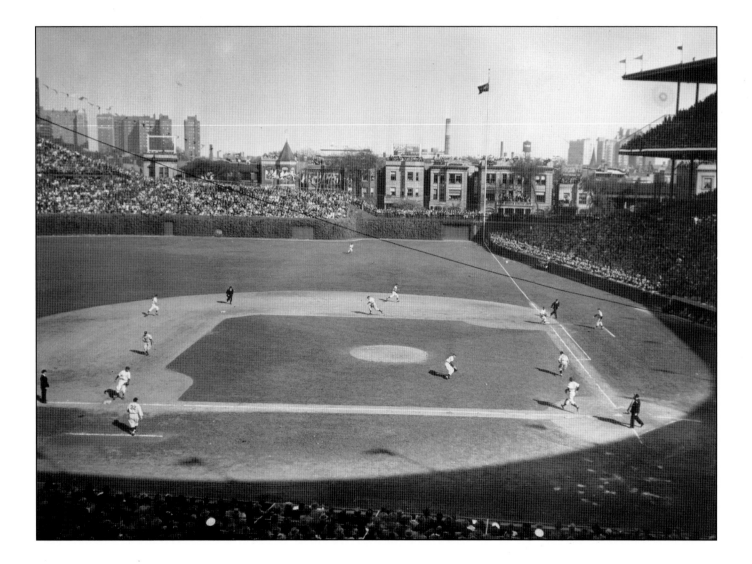

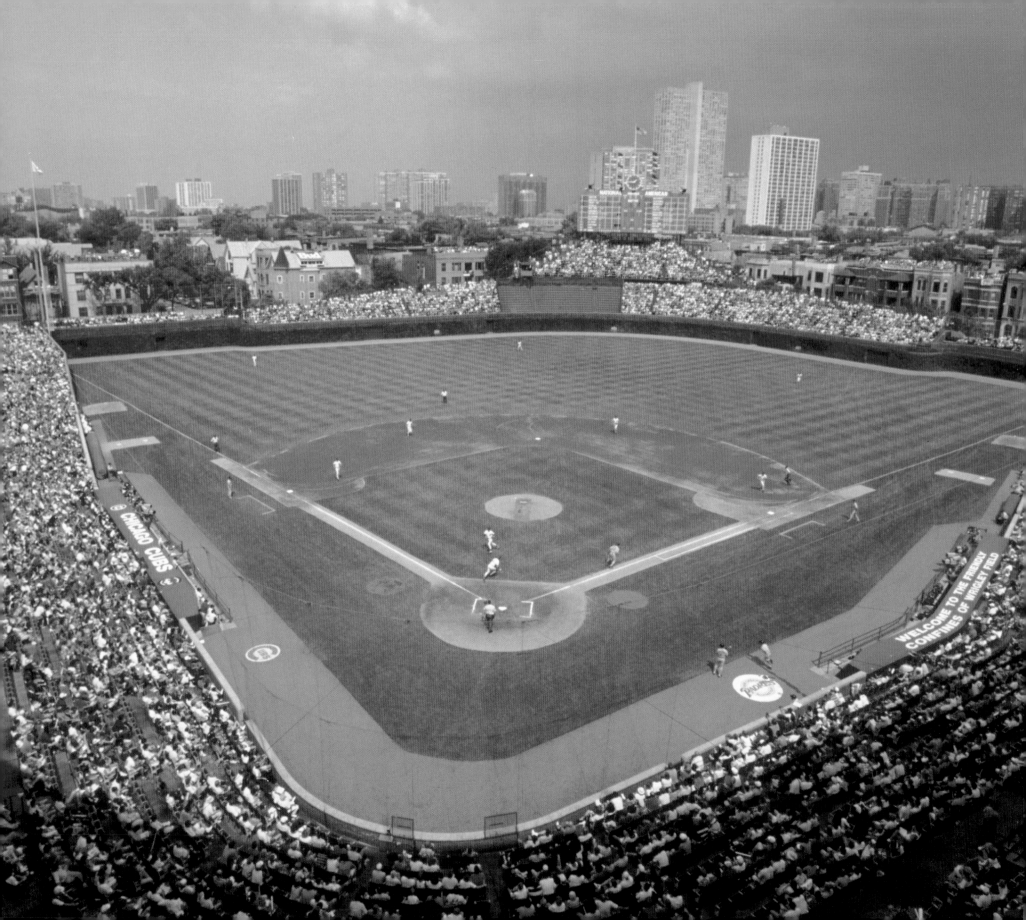

BALLPARKS
THEN & NOW

ERIC ENDERS

THUNDER BAY
P·R·E·S·S

San Diego, California

Thunder Bay Press
An imprint of the Advantage Publishers Group
5880 Oberlin Drive, San Diego, CA 92121-4794
www.advantagebooksonline.com

THUNDER BAY
P · R · E · S · S

Produced by PRC Publishing Ltd,
64 Brewery Road, London N7 9NT, England
A member of the Chrysalis Group plc.

© 2002 PRC Publishing Ltd.

All notations of errors or omissions should be addressed to Thunder Bay Press,
editorial department, at the above address. All other correspondence (author inquiries,
permissions and rights) concerning the content of this book should be addressed to
PRC Publishing Ltd, 8–10 Blenheim Court, Brewery Road, London, N7 9NY, England.

ISBN 1-57145-593-0

Library of Congress Cataloging-in-Publication Data available upon request.

Printed and bound in China

1 2 3 4 5 06 05 04 03 02

ACKNOWLEDGMENTS

The publisher wishes to thank the Baseball Hall of Fame Library, Cooperstown, NY, for kindly
supplying all the photographs in this book, including the photograph on the front cover, with
the exception of the following:

Hulton | Archive for pages 1 and 48;
© Robert Holmes/CORBIS for pages 2 and 49;
© Bettmann/CORBIS for pages 7, 12, 18, 30, 31, 34, 39, 47, 52, 64, 70, 76, 77, 83 and 90;
© Lake County Museum/CORBIS for page 8;
Library of Congress, Prints and Photographs Division for page 9;
© Kevin Fleming/CORBIS for page 10;
© Nik Wheeler/CORBIS for pages 14 and 85;
© Joseph Sohm; ChromoSohm Inc./CORBIS for pages 15, 17, 20, 21, 55, 57, 86 and 95;
© Paul A Souders/CORBIS for page 19;
© Dave Bartruff/CORBIS for page 23;
© CORBIS for pages 35, 122 and 150;
© Chase Swift/CORBIS for page 43;
Eric Enders for pages 53, 125, 127, 157 and 159;
© Jim Richardson/CORBIS for page 66;
© Jan Butchofsky-Houser/CORBIS for page 67;
© Reuters NewMedia Inc./CORBIS for pages 69, 71, 91, 93, 99 and 145;
© Duomo/CORBIS for pages 73 and 115;
© Charles E Rotkin/CORBIS for page 75;
© William Boyce/CORBIS for pages 81 and 84;
© Ted Strehinsky/CORBIS for page 117;
© Gerald French/CORBIS for page 124;
© Charles A Harris/CORBIS for page 131;
© Mark Gibson/CORBIS for page 133;
© James L Amos/CORBIS for page 139;
© Douglas Peebles/CORBIS for page 141;
© Museum of History and Industry/CORBIS for page 144;
© Tony Arruza/CORBIS for page 147;
© Todd Gipstein/CORBIS for back cover photograph.

CONTENTS

INTRODUCTION

Unlike the game of baseball itself, there is no mysterious origin myth surrounding the first ballpark. Although various bat-and-ball games were common in New York and Boston, the first written account of "base ball" in America appeared in the *National Advocate*, a New York newspaper, in 1823. The article described a match taking place at Jones' Retreat, a grassy public area on Broadway about two blocks east of today's Washington Square Park. The first written rules for baseball, and the first formally organized club, weren't created until two decades later by the Knickerbocker Base Ball Club of New York. Alexander Cartwright, one of the club's members, lived in what was then considered upper Manhattan—what we know today as the "Lower East Side." He and his companions couldn't find a proper place in Manhattan to hold their matches, so they took a ferry across the Hudson to Hoboken, New Jersey. There, on a grassy lot called the "Elysian Fields," they practiced among themselves and, on June 19, 1846, held their first official match against an opponent.

While Jones' Retreat and the Elysian Fields were the locations of early baseball games, they were not ballparks. They were grassy lots used for a variety of purposes and were neither enclosed nor designated specifically for baseball. The *Dickson Baseball Dictionary* defines a ballpark as "an enclosed baseball field including its seating areas," and by that definition, baseball historians have always considered the Union Grounds to be the first ballpark ever built. Located in Brooklyn at the corner of Marcy Avenue and Rutledge Street, the field was actually the site of the Union Skating Pond. Since ice skating only made money in winter, owner William Cammeyer decided to use the enclosed grounds as a baseball park during the summer. He catered for female fans: "a grandstand having been erected especially for their use, capable of seating several hundred persons." On May 15, 1862, the Union Grounds officially opened for baseball with admission free for the first day only. Later, when well-known local clubs such as the Eckfords, Putnams, and Constellations used the grounds

for their games, Cammeyer made money by charging fans for admission. According to a recent discovery by historian Tom Shieber, the first enclosed grounds—and therefore the first ballpark—was not the Union Grounds, but actually the Excelsior Grounds in Brooklyn, located at the south end of Court Street on Gowanus Bay. The Excelsior Club, a famed amateur squad featuring pitcher Jim Creighton, moved there in 1859 and apparently erected an enclosure to keep out the local riffraff who were considered "undesirables" at gentlemanly baseball matches. Still, whether the Union Grounds was the first ballpark or not, it was one of the most influential.

In 1869, the Cincinnati Red Stockings became the first team to openly pay its players, and after their success, baseball as a money-making enterprise caught on. The first professional league, the National Association, started in 1871. Its teams played in wooden ballparks hastily erected on empty lots. Almost anyone who owned a ballpark could own a team, and by the mid-1880s the parks were becoming more lavish—for example, the luxurious wooden palaces of the Grand Pavilion in Boston, St. George Grounds in New York, and Sportsman's Park in St. Louis. Even more important than a park's characteristics was its location, as entrepreneurs scrambled to erect ballparks along the trolley and streetcar lines that sprang up in urban areas. As owners invested more money in building ballparks, they also developed greater concern for the fate of their investments. Fire had destroyed parks in Chicago in 1871, Brooklyn in 1889, and Louisville in 1892, and although

Right: One of the most cherished pastimes within the pastime, the Fenway scoreboard is still changed manually, as it is here by one lucky fellow. Down the side of the old scoreboard are a series of dots and dashes, the initials in Morse code of Thomas and Jean Yawkey, who owned the Boston club from 1933 to 1993.

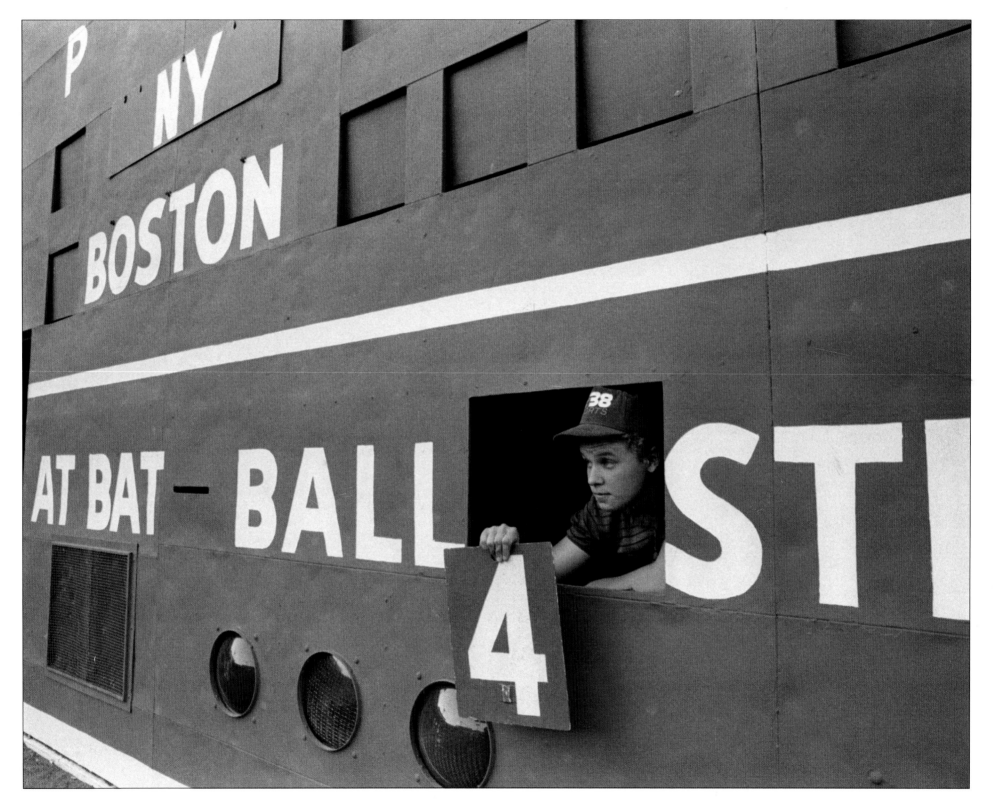

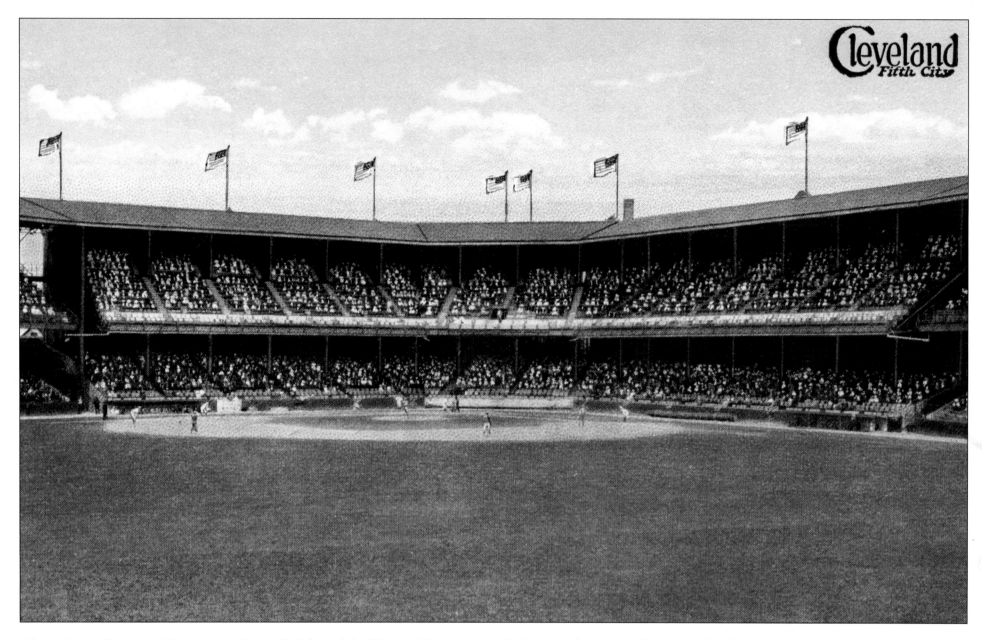

Above: Pictured here in a 1914 postcard, League Park hosted the Cleveland Spiders of the N.L. from 1891 to 1899, and remained their home when the team switched over to the American League and became the Indians in 1900. In 1910 the stadium was renovated, as the wooden grandstands—which caught fire in 1892 after being struck by lightning—were replaced, making League Park baseball's fourth concrete-and-steel stadium.

Right: Any rules that may have existed to ballpark construction in the past were broken by Shibe Park. The Philadelphia Athletics' new home was a masterpiece, the first stadium to use steel and concrete, creating a Renaissance palatial facade with an expansive green field inside. With no right field fence, apartment rooftops across the street capitalized on their viewing location, until the ballpark added a towering "spite fence" blocking nonpaying spectators. In the photograph, the stadium packed in over 24,000 people for the 1910 World Series, which pitted the A's against the Chicago Cubs.

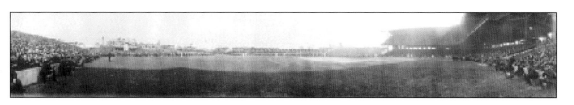

ballparks burned down easily and often, new parks kept rising from the ashes of old ones. In 1894, fire destroyed ballparks in four of the nation's largest cities—Baltimore, Boston, Chicago, and Philadelphia—prompting rumors that a ballpark arsonist, perhaps someone opposed to Sunday baseball, was at work. No conspiracy was ever found, but the ballpark fires of 1894 prompted owners to take fire prevention and safety measures for the fans. Within two decades, almost every major league team would be playing in a relatively fireproof ballpark.

The first park built entirely of steel and concrete was Shibe Park, which opened in Philadelphia on April 12, 1909. In addition to being the most durable ballpark that had ever been built, Shibe was also bigger than most, able to hold 20,000 paying customers. Shibe's success sparked the biggest building spree in baseball history, and within five years most of the ballparks that would become beloved to twentieth-century baseball fans had been built. Pittsburgh's Forbes Field was built in 1909; Chicago's Comiskey Park in 1910; Boston's Fenway Park and Detroit's Tiger Stadium in 1912; Brooklyn's Ebbets Field in 1913; and Chicago's Wrigley Field in 1914. By 1920 the Philadelphia Phillies were the only major league team not playing in a shiny new park of steel and concrete. Most of these parks were built in relatively rural or undeveloped areas, but as America grew more urbanized throughout the 1900s, a growing population moved into the neighborhoods surrounding the ballparks. Most of the stadiums were also located along major routes of public transportation, making it easy for anyone to get to the ball game.

The parks built in the 1909–1914 period were so durable and successful that most of them lasted more than 50 years, and two—Fenway Park and Wrigley Field—are still being used today. The first franchise to abandon its classic ballpark was the Boston Braves, who departed Braves Field for Milwaukee in 1953. A more lasting impact was made by the Brooklyn Dodgers, who shook the foundations of baseball economics by moving to Los Angeles in 1958. Team owner Walter O'Malley played the cities of Brooklyn and Los Angeles against each other, effectively selling himself to the highest bidder. The winner was Los Angeles, which won O'Malley over with 300 acres of free land near downtown Los Angeles, special tax breaks, and promises of road improvements in the stadium area. Although Dodger Stadium was technically constructed with private funds, it was actually the first in a long line of ballparks built at the taxpayers' expense, enabling owners to reap greater profits. Ever since O'Malley's shrewd move, major league teams have been using the threat of relocation to entice the construction of publicly funded ballparks.

Only three years after Dodger Stadium, another ballpark opened that was just as influential, but considerably more bizarre. The Houston Astros introduced the world to futuristic indoor baseball in 1965, and when it was found that grass wouldn't grow in the Astrodome, they introduced another innovation—artificial turf, otherwise known as "AstroTurf." AstroTurf was cheaper and easier to maintain than real grass, and the concept caught on quickly with other teams. Over the next decade a series of large, antiseptic, and largely indistinguishable stadiums opened in cities such as St. Louis, Cincinnati, Pittsburgh, and Atlanta. The new parks—known collectively to baseball fans as "cookie cutters"—greatly affected the style of play during the 1970s and 1980s, particularly in the National League. Teams such as the St. Louis Cardinals and Cincinnati Reds tailored their rosters to the speedy, wide-open style of play that artificial turf encouraged. By 1989, when SkyDome opened in Toronto, 10 of the 26 major league teams played their games on artificial turf.

SkyDome, with its lavish restaurants and luxury suites, turned out to be the harbinger of a new kind of ballpark. The new era began in earnest in 1992, when Oriole Park at Camden Yards opened in Baltimore. It was the anti-Astrodome, with a quaint brick exterior, wrought-iron grillwork, real grass, asymmetrical dimensions, and a vibrant urban setting. Its dignified dark green seats and earth tone colors were the antithesis of the gaudy, plasticized ballparks of the 1960s. The success of Camden Yards ushered in an era of ballpark building unseen since the days of Shibe Park, and more importantly, reestablished the ballpark as a vital part of urban America. Within a decade, similar new parks had been built in eleven major league cities, some of which—including Pacific Bell Park in San Francisco and PNC Park in Pittsburgh—are among the best ballparks ever built. Even teams that didn't build new parks were influenced by Camden Yards, as artificial turf was replaced by real grass in existing stadiums in St. Louis, Kansas City, and Cincinnati. By 2001, only five of the thirty teams still play on artificial turf, and just three in permanently enclosed domes.

The ballpark renaissance of the 1990s sparked a renewed interest in ballpark nostalgia, and in addition to the parks themselves, the last decade has produced a plethora of ballpark memorabilia, ballpark lithographs, ballpark replica models, and ballpark books. While the 1990s produced some of the best stadiums ever, it also saw the ballpark become more of a place to see and be seen, rather than a place to watch a baseball game. In the decade between 1991 and 2001, which saw the opening of fifteen new stadiums, the average cost for a family of

four to attend a game nearly doubled, rising from $76 to $146. As a result, the makeup of the crowd changed in many ballparks, and families and working people were gradually replaced by corporate clients and the well-to-do. While brokers sat in ballparks trading stocks on their cell phones, real fans watched the games at home on television. Another 1990s trend was the sale of ballpark naming rights to corporations. Before 1995, stadiums were usually named after the owner who built them (Ebbets Field), the team that inhabited them (Yankee Stadium), or the municipality that paid for them (Oakland Coliseum). But in 1995 the naming rights for Candlestick Park were sold to 3Com, a technology company, for $4 million. Fourteen other teams followed suit over the next six years, culminating in a record $100 million deal between the Houston Astros and Enron, an energy company. With ballpark names, revolving ads behind home plate, corporate jingles between innings, and even the Miller Beer logo on the caps of the Milwaukee Brewers, fans are being subjected to more advertisements at the ballpark than ever before.

Still, major league attendance is better at the beginning of the twenty-first century than it has ever been. The St. Louis Cardinals drew 110,000 fans for the entire 1918 season, an amount they now routinely surpass in a weekend series. Teams continue to build innovative ballparks, many of them variations on old themes. Camden Yards has a warehouse looming over the playing field, just as the Huntington Avenue Grounds in Boston did. Jefferson Street Grounds, used by the Philadelphia Athletics in the 1870s, had a swimming pool behind the

outfield fence; so too does today's Bank One Ballpark in Phoenix. At Robison Field in St. Louis, a roller coaster delighted fans in the 1890s, just as a roller coaster beyond right field delights today's fans at Blair County Ballpark in Altoona, Pennsylvania. The lighted fountains at Kansas City's Kauffman Stadium may seem unique, but such fountains first arrived on the major league scene in the 1880s, when the New York Mets played at St. George Grounds. Ballparks will never again be built of wood for fire-safety reasons, but the spires and gables at recently remodeled Bowman Field in Williamsport, Pennsylvania, are reminiscent of the wooden parks of the 1890s. Luxury boxes may seem like a modern invention, but they were first installed by Albert Spalding at Chicago's Lake Front Park in 1883.

Of course, there are differences too. Instead of a quarter, the average major league ticket now costs $19. Ballpark construction now takes two to four years, whereas many nineteenth-century parks were constructed in only a week. As baseball enters its third century, the ballpark experience is as vibrant as it ever has been. Just as prior generations cherished Sportsman's Park's beer garden, the Polo Grounds' staggeringly deep center field, or Ebbets Field's nooks and crannies, today's fans will long remember the Camden Yards warehouse and the bayside promenade of Pacific Bell Park. Not every ballpark has had a far-reaching effect on the game's history, but all of them have contributed in their own way to the remarkable tapestry of the game.

Left: Atlanta-Fulton County Stadium was typical of modern "cookie cutter" architecture. Despite Hank Aaron's pursuit of the career home-run record and Ted Turner's crazy promotions—which included Headlock and Wedlock Day, when the field played host to a mass marriage and then a professional wrestling match—Fulton County remained sparsely attended during the 1970s and 1980s.

ANAHEIM

Anaheim Stadium

Also known as: Edison International Field (1998–present)
Opened: April 9, 1966
Home to: California/Anaheim Angels (American League) 1966–present
Capacity: 43,204 (1966); 65,158 (1981); 45,050 (2001)
Greatest Moment: September 14, 1990—Ken Griffey Jr. and Sr., the first father-and-son teammates in baseball history, hit back-to-back home runs off the Angels' Kirk McCaskill.

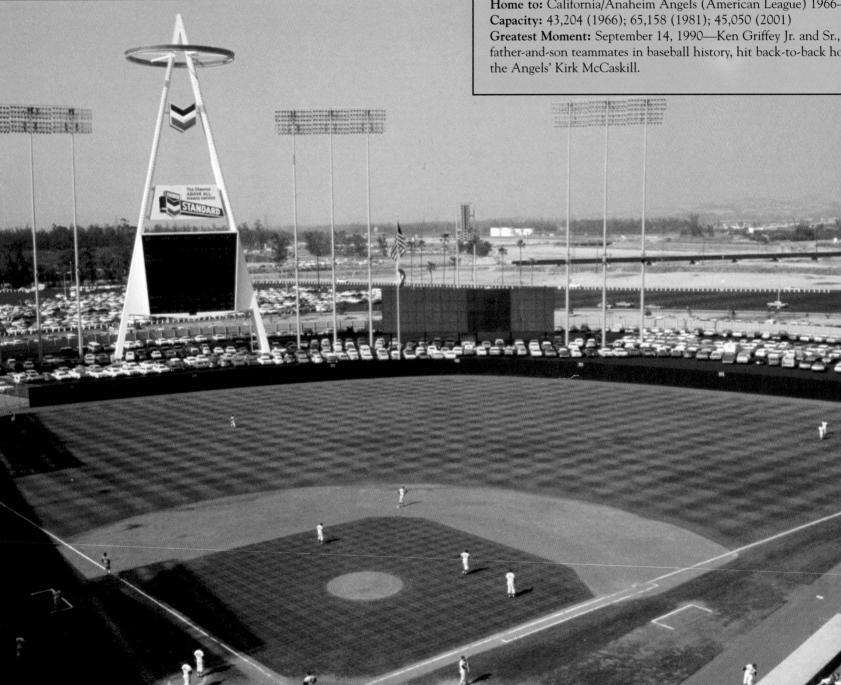

Left: When this photo was taken in 1966, the 230-foot "Big A" in left field was Anaheim Stadium's dominant feature.

Right: Anaheim Stadium has been the site of many great moments in Angels history, including Nolan Ryan's strikeout and no-hitter milestones.

The Angels' franchise started in 1961 as the Los Angeles Angels, and from 1962–65 they were tenants in Dodger Stadium. They called it "Chavez Ravine" in a futile attempt to escape from the shadow of their vastly more popular landlords. In 1966, the team made a concerted effort to establish its own identity. They created a new team name, the California Angels, and moved to a new home city, Anaheim.

Their new park, Anaheim Stadium, was built on 148 acres of fertile farmland and was a near-replica of Dodger Stadium, then considered the jewel of major league ballparks. The dominating feature was a 230-foot-tall letter "A" in left field, which supported the scoreboard and towered over the landscape. The stadium soon became known as "the Big A," a nickname that stuck even after the huge structure was moved into the parking lot as part of a 1980 renovation that enlarged the stadium to accommodate Los Angeles Rams football games.

In 1996, shortly after the Disney Corporation purchased the team, a two-year renovation returned the stadium to a baseball-only facility. The seating capacity was reduced, and a new scoreboard and rocky waterfall were installed behind the center field fence.

In September 1997, the Angels announced that Edison International, an energy conglomerate, had purchased the "new" stadium's naming rights for $28 million over twenty years. When the remodeled Edison International Field opened on April 1, 1998, few vestiges of Anaheim Stadium remained, and the team even went so far as to list them as two different ballparks in its media guide.

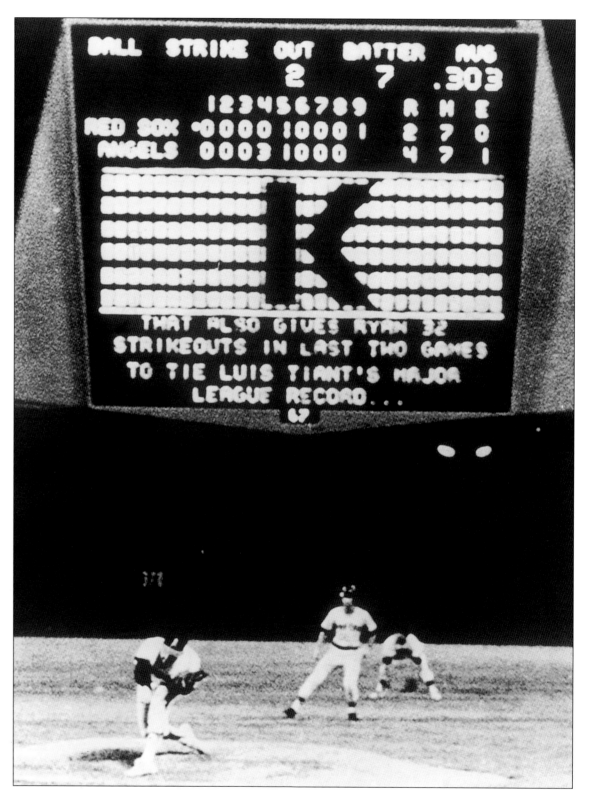

ATLANTA

Atlanta-Fulton County Stadium

Also known as: Atlanta Stadium (1966–75)
Opened: April 12, 1966
Home to: Atlanta Braves (National League) 1966–1996
Capacity: 51,500 (1965)
Greatest Moment: April 8, 1974—Hank Aaron hits his 715th home run, breaking the career mark of Babe Ruth, which had stood for 39 years.

Left: Atlanta-Fulton County Stadium was affectionately known as "the Launching Pad" for all the home runs hit there by Hank Aaron and others.

Right: Turner Field, home of the Braves since 1997, hosted a division champion in each of its first five years of existence.

For years, Atlanta's minor league and Negro League teams had played at Ponce de Leon park, a tiny facility built in 1903 and notable for a huge magnolia tree in the field of play. When the Braves moved south in 1966, they were greeted by Atlanta Stadium. It was a circular concrete bowl, which differed from its cookie-cutter brethren only in its use of natural grass. At 1,000 feet above sea level, it was the highest park in the major leagues until 1993, and it became known as "the Launching Pad" because of the home runs that routinely cleared its fences.

This hitter's haven enabled Henry "Hank" Aaron, who had spent the first half of his career playing in a hitter's graveyard in Milwaukee, to break Babe Ruth's career home run record in 1974. After Aaron's departure, the team deteriorated, and despite a Ted Turner cable television campaign, which ambitiously labeled them "America's Team,"

the hapless Braves often found themselves playing in a near-empty stadium during the 1980s.

In 1996, Atlanta hosted the Summer Olympics and built its Olympic stadium in Fulton County Stadium's parking lot. After the Olympics ended, Atlanta Olympic Stadium was retrofitted for baseball by removing 35,000 seats and the track-and-field complex. Although most Atlantans wanted the new ballpark to be named after Aaron, it was named Turner Field after the team owner.

Although it attempted to mimic the retro look of other 1990s ballparks, Turner Field was notable mostly for its exorbitant concession prices, where fans paid as much as six dollars for hot dogs. Meanwhile in August 1997, as the Braves coasted toward their sixth division title in seven years, Atlanta-Fulton County Stadium was imploded. The site is now a parking lot.

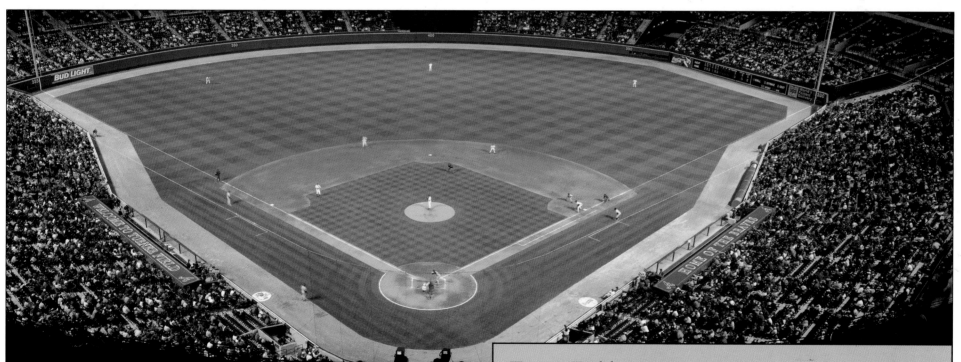

Turner Field

Also known as: Atlanta Olympic Stadium (1996)
Opened: July 19, 1996
Home to: Atlanta Braves (National League) 1997–present
Capacity: 50,191 (1997)
Greatest Moment: July 19, 1996—In a moving Opening Ceremony, Muhammad Ali lights the torch to begin the 26th Summer Olympic Games.

BALTIMORE

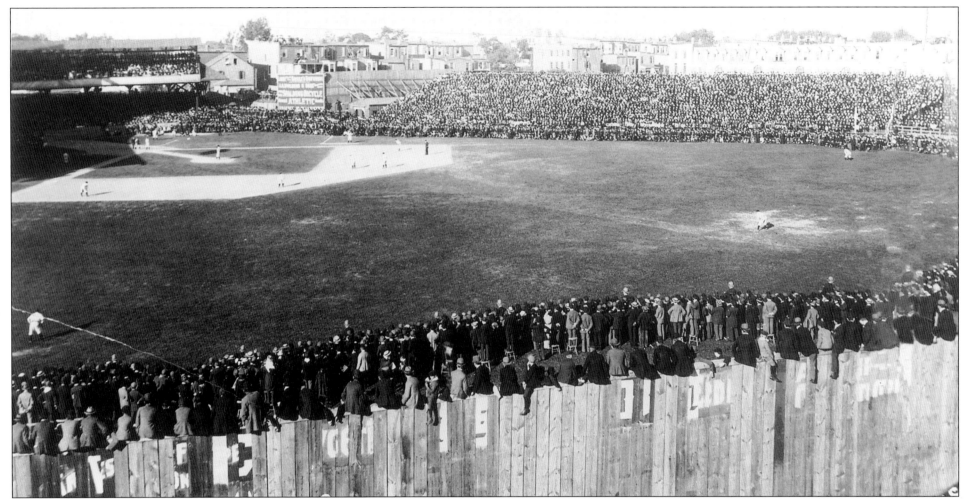

One of the earliest Baltimore ballparks was the Madison Avenue Grounds, which was built in the 1860s. St. Paul's Orphan Asylum was just beyond the right field fence. When the first professional baseball league, the National Association, was formed in 1871, the Olympic Club of Washington, D.C. sometimes used Madison Avenue Grounds for its games. A year later in 1872, Baltimore got its own team in the league, the Lord Baltimores, who played their games at Newington Park.

Baltimore did not become a fully fledged major league city until 1882, when the new American Association debuted with the Baltimore

Oriole Park

Also known as: Union Park
Opened: May 11, 1891
Home to: Baltimore Orioles (National League) 1891–1899
Capacity: 30,000 (1891); 11,000 (1897)
Greatest Moment: September 27, 1897—As Baltimore and Boston both vie for the pennant, an estimated 30,000 fans fill the park to overflowing for the final game of the season between the two contenders. Boston's hitting dominates, and their 19-10 victory seals the pennant.

Orioles as one of its teams. At first the Orioles played at Newington Park, but they soon moved to a new field, Oriole Park, which was the first of six Baltimore ballparks to bear that name. A second Oriole Park was built in 1890, and a third in 1891. This third Oriole Park was home to the team for nine years until the team folded in 1899. The wily, tough Orioles won three consecutive pennants (1894–1896) there thanks to

Oriole Park at Camden Yards

Opened: April 6, 1992
Home to: Baltimore Orioles (American League) 1992–present
Capacity: 48,876 (2001)
Greatest Moment: September 6, 1995—Cal Ripken plays in his 2,131st consecutive game, braking Lou Gehrig's all-time record. He caps the celebration with a fourth-inning home run.

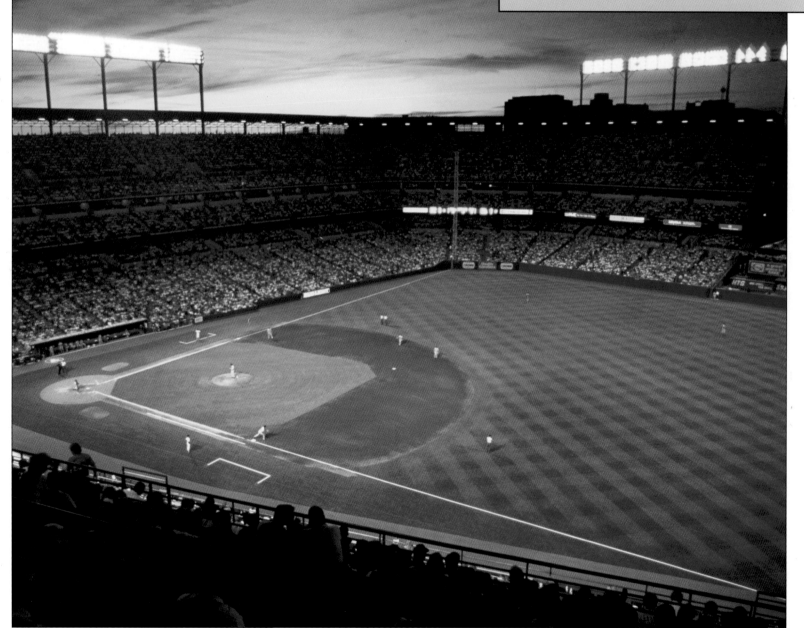

Far Left: An overflow crowd at Oriole Park watches their team lose the pennant-deciding game on September 27, 1897, as Orioles right fielder Willie Keeler stands in the foreground on the left.

Left: In 1992, the Orioles opened Oriole Park at Camden Yards, which immediately became the standard by which modern ballparks are judged.

scrappy gamers such as John McGraw and Wee Willie Keeler. Groundskeeper Thomas Murphy made sure the Orioles enjoyed a significant home-field advantage, packing the dirt around home plate so Orioles' batters could practice the "Baltimore Chop," and letting the outfield grass grow high so the Orioles could hide spare baseballs in strategic places. It worked brilliantly, as visiting teams won only 43 of 198 games in Baltimore during the Orioles' three-year pennant run.

Baltimore had two brief flings with the major leagues in the early twentieth century. In 1903, the Baltimore Orioles of the American League moved to New York, where they eventually became the Yankees. In 1914 a new major league, the Federal League, debuted with the Baltimore Terrapins as members. The team built a 15,000-seat park, named Terrapin Park, just across the street from the fourth Oriole Park, where 19-year-old pitcher Babe Ruth was the star attraction

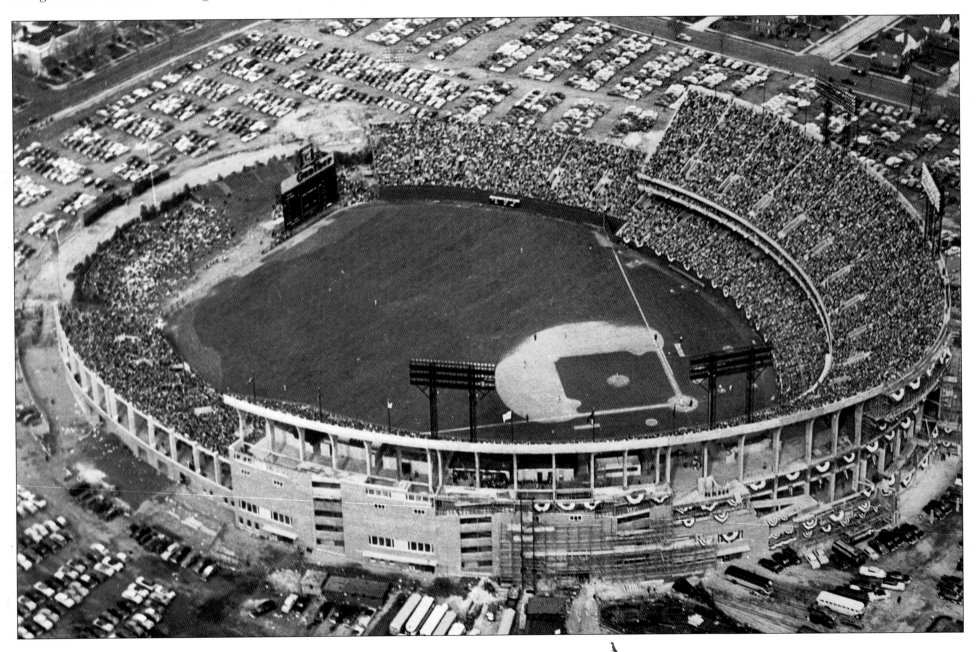

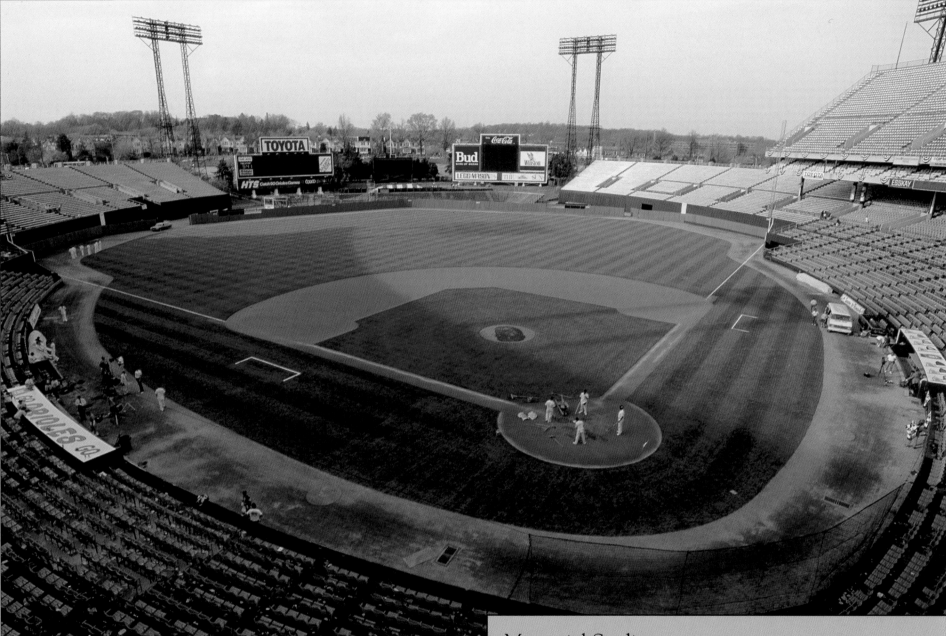

Above: When the Orioles left St. Louis for Baltimore, they were greeted by Memorial Stadium, a football facility named in honor of fallen American soldiers.

Left: The Orioles shared Memorial Stadium with football's Colts, but to the chagrin of Baltimore fans, the famous 1958 Johnny Unitas-Alan Ameche touchdown actually happened at Yankee Stadium in New York.

Memorial Stadium

Opened: 1922
Home to: Baltimore Orioles (American League) 1954–1991
Capacity: 47,778 (1958); 53,371 (1991)
Greatest Moment: October 13, 1970—In Game 3 of the World Series, Brooks Robinson makes three unbelievable defensive plays and also drives in two runs at the plate as the Orioles beat the Reds, 9-3.

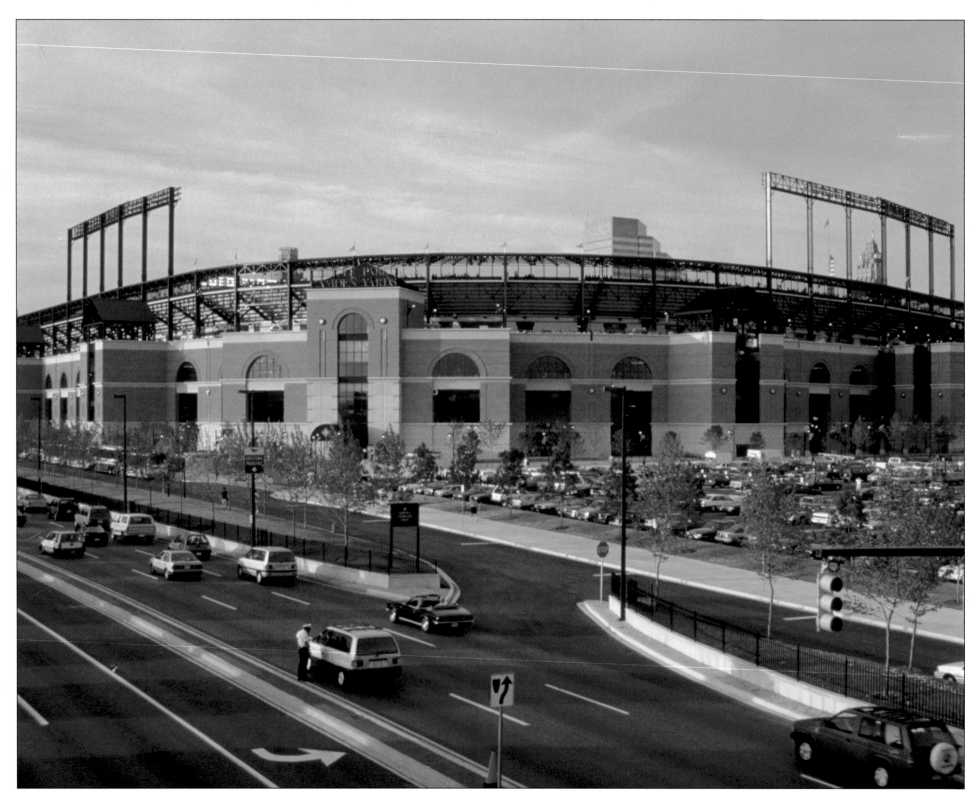

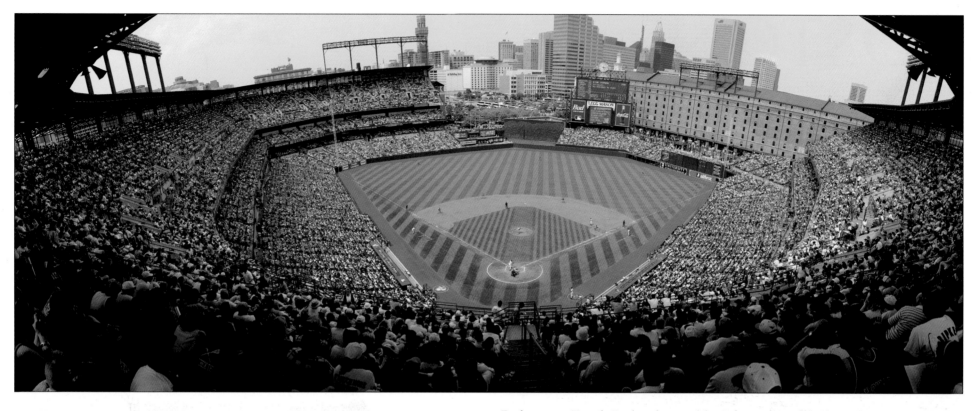

Above: The B&O Railroad Warehouse, built in 1898, provides one of the most picturesque backdrops in baseball.

Left: Located at the corner of Camden and Eutaw Streets, Camden Yards is only two blocks southeast of the house where Babe Ruth was born.

for the minor league Baltimore Orioles. The Orioles and Terrapins competed for fans until the Federal League folded after the 1915 season. Terrapin Park was later renamed, becoming the fifth and best-known Oriole Park, and longtime home of both the minor league Orioles and the Negro League's Baltimore Elite Giants.

After the 1953 season, maverick owner Bill Veeck decided to move his hapless St. Louis Browns to Baltimore, where they became the fourth major league franchise to be named the Baltimore Orioles. They played in pitcher-friendly Memorial Stadium, a football stadium that had been renovated for baseball in 1949. It was a relatively nondescript ballpark, but Baltimore fans supported the team well, and the franchise became one of the most successful in baseball. With classy players such as Brooks

Robinson, Frank Robinson, Eddie Murray, and Cal Ripken, the Orioles won six pennants and three World Series between 1966 and 1983. In 1992, the team vacated Memorial Stadium for a brand-new gem of a ballpark. Officially named "Oriole Park at Camden Yards" (making it the sixth Oriole Park), it is one of the most beautiful and influential ballparks ever built. Combining the intimate feel of an old ballpark with the modern amenities of a new one, Camden Yards is both an homage to the past and a masterpiece of modern urban architecture. The stadium is built on the site of a bar once owned by Babe Ruth's father, and blends in seamlessly with the downtown Baltimore waterfront around it. Its crowning achievement is the incorporation of the B&O Railroad warehouse into the right field stands, an idea dreamed up by Eric Moss, a Syracuse University architecture student. The warehouse is believed to be the longest building on the East Coast, and at 432 feet away from home plate, it serves as both a landmark and as a target for left-handed sluggers. Other features include double-decked bullpens and a playing field 16 feet below street level. With its brick exterior, luxury boxes, upscale concessions, and remarkable aesthetic beauty, Camden Yards has inspired a rash of imitators, revolutionizing the ballpark experience for an entire generation of fans.

BOSTON

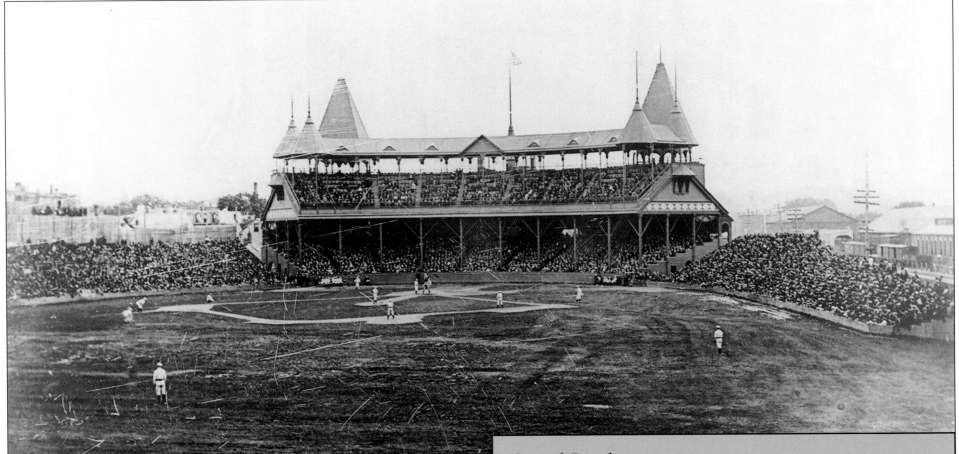

The grandest baseball park when it opened in 1888, the Grand Pavilion remains the only double-decked ballpark ever built in Boston. Six conical "witch's cap" spires rose from the top of the grandstand, with flags flying from each. It was a place that, as Michael Gershman wrote, "in earlier times might have hosted jousting tournaments." Regrettably, this first of baseball palaces lasted only six years before it burned to the ground on May 15, 1894. The fire started in the third inning of a game between Boston and Baltimore, when some mischievous children set debris on fire under the right field bleachers. "The base ball grand stand and bleachers, a large school house, an engine house, and 164 wooden buildings were destroyed," the *Boston Post* reported. Alas, the park had

Grand Pavilion

Also known as: South End Grounds II
Opened: May 25, 1888
Home to: Boston Beaneaters (National League) 1888–1894
Capacity: 6,800 (1888)
Greatest Moment: May 25, 1888—In the first game ever played at the Grand Pavilion, a crowd of 12,000—double the intended capacity—watches Boston lose to the Phillies, 4-1.

been underinsured, and its replacement—the third South End Grounds, built on the same site—was nowhere near as grand. Still, it served as the home of the Beaneaters (later known as the Braves) until Braves Field was built in 1915.

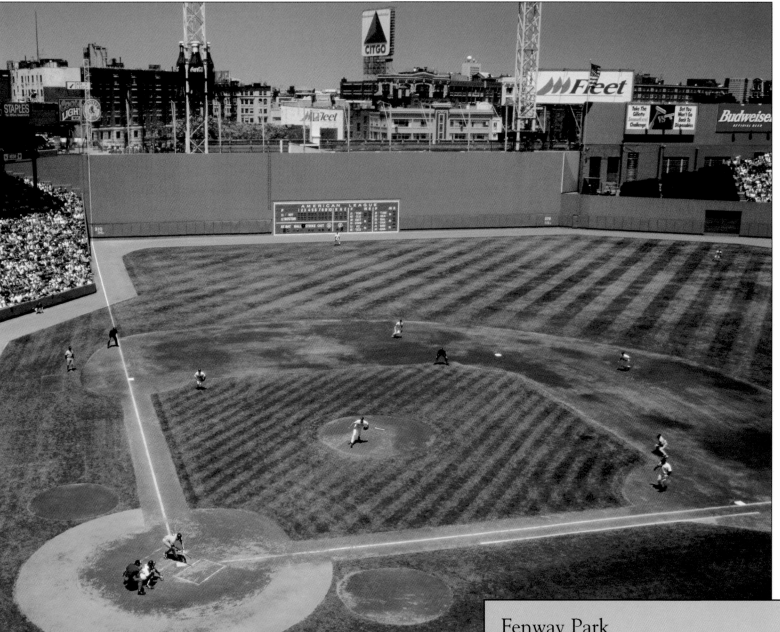

Far Left: With its six "witch's cap" spires, the Grand Pavilion was the most architecturally distinctive ballpark of the 1880s.

Left: Fenway Park's Green Monster stands just 308 feet from home plate, providing an inviting target for right-handed sluggers.

In 1901, the Boston Americans, soon to become the Red Sox, made their debut. Their ballpark, the Huntington Avenue Grounds, was located on a former circus lot just across the railroad tracks from the South End Grounds, where the rival Beaneaters played. Although it was a decent home-run park for dead-pull hitters, Huntington's center field fence stood an astounding 635 feet away, so unreachable that a tool shed

Fenway Park

Opened: April 9, 1912
Home to: Boston Red Sox (American League) 1912–present
Capacity: 35,000 (1912); 33,871 (2001)
Greatest Moment: October 16, 1912—The Giants' Fred Snodgrass muffs Clyde Engle's fly ball in the tenth inning of the final game of the World Series. He makes a great catch on the next batter, but the error eventually gives the game, and the championship, to the Red Sox.

there was part of the field of play. In a foreshadowing of Camden Yards, the massive Boston Storage Warehouse loomed over the left field bleachers. The biggest bean cannery in Boston sat just behind the right field stands, and it became a factor in a bizarre incident on August 11, 1903, during a game between Boston and Philadelphia. Rube Waddell hit a foul ball that landed on the bean factory, lodging between a steam whistle and a valve stem. The pressure caused the factory's whistle to blow continuously until a few minutes later when a steam cauldron in the factory exploded, dislodging the foul ball and spewing a mass of beans high into the air. The beans landed on the unfortunate occupants of the right field bleachers, where a mild panic ensued.

During the twentieth century's first decade, the Red Sox eclipsed the Braves in popularity, and by 1912 they had outgrown the Huntington Avenue Grounds. A new park was built on a former landfill site in a marshy area of Boston known as "the Fens." At first, the only thing Fenway Park had going for it was its location on a developing streetcar line. The park was built mostly of steel and concrete, with wooden bleachers and oak seats, and bore little resemblance to the place which John

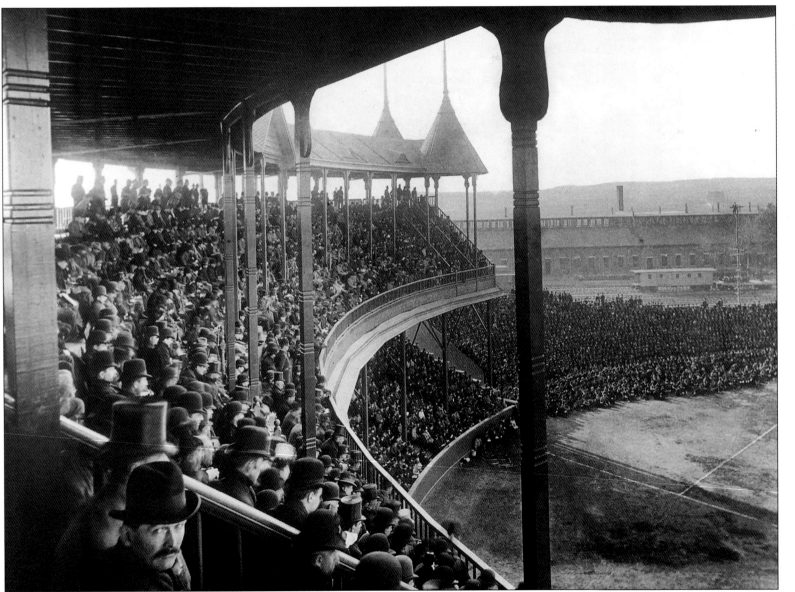

Left: When it opened in 1888, the Grand Pavilion was one of the most lavish ballparks ever constructed.

Right: This photo was taken before the first World Series game ever played, as fans at the Huntington Avenue Grounds mob the players trying to take pregame infield practice.

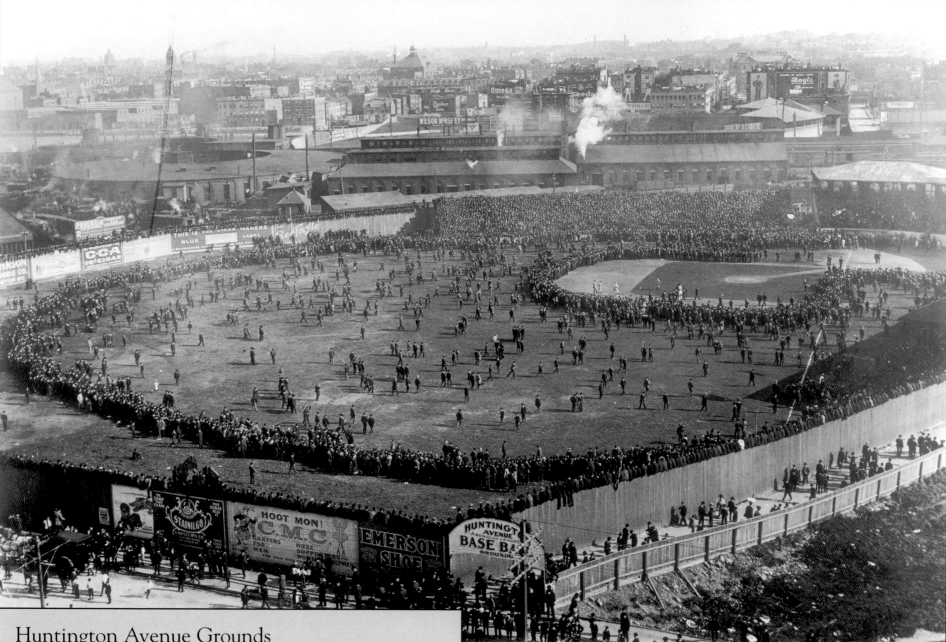

Huntington Avenue Grounds

Opened: May 8, 1901
Home to: Boston Red Sox (American League) 1901–1911
Capacity: 9,000 (1901)
Greatest Moment: October 1, 1903—Boston and Pittsburgh face off in the first-ever game in a new postseason contest called the "World's Series." Boston loses the game but wins the series, five games to three.

Updike would describe 48 years later as "a lyric little bandbox." Its shape determined by the parcel of land it occupied, the park was about 320 feet down each foul line, but a cavernous 488 feet to center field. It was death to left-handed power hitters. In 1919, when Babe Ruth hit 29 home runs, only nine of them were at Fenway. (In fact, the single most

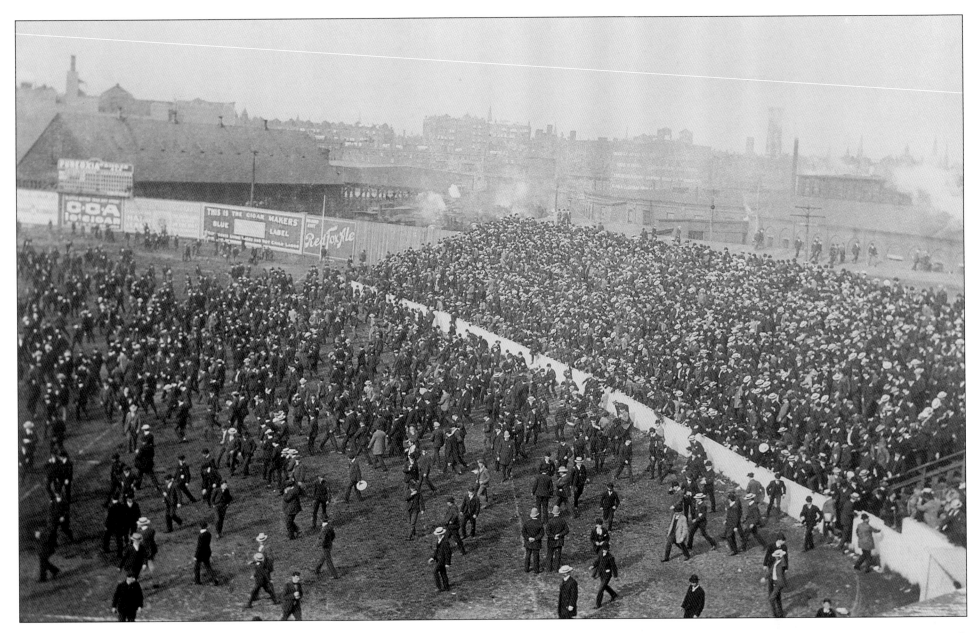

important factor in Ruth's power surge of 1920 was not a livelier ball or the banning of the spitball, but simply the fact that he escaped Fenway Park. His road homers stayed roughly the same from 1919 to 1920, but when he was batting in the cozy Polo Grounds in 1920, his home-run numbers at home more than tripled.)

Fenway's most recognizable feature—and the most recognizable feature of any ballpark, anywhere—is the left field wall known as the "Green Monster." It may strike us as a noble work of art today, but when

the Monster was constructed in 1912, its purpose was purely commercial. At 25 feet high, it was built to prevent people in the apartments across Lansdowne Street from watching the games for free. In 1934, the wall was completely torn down and rebuilt to its current height of 37 feet. In 1947, the advertisements were removed, the wall was painted green, and it became what is now baseball's most visible symbol of tradition and consistency. From 1912 to 1933, a 10-foot incline ran along the base of the Monster, creating an obstacle for all left fielders except apparently

Left: With the factories of Boston looming in the background, fans stream onto the field at Huntington Avenue Grounds after a doubleheader on June 17, 1903.

Below: The Braves drew 517,000 fans to Braves Field in 1933, the year this photo was taken.

Braves Field

Opened: August 18, 1915
Home to: Boston Braves (National League) 1915–1952
Capacity: 40,000 (1915); 37,106 (1948)
Greatest Moment: May 1, 1920—In the longest game in major league history, Brooklyn and Boston play to a 1-1 tie over 26 innings before the game is called due to darkness. Both starting pitchers, Brooklyn's Leon Cadore and Boston's Joe Oeschger, go the distance.

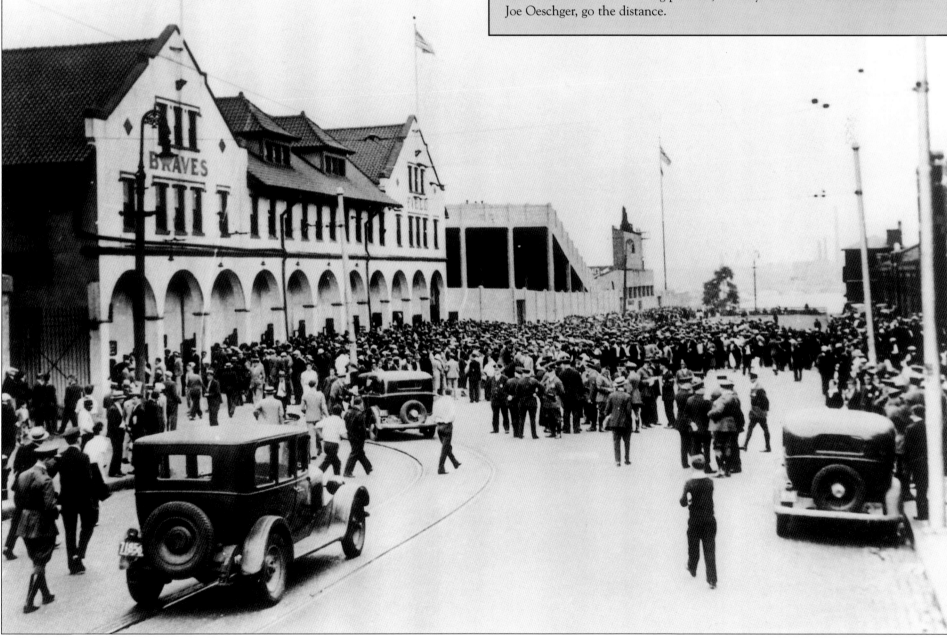

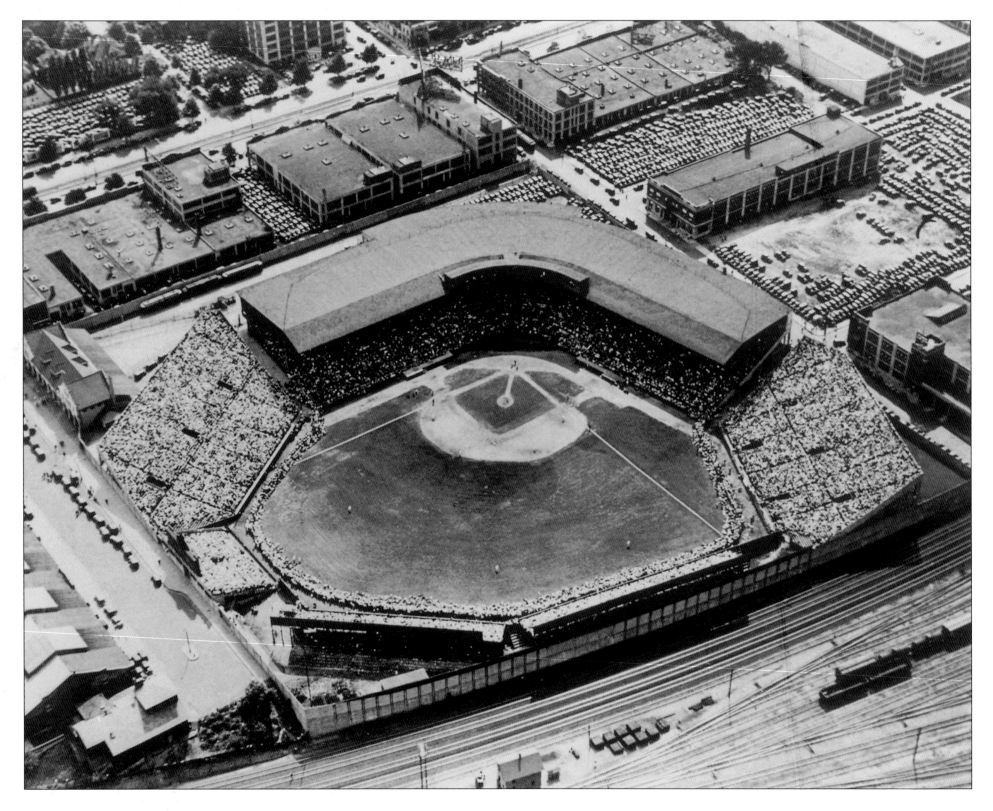

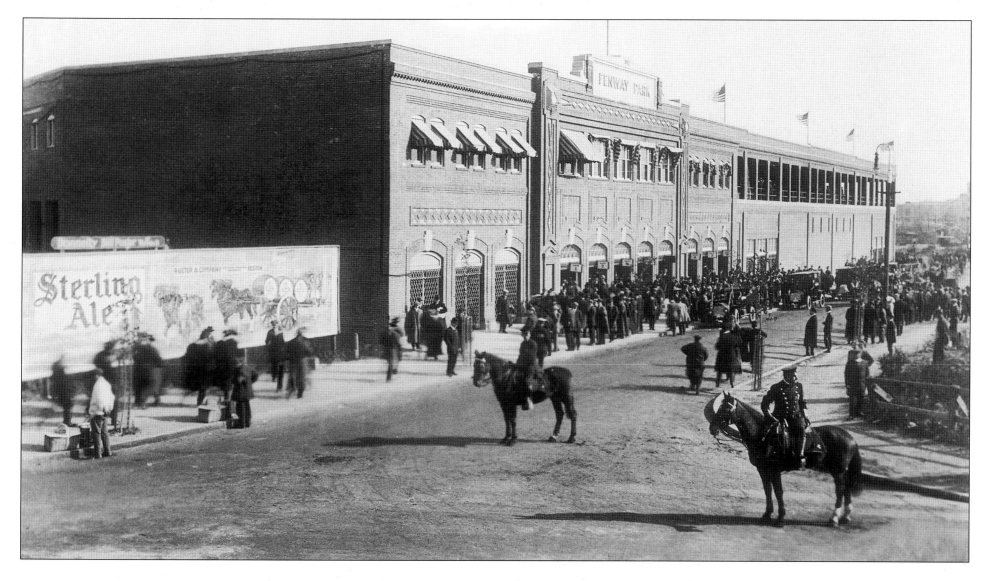

Above: The Red Sox built Fenway Park in 1912, when mounted police still roamed the streets of Boston.

Left: Train tracks ran behind the left field wall at Braves Field, where some home runs were said to have traveled hundreds of miles after landing in a train car.

the Red Sox' Duffy Lewis, whose masterful defensive play on the ledge caused it to be nicknamed "Duffy's Cliff."

Through 2001, the Red Sox had called Fenway Park home for 90 years, the longest time period that any team has ever used one ballpark. Thanks to its location in the literary and educational capital of America, Fenway has had more written about it than any park in baseball history. It has also been the site of many of baseball's most exciting moments, including Fred Snodgrass's muff that gave the 1912 World Series to the Red Sox, Ted Williams's home run in his final major league at bat, and Carlton Fisk's dramatic homer in the 1975 World Series.

Like the Red Sox themselves, Fenway has seen a number of changes and renovations over the years. In addition to the razing of Duffy's Cliff and the creation of the Green Monster, the 1934 renovation also included concrete bleachers to replace wooden ones in center field.

In 1940, bullpens were built in right field so the fence would be 23 feet shorter for Boston's young left-handed power hitter, Ted

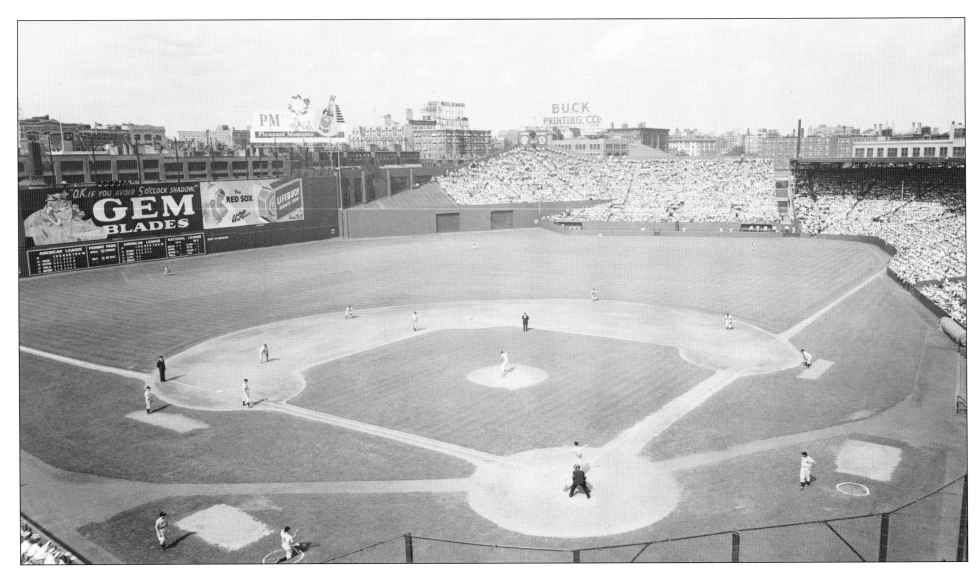

Williams. Lights came in 1947, the same year the Monster was painted green, and due to fire marshal's restrictions on overcrowding, Fenway's capacity today is actually 1,129 seats fewer than when it opened in 1912.

In 1914, when the Boston Braves miraculously rebounded from last place on July 4 to win the pennant, they were forced to play their World Series home games at Fenway Park. Their own home, the South End Grounds, was far too small to accommodate all the fans who wanted to attend. The following year Braves Field opened, and it was the Red Sox' turn to be envious. It was a gigantic stadium, built on a lot measuring 675 x 850 feet. When the Red Sox made the 1915 World Series, they borrowed Braves Field, which held 5,000 more fans than three-year-old Fenway. For the second consecutive year, a Boston team played its home World Series games in the other team's park.

In later years, the Braves could do hardly anything right, losing fans to the Red Sox while finishing in the second division 27 times in their 38 seasons at Braves Field. Their ineptness even extended to the ballpark when in 1946, 18,000 fans left the home opener with ruined clothing because the green paint on the seats had not yet dried. The Braves left for Milwaukee in 1953, and the site of Braves Field is now a football field on the Boston University campus.

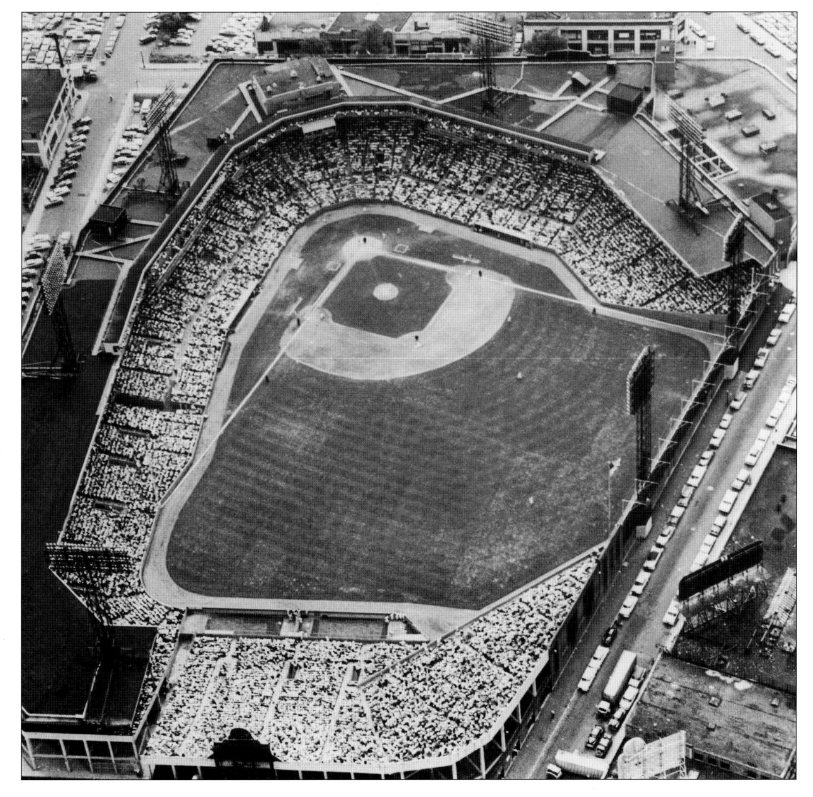

Left: Before 1947, Fenway Park's Green Monster wasn't even green. Instead, it was covered with advertisements.

Right: The right field bullpens were added to Fenway in 1940 to make it easier for Ted Williams, the young Red Sox left fielder, to hit home runs.

BROOKLYN

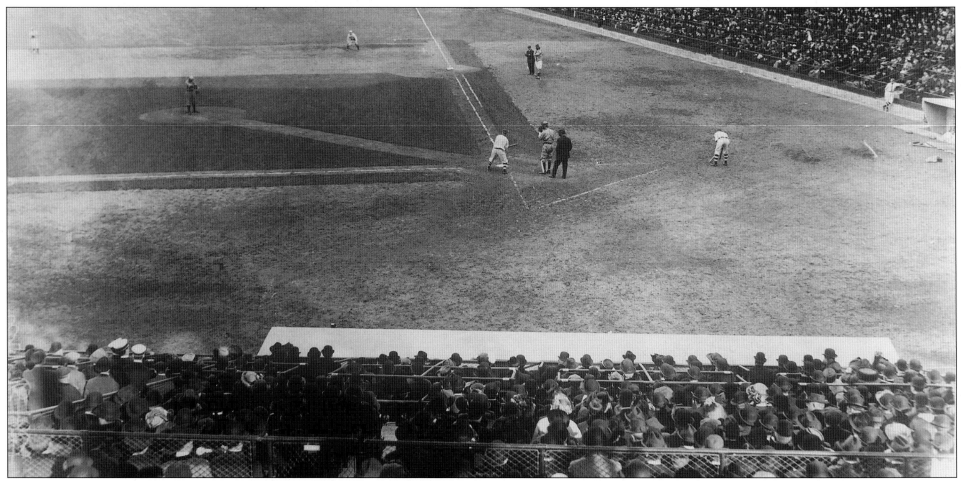

Union Grounds

Opened: May 15, 1862
Home to: New York Mutuals (National Association 1871–1875, National League 1876); Brooklyn Eckfords (National Association) 1871–1872; Brooklyn Atlantics (National Association) 1873–75; and Hartford Dark Blues (National League) 1877
Capacity: approximately 8,000
Greatest Moment: June 15, 1865—Two months after the end of the Civil War, 6,000 fans, the largest number to ever attend a ball game, watch the visiting Philadelphia Athletics defeat the Brooklyn Resolutes, 39-14.

William Cammeyer's Union Grounds may not have been the world's first ballpark, but it was without question the most influential. Home to baseball games in the summer, and an ice-skating rink in the winter, it proved that baseball could be a moneymaking enterprise. The park was home to many of the most prestigious teams of the 1860s and 1870s, including the New York Mutuals, Brooklyn Eckfords, and Brooklyn Atlantics.

Its success inspired others, particularly Reuben Decker and Hamilton Weed, who built the nearby Capitoline Grounds in 1864. This was the site of perhaps the greatest game in baseball history on June 14, 1870. The Cincinnati Red Stockings, winners of 84 straight games, faced the

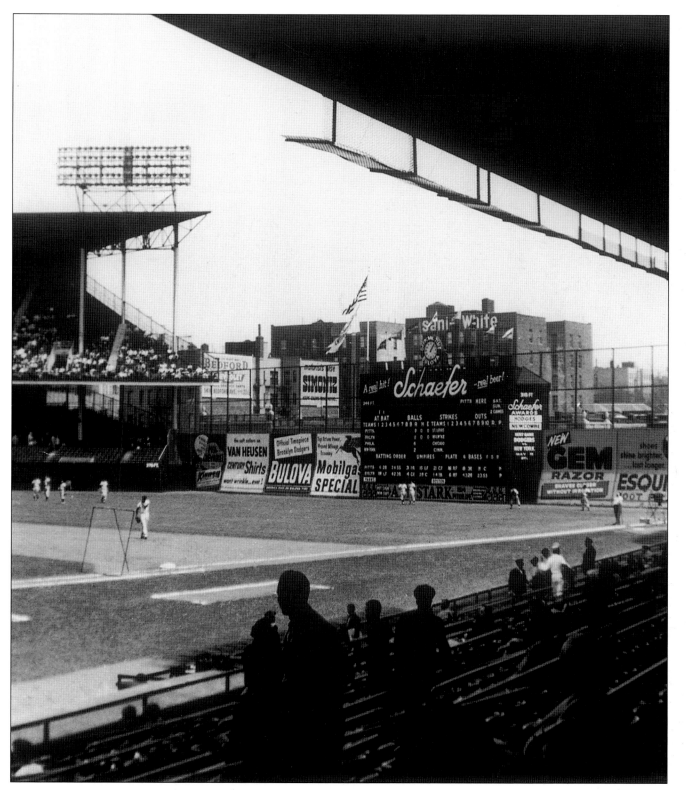

powerful Brooklyn Atlantics before an overflowing crowd at the Capitoline Grounds. The game was tied 5-5 after nine innings, and Cincinnati scored twice in the top of the eleventh. But in the bottom of the inning, the Atlantics scored three runs, the last on a botched grounder, and won the game 8-7. Cincinnati's winning streak was over, and Red Stockings owner Aaron Champion sent a telegram back to the newspapers in Cincinnati: "The finest game ever played. Our boys did nobly, but fortune was against us. Eleven innings played. Though beaten, not disgraced."

In 1884, Brooklyn got its first major league team, the Brooklyn Grays, who switched from the Inter-State League (a minor league) to the American Association (a major league) that spring. Their ballpark was situated on the site of a famous Revolutionary War conflict, the Battle of Long Island, and was named for that battle's losing general, George Washington. The Grays even used as their clubhouse the same stone building that had been General Washington's headquarters during the 1776 battle. The park burned down on May 19, 1889, but was rebuilt in eleven days. In 1891, the team abandoned Washington Park for

Far Left: Ray Caldwell pitches in the first game ever at Ebbets Field on April 5, 1913, an exhibition game which was also the first-ever meeting of the Dodgers and Yankees.

Left: During the 1950s, the Schaefer beer sign on Ebbets Field's scoreboard was the center of attention on close plays—the "h" in Schaefer lit up for a hit, and the "e" for an error.

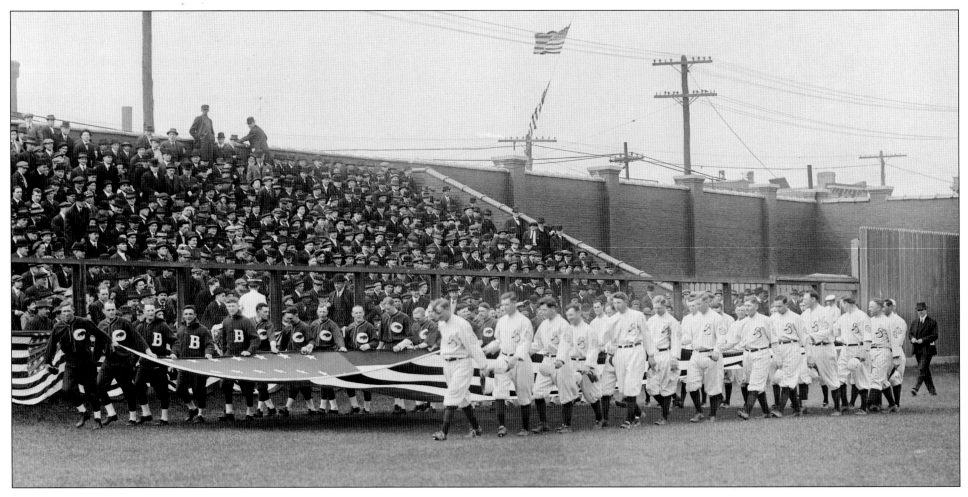

Above: Washington Park was refurbished in 1914, when the Brooklyn Tip-Tops (who were owned by the makers of Tip-Top Bread) moved in.

Right: Fans crowd into special bleachers erected at Ebbets Field for Game 1 of the 1920 World Series. The Dodgers lost the game, 3-1, and the series, five games to two.

Washington Park

Opened: April 30, 1898
Home to: Brooklyn Dodgers (National League) 1898–1912; Brooklyn Tip-Tops (Federal League) 1914–1915
Capacity: 18,800 (1914)
Greatest Moment: September 12, 1900—Cincinnati commits 17 errors while losing a doubleheader to Brooklyn, 7-2 and 13-9. "Iron Man" Joe McGinnity closes out both games for the Dodgers.

Eastern Park, which was located along the new electric trolley lines that had first appeared in Brooklyn the previous year. In order to get to the ballpark from the nearest trolley stop, fans had to cross a set of railroad tracks, so the Grays soon became known as the "Trolley Dodgers," a name that has stuck even though the team now plays in trolleyless Los Angeles.

In 1898, the Dodgers (also known variously as the "Bridegrooms" and the "Superbas") moved back into a third version of Washington Park, which had been rebuilt yet again. The Gowanus Canal running behind left field often caused a foul smell in the stands, while the Dodgers' play often caused a foul smell on the field, as they finished in the second division in 11 of the 15 seasons they played there. The Dodgers left in 1913, and after a brief occupation by the Federal League's Brooklyn Tip-Tops in 1914–1915, Washington Park closed. In 1922 an attempt was made to save the park as "a playground and national memorial," which,

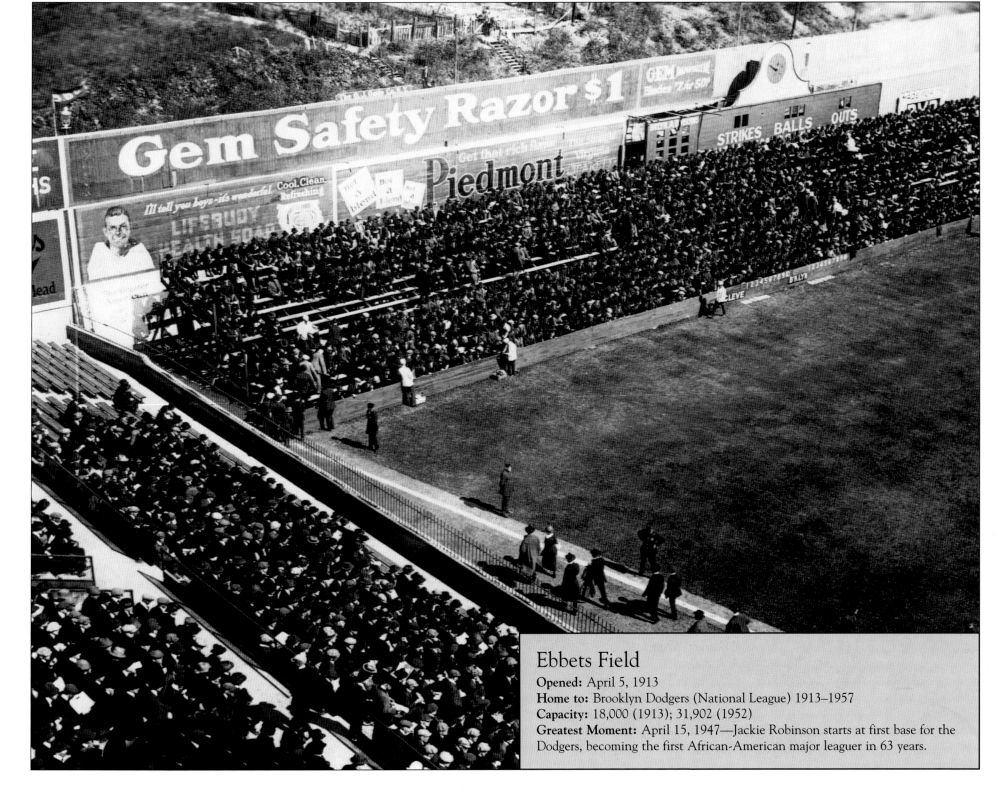

Ebbets Field

Opened: April 5, 1913
Home to: Brooklyn Dodgers (National League) 1913–1957
Capacity: 18,000 (1913); 31,902 (1952)
Greatest Moment: April 15, 1947—Jackie Robinson starts at first base for the Dodgers, becoming the first African-American major leaguer in 63 years.

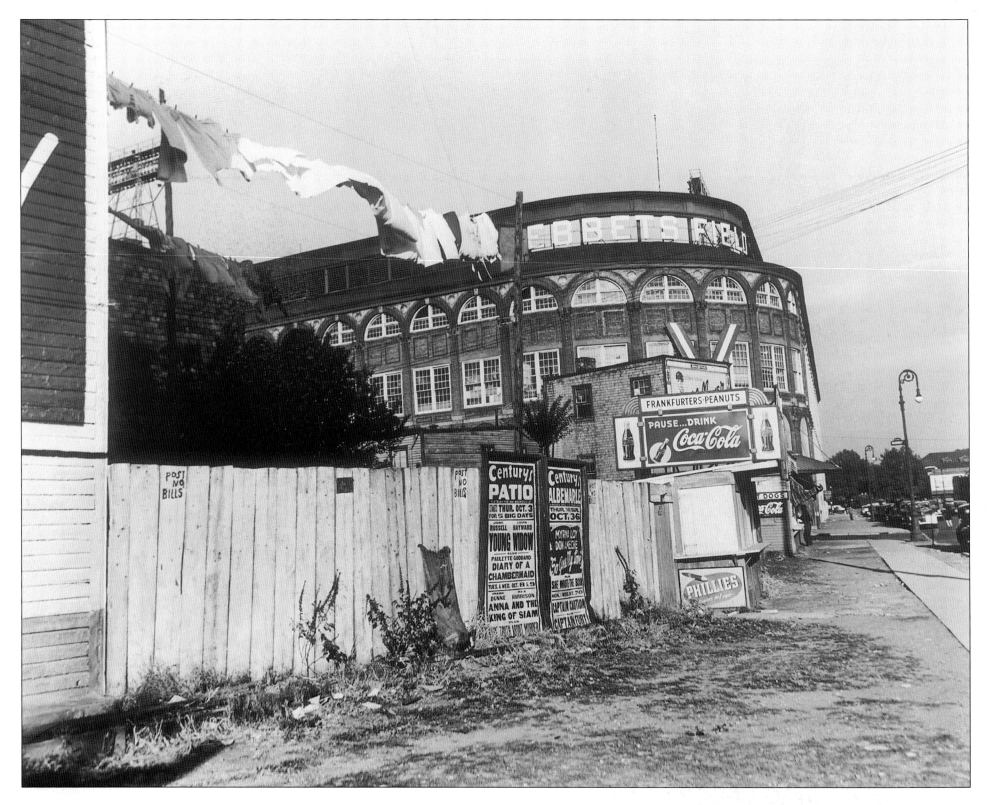

according to historian Michael Gershman, was the first-ever attempt to preserve a ballpark for historic reasons. The attempt failed however, and all that remains of the ballpark is the stone house that once served as George Washington's headquarters, which itself has been threatened with demolition in recent years.

As Washington Park grew more dilapidated, Dodgers owner Charles Ebbets decided he wanted a vast concrete-and-steel stadium like those that had recently been built in Philadelphia, Pittsburgh, and elsewhere. He purchased cheap plots of land one by one in the Flatbush section of Brooklyn, known as "Pigtown" because it was frequently used by residents as a garbage dump. Remarkably, the result was a $750,000 stadium that was, if not the best ballpark ever built, certainly the best-loved. When it opened in 1913, Ebbets Field featured an entrance rotunda of Italian marble with a floor tiled in baseball patterns. When the ballpark hosted it first exhibition game—appropriately enough, against the Yankees—Ebbets forgot to bring the keys to the park, and had to call a locksmith. It was a prescient mistake, as for the first three decades of its existence the park played host to mostly inept teams, personified by Wilbert

Robinson, Babe Herman, and the "Daffiness Boys" of the 1930s. In the 1940s, however, the team became competitive, and "Dem Bums"—a derisive nickname, which Brooklyn fans had used to describe their team—became a term of affection. On April 15, 1947, Ebbets Field played host to one of the most important moments in baseball history when Jackie Robinson, the first African-American major leaguer since 1884, debuted with the Dodgers. Robinson went 0-for-3, but over the next decade he would lead a star-studded Dodger team to six pennants and a world championship.

In addition to Robinson, the team featured Pee Wee Reese, Duke Snider, Roy Campanella, Gil Hodges, Carl Furillo, Don Newcombe, Carl Erskine, and Preacher Roe—all of whom were colorful personalities as well as outstanding players. The intimate ballpark they played in only added to their mystique, as the stands boasted more interesting characters than the average circus. There was Hilda Chester, the self-proclaimed "Mother of the Dodgers," who sat in the center field bleachers ringing a cowbell. In Section 8, there was the Dodger Sym-Phony Band (with the emphasis on "phony," as broadcaster Red Barber

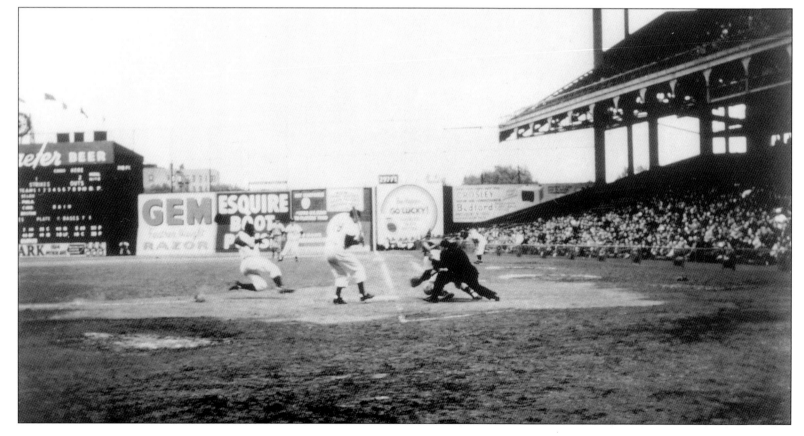

Left: Movie posters on the wooden fence in the foreground pinpoint when this photo was taken of Ebbets Field— October 1946.

Right: Jackie Robinson steals home, beating the tag from Cubs catcher Johnny Pramesa on May 18, 1952 at Ebbets Field. It was Robinson's sixteenth career steal of home; looking on is batter Preacher Roe.

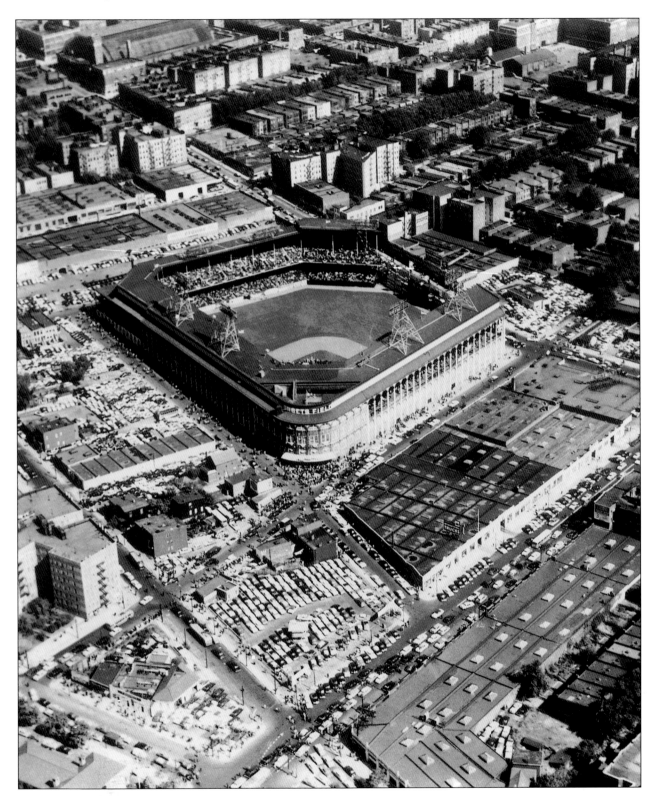

observed), a collection of extraordinarily untalented musicians who banged away on their instruments in support of the team. On the sideline there was Happy Felton, the host of "Happy Felton's Knothole Gang," a popular kids' television show about the Dodgers. In the broadcast booth, there was Barber himself, a redheaded Southerner whose descriptive play-by-play on the radio made him a Brooklyn icon. ("They're tearin' up the pea patch," he'd say during a rally.) A famous sign in right field offered a free suit of clothes from tailor Abe Stark to any batter who could hit the sign, but with Furillo playing right field, not many did.

By the mid-1950s, the luster was fading from the Dodger franchise. Barber left for the Yankees, the nucleus of stars were losing their skills, and the Dodgers' white fan base began moving to suburbia. African-American and Hispanic families moved into the neighborhood around Ebbets Field, which made some whites reluctant to attend games. The stadium itself was decrepit, at least according to Dodgers owner Walter O'Malley. "The aisles are too narrow," he told Roger Kahn. "The stairs are too steep. Poles obstruct the views. We can't park enough cars. We need twice as many seats. The bathrooms smell. The girders holding up the whole thing are rusting away." The Dodgers were still turning a tidy profit, but O'Malley wanted to replace Ebbets Field with a new domed stadium

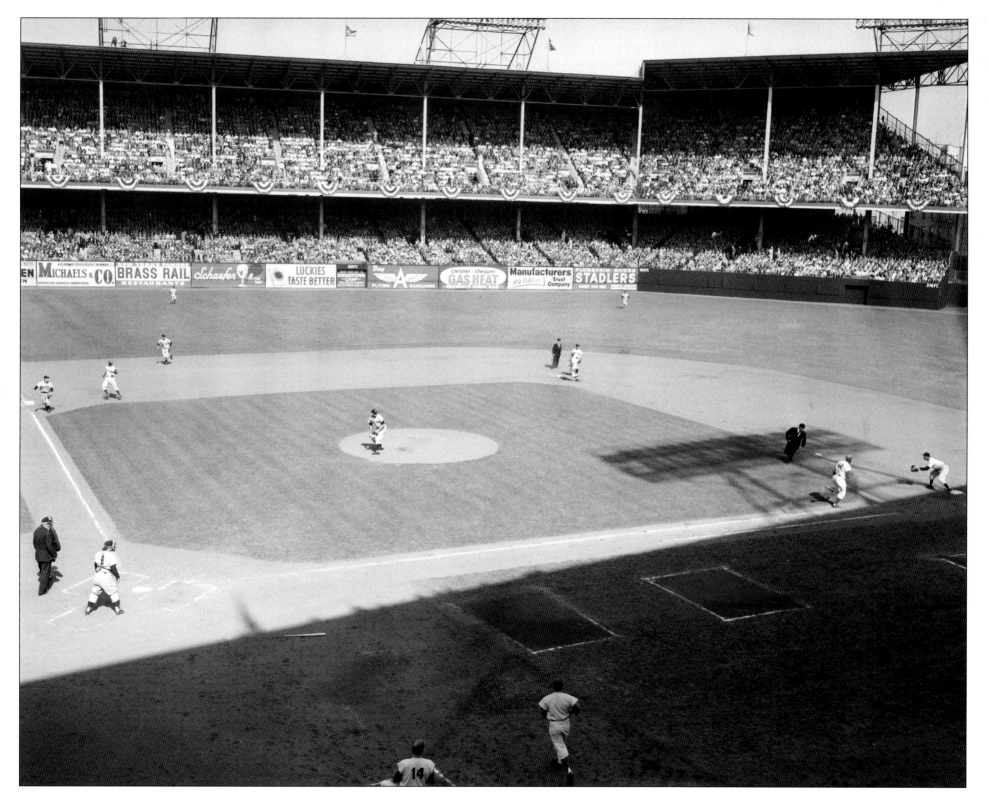

at the corner of Flatbush and Atlantic Avenues in the heart of Brooklyn. Parks commissioner Robert Moses refused to let him build it, saying a stadium there would bring traffic to a standstill. Instead, Moses suggested the site in Queens where Shea Stadium would later be built. "If my team is forced to play in the borough of Queens," O'Malley replied, "they will no longer be the Brooklyn Dodgers." And so it was. O'Malley accepted an extraordinary offer from the city of Los Angeles to relocate his team there, and on September 24, 1957, the Brooklyn Dodgers played their last game at Ebbets Field. The old stadium stood vacant for two years before demolition began on February 23, 1960. The neighborhood is now an inner-city slum, and the ballpark site is home to the Ebbets Field Apartments, a low-income housing project.

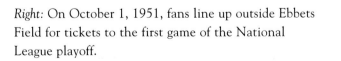

Right: On October 1, 1951, fans line up outside Ebbets Field for tickets to the first game of the National League playoff.

Far Right: A barren flagpole and broken windows indicate that this photo of Ebbets Field was taken after the Dodgers moved away in 1958.

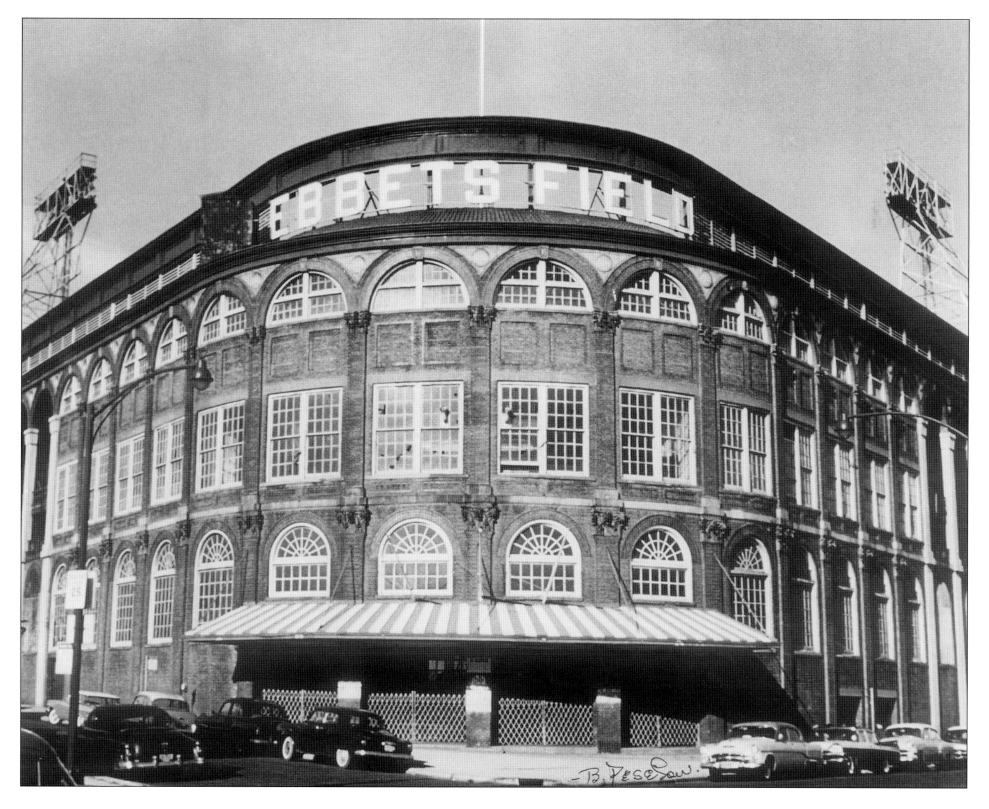

CHICAGO

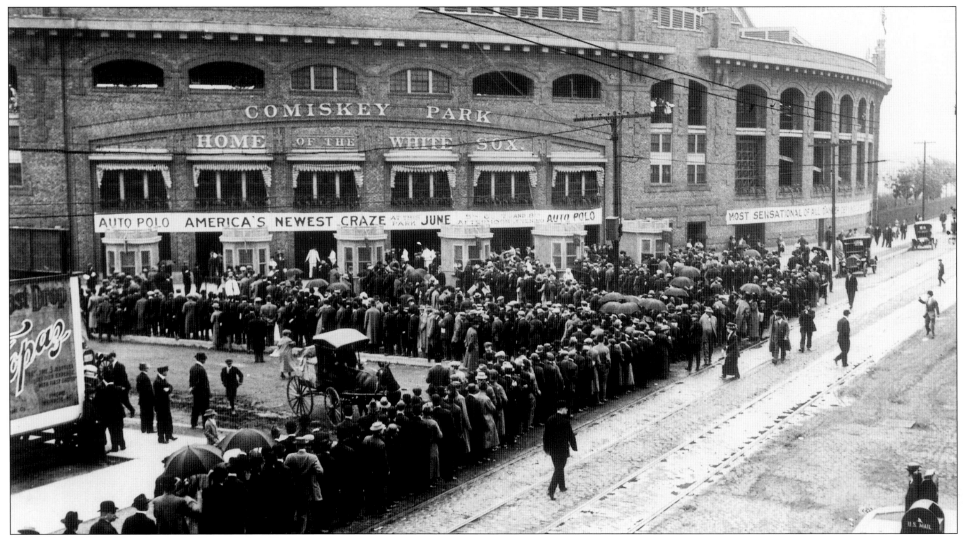

Chicago's first professional team, the White Stockings, began play in 1871 at the Union Grounds along the shore of Lake Michigan. The ballpark burned down in the great fire of 1871, and the city was left without professional baseball for two years. During the nineteenth century, Chicago was home to three different major league teams, and they played at a long succession of ballparks, including 23rd Street Grounds, Lake Front Park (two versions), South Side Park (three versions), West Side Park, and West Side Grounds.

The most significant of these was the second Lake Front Park, home of the White Stockings, which is notable for having the shortest outfield dimensions of any park in major league history: 180 feet to left field, 196 feet to right, and 300 feet to dead center.

Normally balls hit over the left field fence were considered ground-rule doubles, but for one season only, in 1884, they were home runs. Not surprisingly, Chicago's home-run totals exploded, led by Ned Williamson with 27, Fred Pfeffer with 25, Abner Dalrymple with 22, and Cap Anson

with 21. They were the four highest single-season home-run totals of all time, and Williamson's record stood until Babe Ruth broke it in 1919.

In 1893, the White Stockings (soon to become known as the "Cubs") moved into West Side Grounds, where they would spend the next 23 years. In the first decade of the twentieth century, the park was home to a Cubs dynasty led by pitcher Mordecai Brown and manager Frank Chance. The team won four pennants in five years, and posted 116 wins in 1906, a record that stood untouched for 95 years until the Seattle Mariners tied it in 2001. In 1914, big-league baseball came to Chicago's North Side for the first time when the Chicago Whales of the outlaw Federal League began play. The Whales had two main selling points: one, they played on the North Side, far away from the stench of the stockyards that filled the South Side air; and two, they were playing in a brand-new, 14,000-seat gem of a ballpark at the corner of Clark and Addison Streets.

The $250,000 park was named "Weeghman Park" after the team's owner, and when the Federal League collapsed after only two seasons, Weeghman bought the Cubs and moved them into his new park. They've been there ever since.

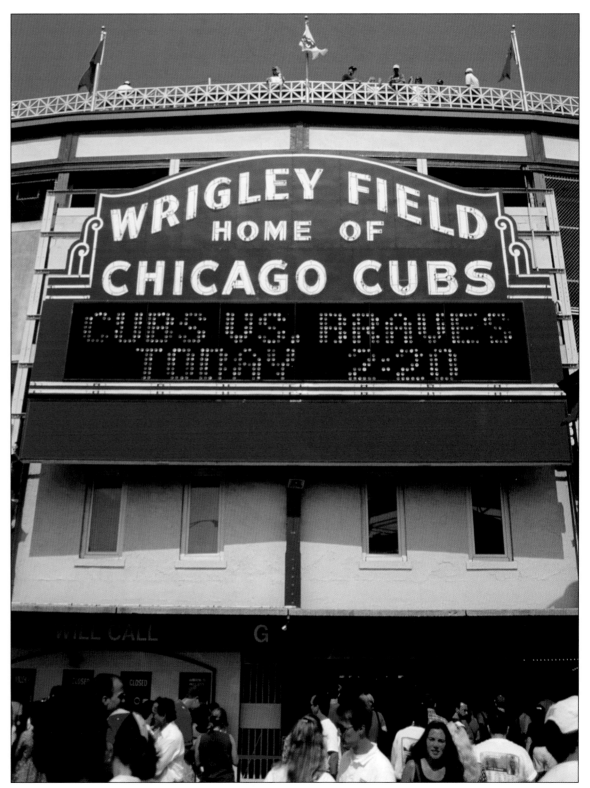

Left: Opened in 1910, old Comiskey Park stood in the heart of Chicago's South Side.

Right: For its first 75 years, Wrigley Field's marquee announced day games only. Although lights were installed in 1988, most games still take place in the sunshine.

West Side Grounds

Opened: May 14, 1893
Home to: Chicago Cubs (National League) 1893–1915
Capacity: 16,000; 30,000 (1908)
Greatest moment: August 5, 1894—Fire breaks out in the stands during the seventh inning of a Chicago-Cincinnati game. Chicago players Jimmy Ryan and Walt Wilmot save 1,600 fans by hacking through a barbed-wire fence with their baseball bats, allowing the fans to escape onto the field.

Weeghman Park was renamed "Wrigley Field" by William Wrigley Jr., the chewing-gum heir, who purchased the Cubs in 1918. The best of the classic concrete-and-steel stadiums, it is situated only three blocks from Lake Michigan, allowing the lake breezes to affect the game just enough to make things interesting. Under Wrigley's direction, the park underwent major renovations in 1922, 1928, and 1937, and today it barely resembles Weeghman's 1914 palace. The stadium was double-decked in the 1920s, and the famed scoreboard and ivy were added in 1937 by 23-year-old Cubs assistant Bill Veeck.

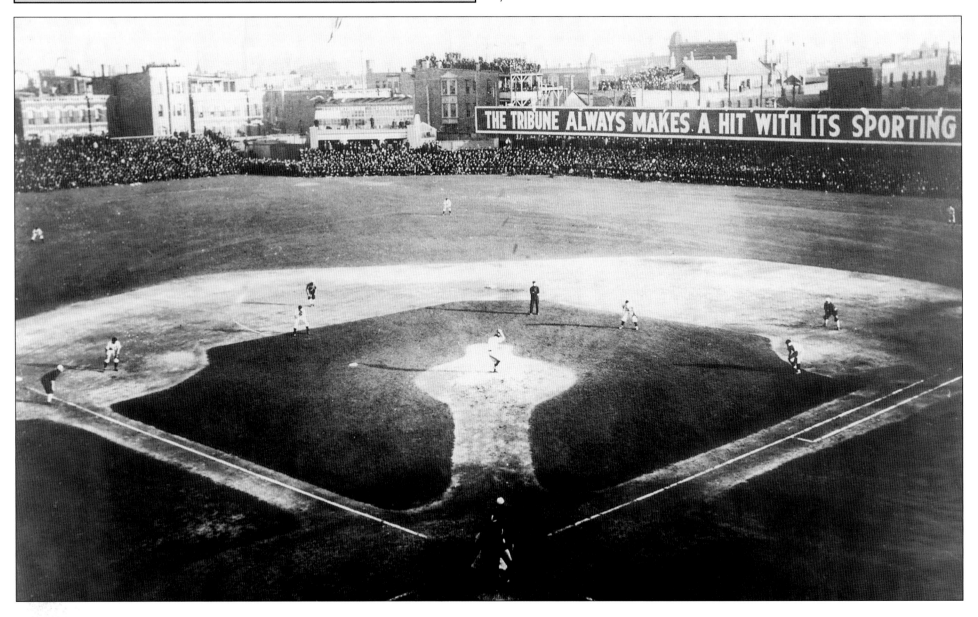

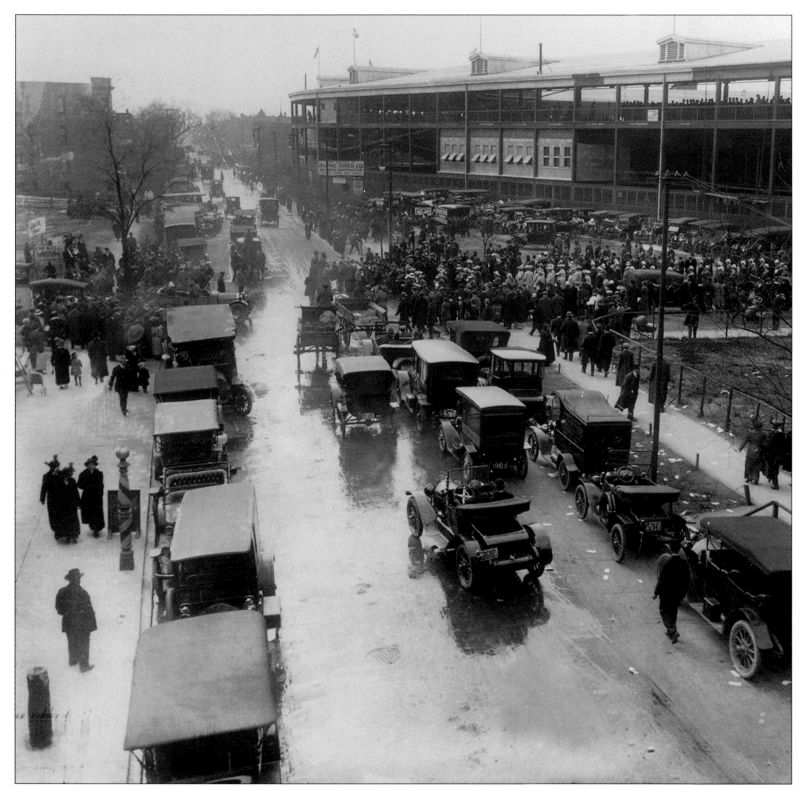

Far Left: Cubs 20-game-winner Jack Pfiester delivers a pitch in Game 3 of the 1906 World Series at West Side Grounds. The bases are loaded and the infield is playing in, enabling base runner Ed Walsh to take an enormous lead at second base. All three base runners would eventually score, and the White Sox won the game, 3-0.

Left: When this photo of Weeghman Park (later Wrigley Field) was taken in 1915, some fans were still driving to the ballpark in a horse and carriage.

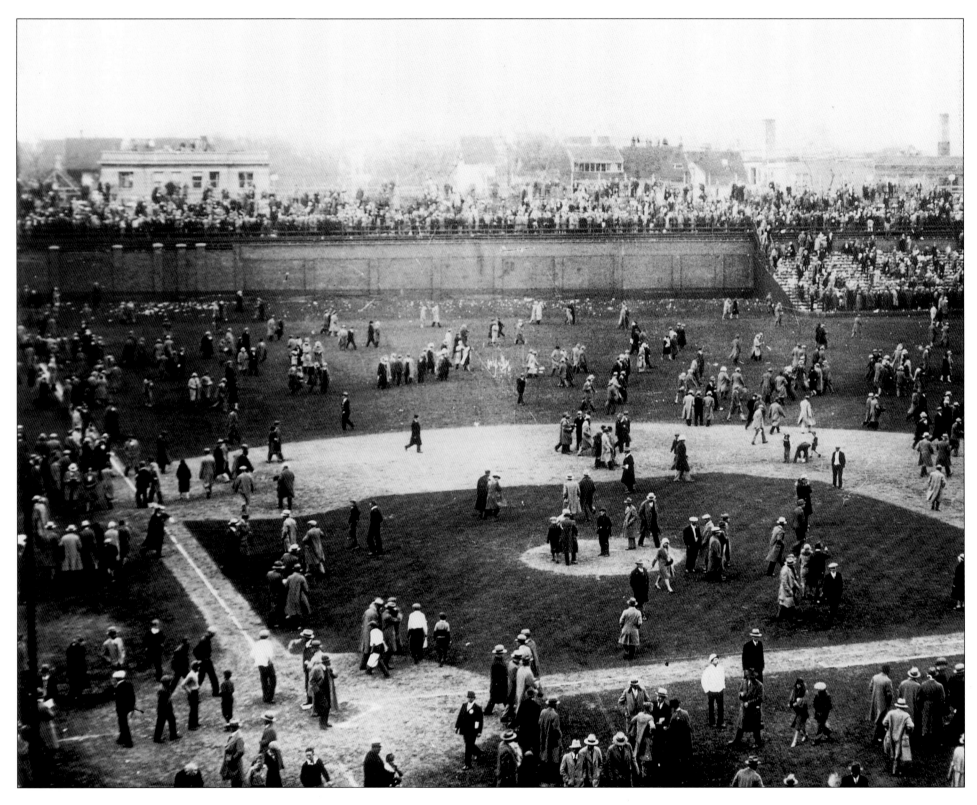

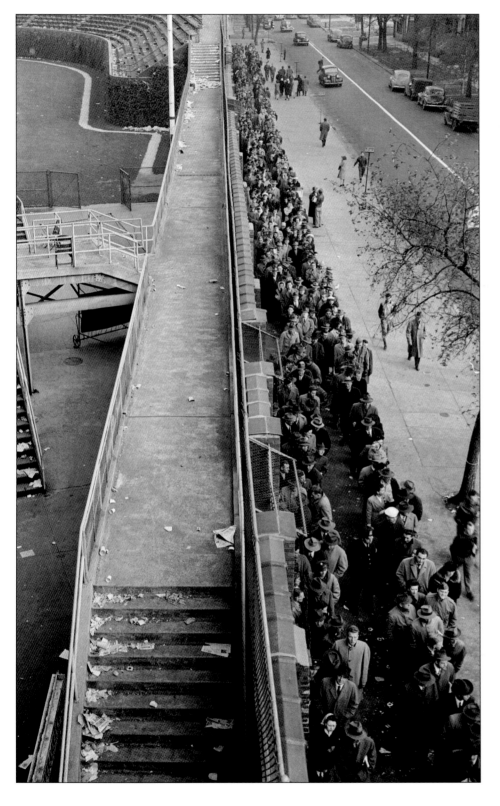

Wrigley Field

Also known as: Weeghman Park (1914–1915); Cubs Park (1916–1925)
Opened: April 23, 1914
Home to: Chicago Whales (Federal League) 1914–1915; Chicago Cubs (National League) 1916–present
Capacity: 14,000 (1914); 38,765 (2001)
Greatest Moment: October 8, 1929—35-year-old Howard Ehmke, winner of only seven games during the season, is Philadelphia's surprise starter in the opening game of the World Series. He wins 3-1, setting a Series record with 13 strikeouts. It is the last victory of Ehmke's career, and the A's go on to win the series.

In 1932 the park witnessed one of the most debated events in baseball history. During Game 3 of the World Series, 37-year-old Babe Ruth, who had been jeered by the Cubs all day, gestured toward Wrigley's center field bleachers. He hit a home run on the next pitch, and for the last seven decades, baseball fans have argued over whether or not he really "called his shot."

Wrigley Field probably became the first major league ballpark to have lights, when in 1915 Weeghman installed a complete electric lighting system. The lights were not for baseball, but for a nightly postgame hippodrome show featuring horses, jugglers, and a comedian specializing in baseball pantomime. In 1941, Wrigley Field again came tantalizingly close to night baseball, as Wrigley purchased lights and had them inside the park waiting to be installed. But when World War II broke out, he donated the steel to the war effort instead. Finally on August 9, 1988, Wrigley Field hosted its first night game, after more than four decades as the only major league stadium without lights. Fortunately, most Cubs games are still played in the afternoon, preserving the tradition of daytime baseball for a new generation of fans. The stadium remains a holdout in another area, too. It is the only current major league park with no

Far Left: When this photo of ivy-less Wrigley Field was taken in the 1930s, fans were allowed to mill about on the playing field after the games.

Left: Fans line up for tickets to the 1945 World Series at Wrigley Field. Little did they know that their team would not appear in another Fall Classic for the rest of the twentieth century.

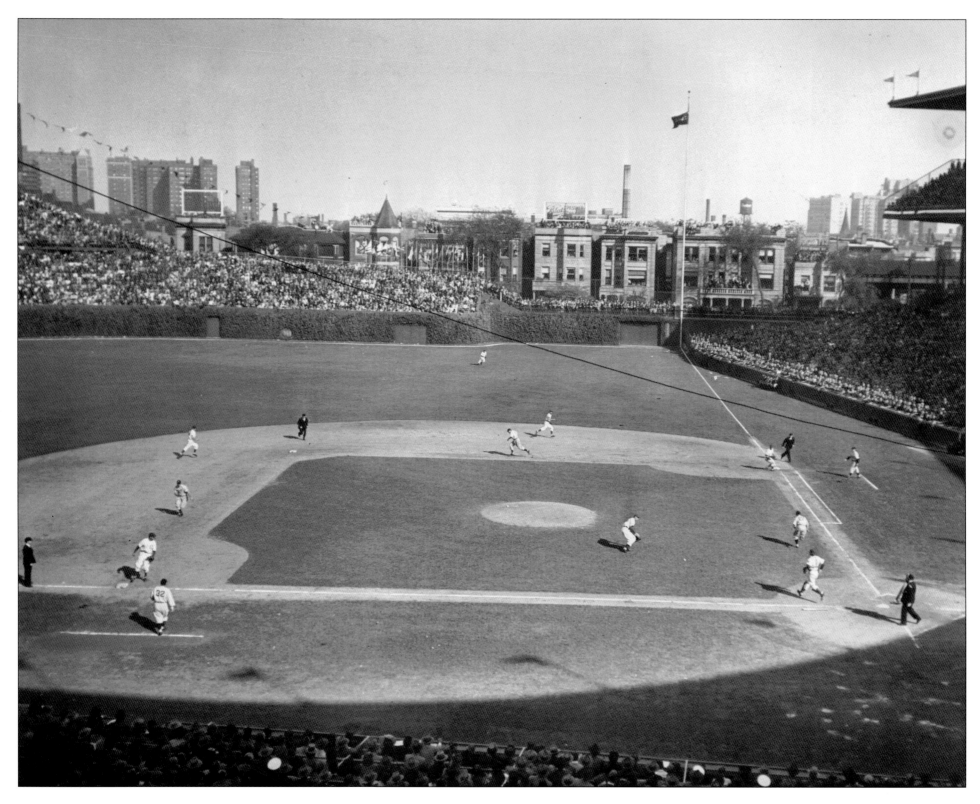

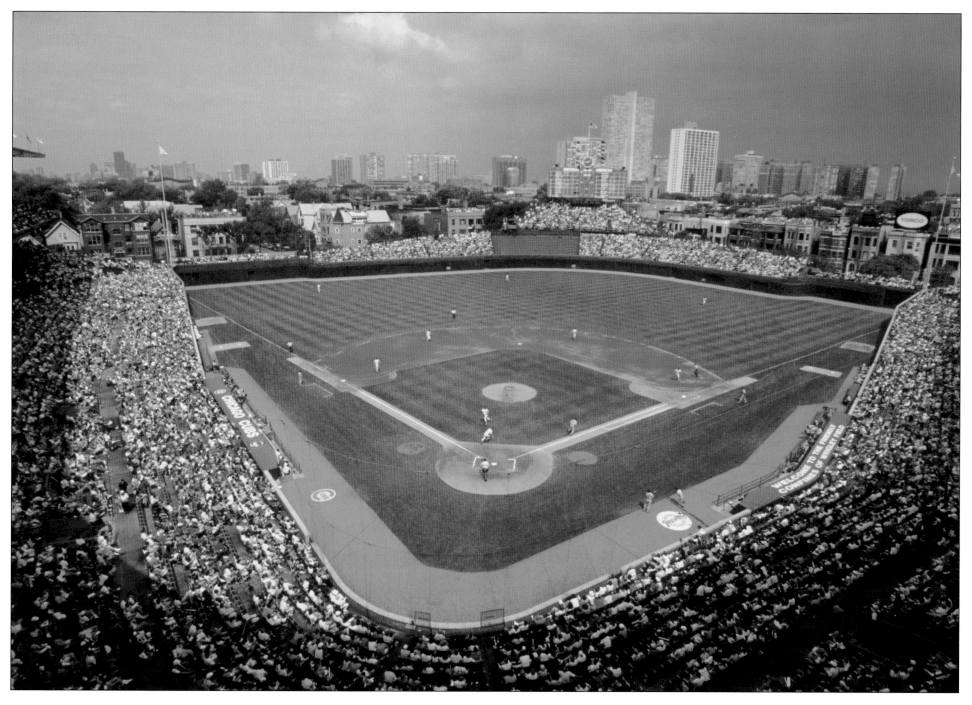

Left: Wrigley has always been a friendly park for hitters, especially Ernie Banks, who hit 512 home runs with the Cubs, and Sammy Sosa, who slugged over 60 in three different seasons.

Above: After each game at Wrigley Field, the Cubs run a flag up the flagpole on the center field scoreboard. A white flag signifies a Cub win, a blue one a loss.

Right: After the White Sox abandoned South Side Park, the Chicago American Giants, one of the best teams in the Negro Leagues, moved in.

Far Right: In the 1939 Negro League East-West Game at Comiskey Park, Henry Milton slides home as Josh Gibson blocks the plate. Milton was called out, but his West team still won, 4-2.

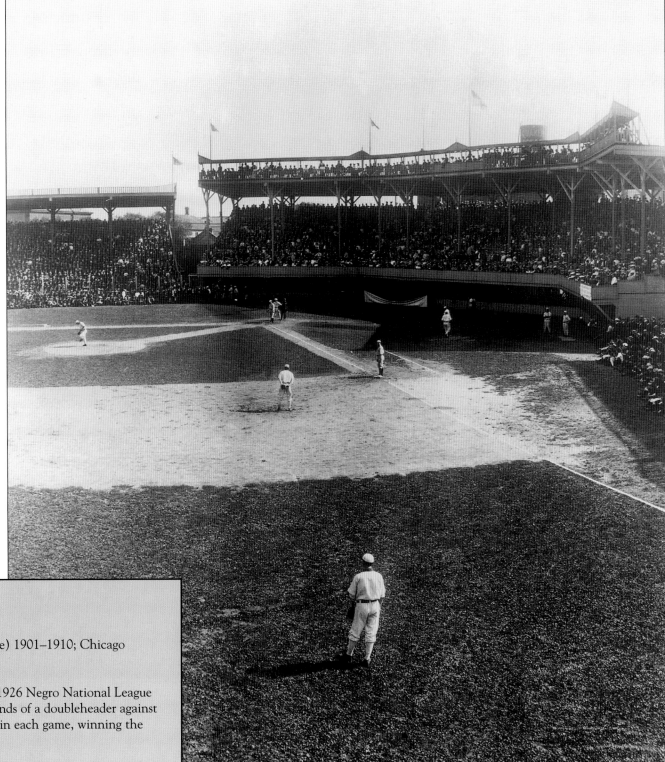

South Side Park

Opened: April 24, 1901
Home to: Chicago White Sox (American League) 1901–1910; Chicago American Giants (Negro Leagues) 1911–1940
Capacity: 15,000
Greatest Moment: In the last two games of the 1926 Negro National League playoffs, Hall-of-Famer Bill Foster pitches both ends of a doubleheader against the Kansas City Monarchs. He throws a shutout in each game, winning the pennant for the American Giants.

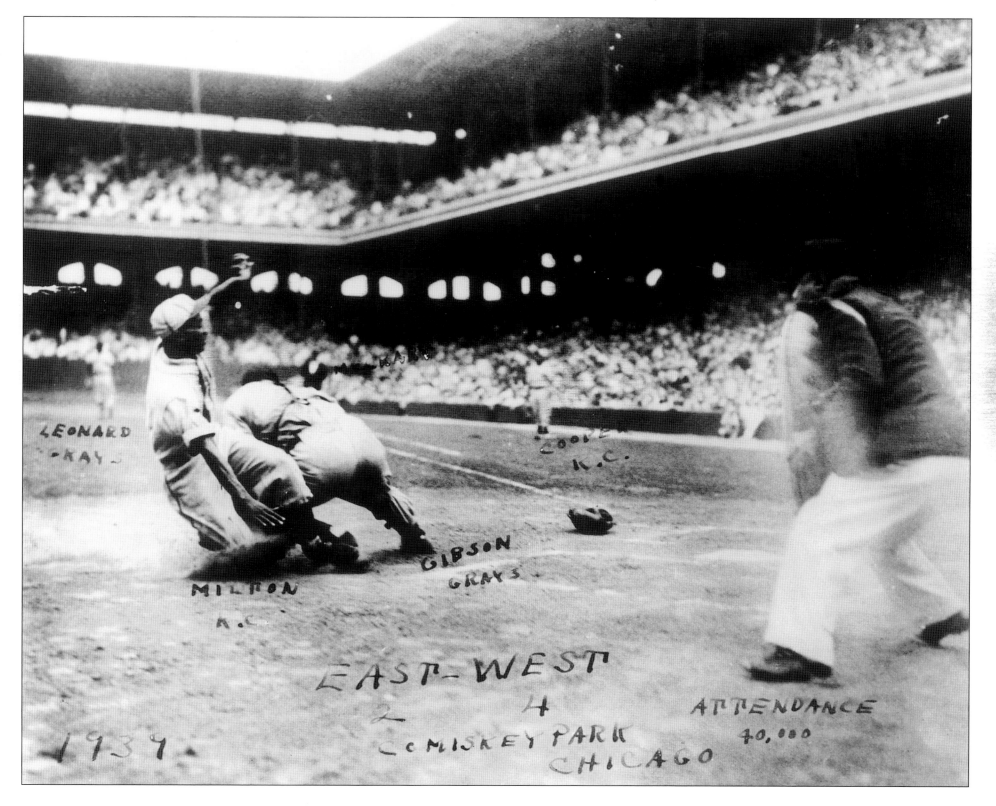

LEONARD
GRAY

COOPER
K.C.

GIBSON
GRAYS

MILTON
K.C.

EAST-WEST
2 4 ATTENDANCE
COMISKEY PARK 40,000
1939. CHICAGO

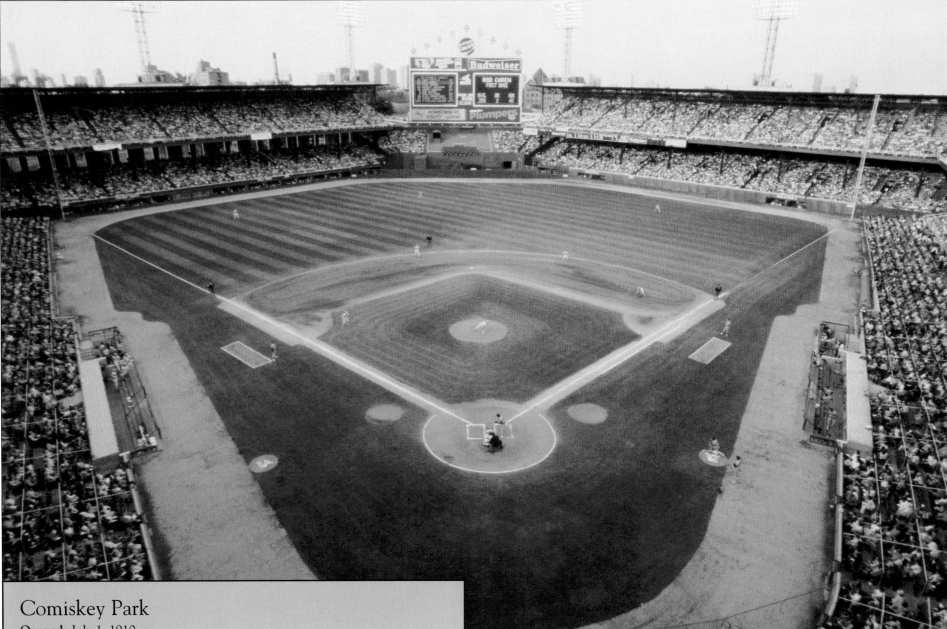

Comiskey Park

Opened: July 1, 1910
Home to: Chicago White Sox (American League) 1910–1990; Chicago
American Giants (Negro Leagues) 1941–1950
Capacity: 28,810 (1910); 43,951 (1990)
Greatest Moment: August 26, 1934—In one of the most exciting ball games
ever played, the East defeats the West 1-0 in the Negro League East-West
Game. Satchel Paige is the winning pitcher, and Cool Papa Bell scores the
only run after he walks and steals second in the eigth inning.

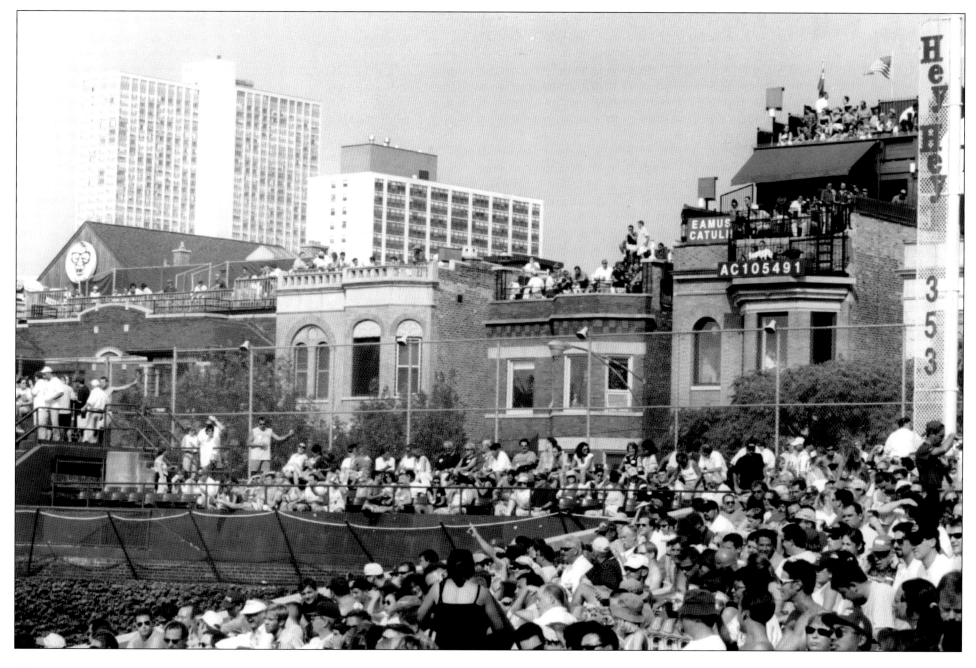

Above: Fans watch a Cubs game from the rooftop bleachers across Sheffield Avenue in this 1999 photo. The slogan "Eamus Catuli" on the building on the right means "Let's Go Cubs" in Latin.

Left: After 1960, old Comiskey Park's most distinctive feature was the exploding scoreboard installed by Bill Veeck.

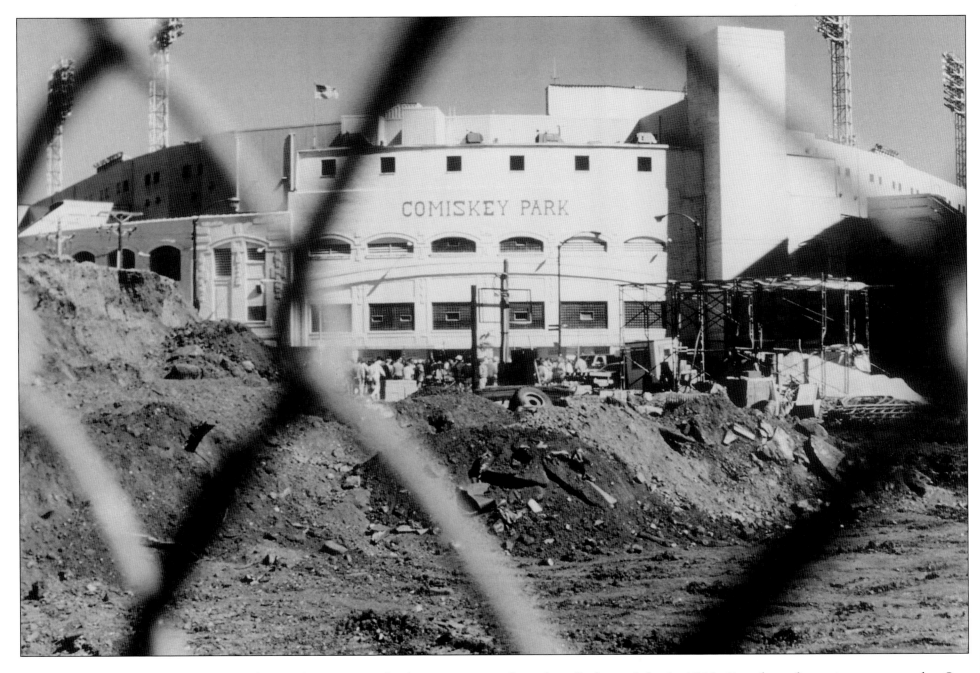

display advertising, a classy feature that makes it easier for fans to concentrate on the game at hand. Wrigley Field stands today as a glorious hodgepodge of elements, shaped by the neighborhood surrounding it, and there has never been a better place to watch a baseball game.

Wrigley, however, was not the first classic ballpark built in Chicago. That honor belongs to the Chicago White Sox, who unveiled Comiskey Park on July 1, 1910. For their first nine seasons the Sox had played at the third version of South Side Park, and it was there in 1906 that they beat the Cubs in the first World Series to take place entirely in one city. However, owner Charles Comiskey felt his team was outgrowing the 15,000-seat stadium, and sold it to his son-in-law John Schorling.

Comiskey Park

Opened: April 18, 1991
Home to: Chicago White Sox (American League) 1991–present
Capacity: 44,702 (1991)
Greatest Moment: June 22, 1993—Carlton Fisk breaks the all-time record by catching his 2,226th major league game. Six days later, he is unceremoniously released by the White Sox.

Left: Old Comiskey stands in the background, while in the foreground a new park rises to take its place.

Below: The new Comiskey Park, which opened in 1991, tried to copy many features of its predecessor, including the famous scoreboard.

Schorling, in turn, leased it to Rube Foster, owner and manager of the American Giants, Chicago's premier African-American team. The park Comiskey built to replace it stood in the heart of Chicago's meat-packing South Side, and as Tony Cuccinello remembered, "When you could smell the stockyards, that meant the wind was blowing out."

Comiskey was not a significant park architecturally, but was the site of some of baseball's most memorable moments. These included the "Black Sox" World Series of 1919, the first All-Star Game in 1933, the Negro Leagues' annual East-West all-star game from 1933–1950, and Bill Veeck's infamous Disco Demolition Night on July 12, 1979.

In 1991, the old park crumbling, the White Sox moved into a new Comiskey Park, built in the parking lot of the old one. The new Comiskey was a replica of its predecessor, and even included a gaudy scoreboard like the one Veeck had installed in 1960. It was easily the least-imaginative ballpark built in the 1990s, and by 2001 renovations were necessary to keep it from becoming completely obsolete.

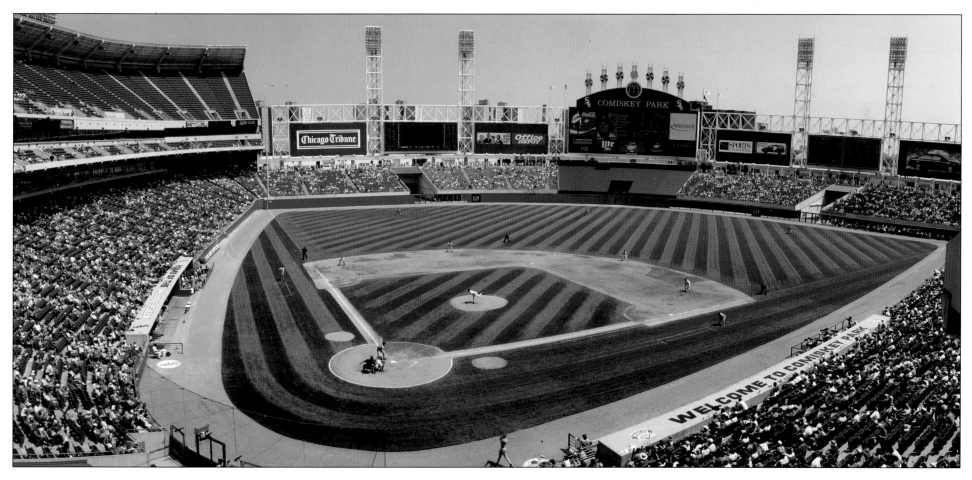

CINCINNATI

In 1902, the Cincinnati Reds built the Palace of the Fans, an ambitious structure intended to mimic a Greek temple, complete with an extravagant facade and opera-style private boxes lining the front rows. The fancy stadium burned down in 1911, and a replacement, Redland Field, was built on the same site.

Unlike its contemporaries Wrigley Field and Fenway Park, Redland Field was a double-decked stadium from the day it opened, and it was renamed "Crosley Field" in 1934. The park featured an incline at the base of the fence all the way around the outfield, similar to Duffy's Cliff in Fenway Park. The three-story Crowe Engineering Co. building was a longtime landmark behind the center field fence, and it came into play in 1960 when Reds manager Fred Hutchinson was accused by the Chicago Cubs of using the building to steal signs. By the late 1960s, the Reds were eager to jump on the multipurpose stadium bandwagon, and on June 24, 1970, they played their last game at the corner of Western and Findlay, which the franchise had called home since 1884. Their new home was Riverfront Stadium, a publicly financed concrete bowl that had the dubious distinction of being the first outdoor stadium with artificial turf. The best thing about the $45 million stadium was its location downtown on the banks of the Ohio River. In 1996, Hamilton County sold the stadium's name to Cinergy Corp. for $6 million, and the same year voters approved a tax hike for a new Reds ballpark. Great American Ball Park, located adjacent to Riverfront Stadium, was expected to open in 2003.

Above: Palace of the Fans featured a facade that made it look more like a courthouse than a ballpark.

Right: Located just across the Ohio River from Kentucky, Riverfront Stadium has one of the most picturesque settings in baseball.

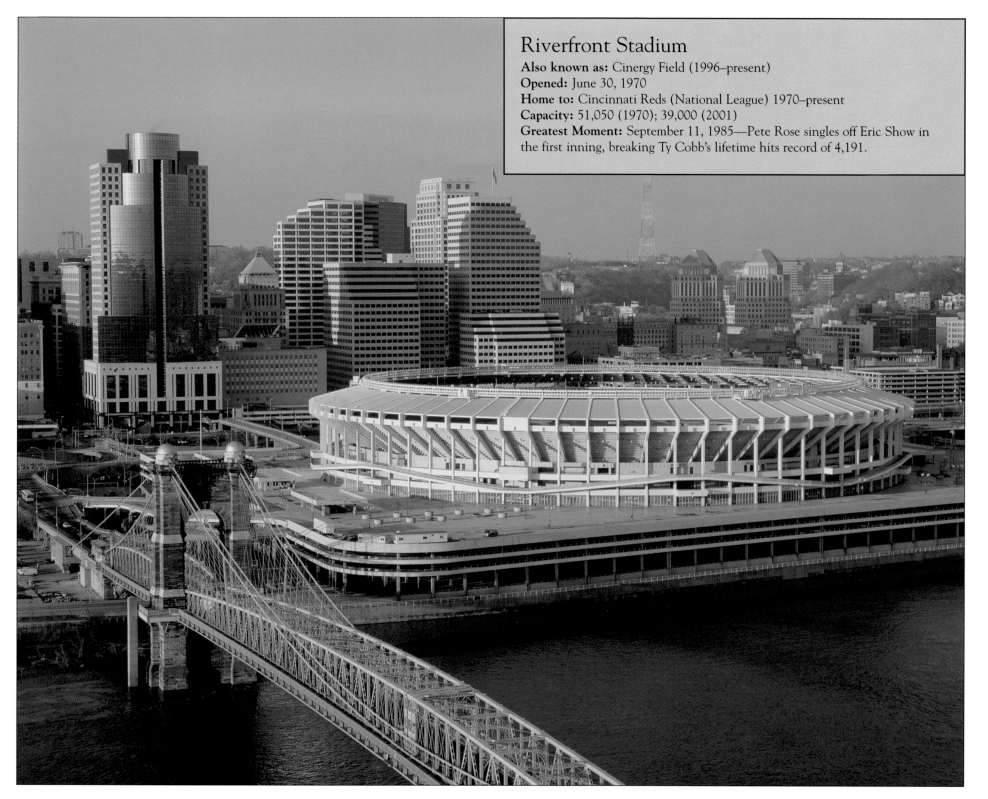

Riverfront Stadium

Also known as: Cinergy Field (1996–present)
Opened: June 30, 1970
Home to: Cincinnati Reds (National League) 1970–present
Capacity: 51,050 (1970); 39,000 (2001)
Greatest Moment: September 11, 1985—Pete Rose singles off Eric Show in the first inning, breaking Ty Cobb's lifetime hits record of 4,191.

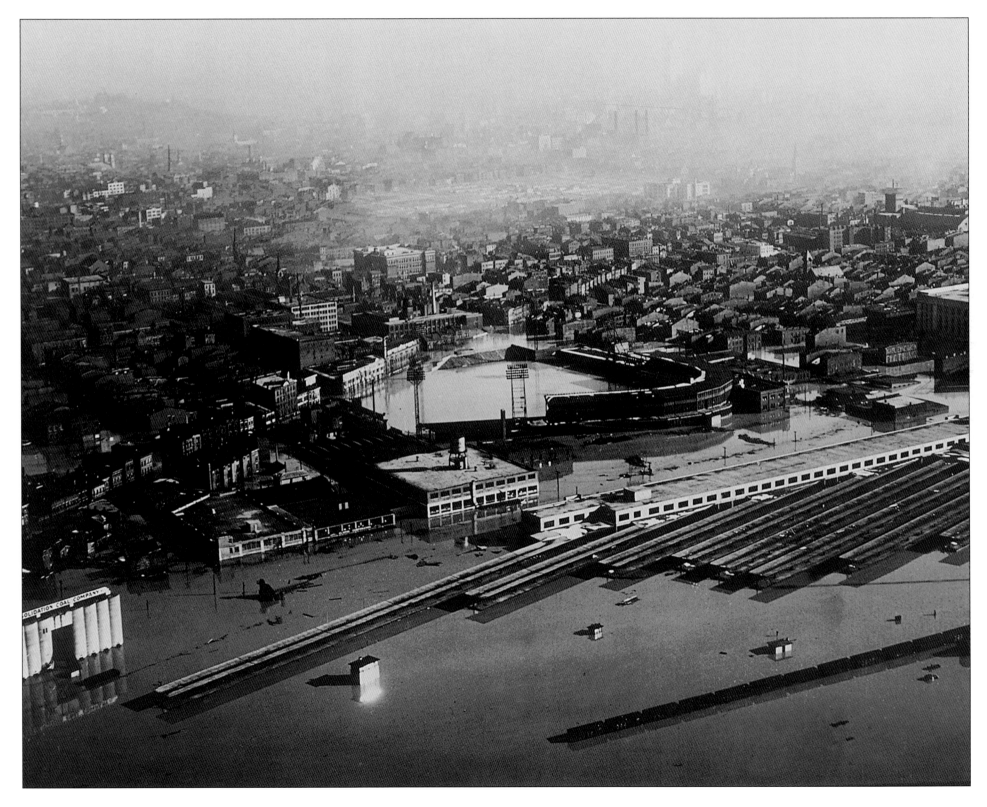

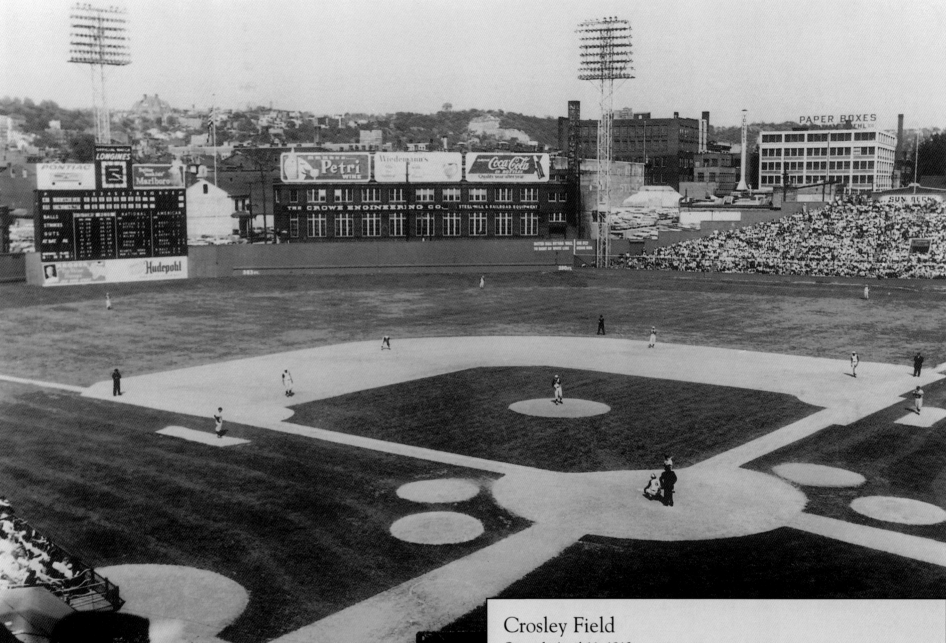

Above: In 1960, the Reds were accused of stealing signs by using the Crowe Engineering Co. building behind the center field fence at Crosley Field.

Left: On January 25, 1937, the Mill Creek Flood covered Crosley Field's playing field with 21 feet of water.

Crosley Field

Opened: April 11, 1912
Also known as: Redland Field (1912–1933)
Home to: Cincinnati Reds (National League) 1934–1970
Capacity: 25,000 (1912); 29,400 (1970)
Greatest Moment: May 24, 1935—Franklin D. Roosevelt flips an electric switch in the White House that turns on Crosley Field's lights, and the Reds defeat Philadelphia 2-1 in the first night game in major league history.

CLEVELAND

Though Cleveland major league teams used many different stadiums before the turn of the twentieth century, the first one of significance was League Park, built in 1891. It was smaller than most parks because owners of some adjacent lots refused to sell their property. However, despite an 1892 lightning strike that set the park on fire during a game, the facility was home to the Cleveland Spiders until 1899. They folded after a dismal season, where they finished with the worst record in major league history (20-134).

Major league baseball returned to League Park in 1901, when the upstart American League placed a team in Cleveland. After the 1910 season, League Park was completely rebuilt, but due to the small tract of land it occupied, it still had one of the smallest

League Park

Also known as: Dunn Field (1916–1927)
Opened: April 21, 1910
Home to: Cleveland Indians (American League) 1910–1932 (all games), 1934–1946 (weekday games); Cleveland Bears (Negro American League) 1939–1940; Cleveland Buckeyes (Negro American League) 1943–1948, 1950
Capacity: 21,000 (1910); 22,500 (1939)
Greatest Moment: August 11, 1929—Babe Ruth becomes the first player to ever hit 500 career home runs. A young fan catches the lucky ball and returns it to the Babe in exchange for $20, an autographed baseball, and a chance to sit in the Yankee dugout during the next game.

Left: Center field at League Park was 450 feet away in the 1920s, but the distance seemed shorter because Indians' center fielder Tris Speaker covered it so well.

Below: The Indians sold out 483 consecutive games at Jacobs Field from 1995 through 2001.

Jacobs Field

Opened: April 4, 1994
Home to: Cleveland Indians (American League) 1994–present
Capacity: 43,368 (1994)
Greatest Moment: October 11, 1997—In a memorable ALCS pitching duel between Mike Mussina and Orel Hershiser, Mussina strikes out 15, but Hershiser's Indians win 2-1 in the twelfth when Marquis Grissom scores on a botched squeeze play.

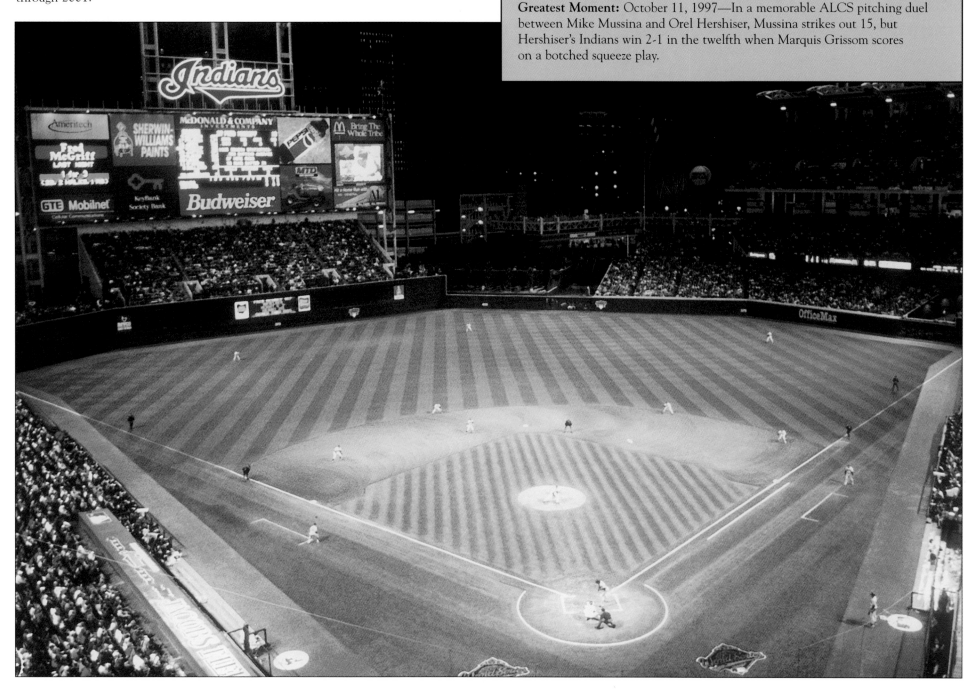

CLEVELAND

Far Right: The steel exterior of Jacobs Field was intended to evoke Cleveland's industrial heritage.

Below: Cleveland Municipal Stadium, which has now been torn down, stood on the Lake Erie waterfront near where the Rock and Roll Hall of Fame sits today.

Municipal Stadium

Opened: July 1, 1931
Home to: Cleveland Indians (American League) 1932–1933, 1947–1993 (all games), 1934–1946 (weekend, holiday, and night games)
Capacity: 78,000 (1931); 74,483 (1989)
Greatest Moment: April 8, 1975—Indians player-manager Frank Robinson debuts as the first African-American manager in major league history, then hits a home run in his first at bat.

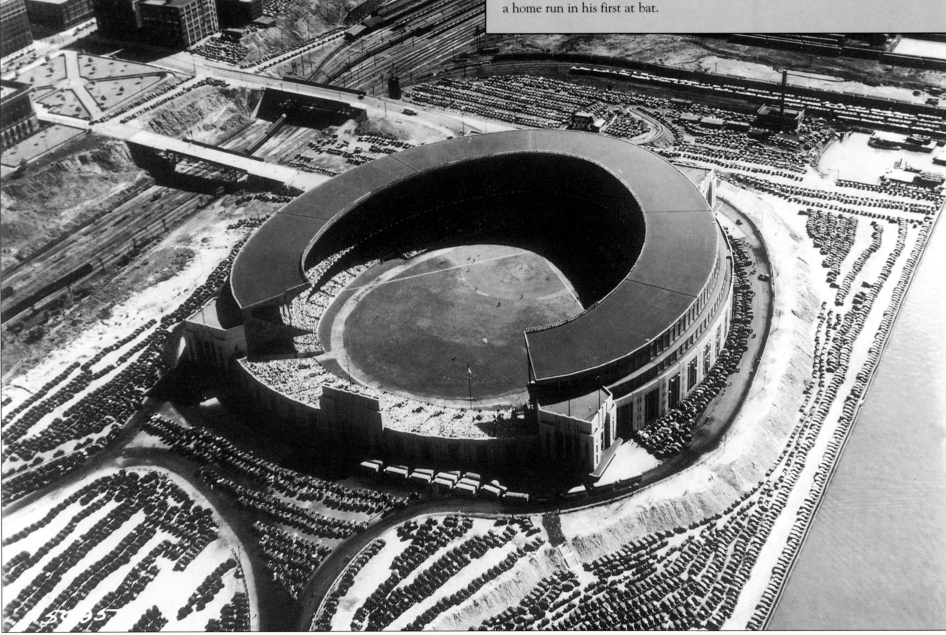

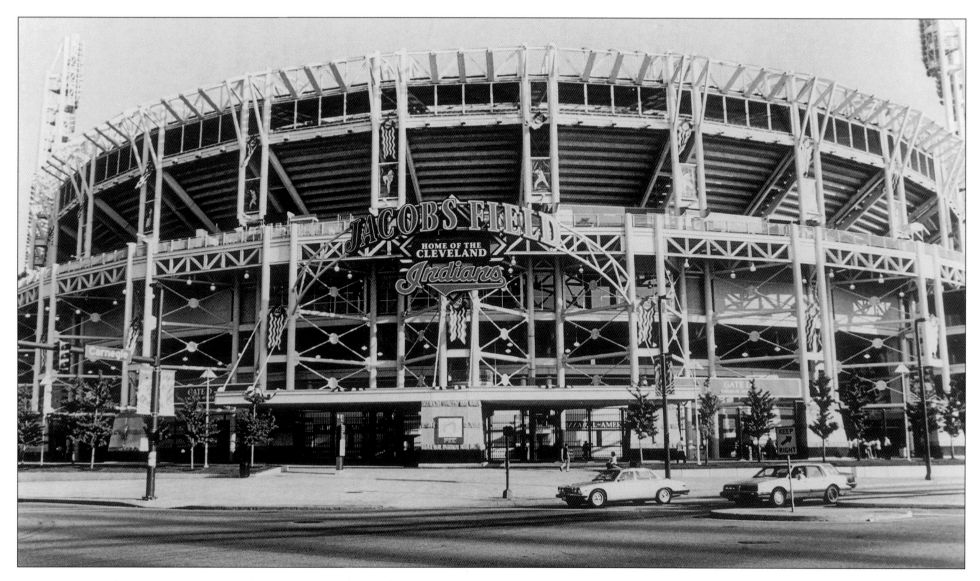

capacities in the major leagues. Then in 1932 the Indians suddenly found themselves with access to one of the largest stadiums in the country, the Cleveland Public Municipal Stadium. It was a 78,000-seat behemoth that had been built in an unsuccessful attempt to attract the 1932 Olympics. From 1934 to 1946, the Indians were the only team with two home ballparks, playing at Municipal Stadium for weekend, holiday, and night games, and at League Park for all other games.

Finally in 1947, after Bill Veeck purchased them, the Indians began playing exclusively in Municipal Stadium. Though large, the stadium was no work of art, and it quickly became known as "the Mistake by the Lake" for the chilling winds that blew in from Lake Erie at night. Its huge capacity proved completely unnecessary, as decades of dismal Indians teams resulted in nights such as September 15, 1956, when the stadium hosted only 365 fans.

The Indians finally got a new stadium, Jacobs Field, in 1994. The urban ballpark was an architectural tour de force; its exposed steel framework intended to evoke the bridges and smokestacks of industrial Cleveland. Its opening coincided with the development of a talented young team, and remarkably, the Indians sold out 483 consecutive games over their first eight years at Jacobs Field, which included 27 postseason games and one All-Star Game.

DALLAS/FORT WORTH

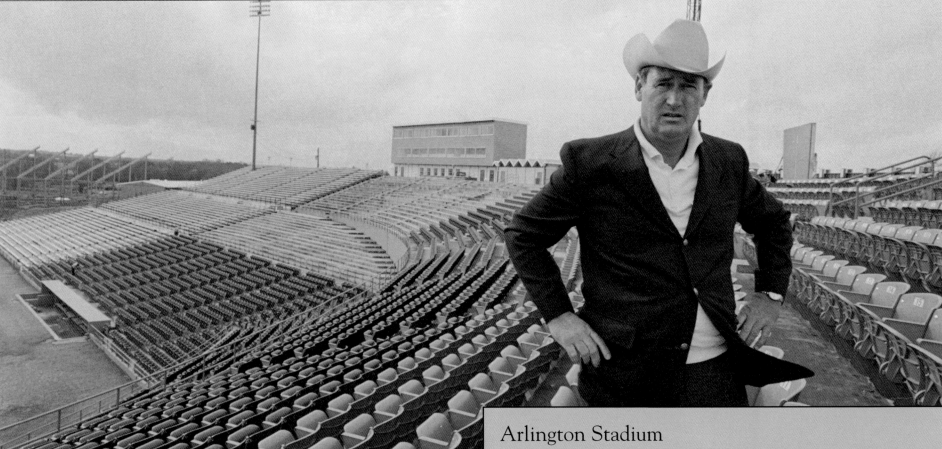

Arlington Stadium
Also known as: Turnpike Stadium (1965–1971)
Opened: 1965
Home to: Texas Rangers (American League) 1972–1993
Capacity: 10,500 (1965); 35,185 (1972); 43,521 (1992)
Greatest Moment: May 1, 1991—Nolan Ryan, 44, throws his record seventh career no-hitter, striking out 16 Toronto Blue Jays in a 3-0 victory.

Major league baseball came to the metroplex in 1972, when the Washington Senators relocated to the suburb of Arlington, midway between Dallas and Fort Worth. They played at Arlington Stadium, an undistinguished ex-minor league park that was built below ground level to lessen the intensity of the Texas heat. In 1994, the Rangers moved into a new stadium, which was named "The Ballpark in Arlington." At nearly 50,000 seats, it is one of the largest of the retro ballparks, and also one of the best. Although the park lacks the familiar urban atmosphere—it was built in the middle of a suburban pastureland—it features a traditional home-run porch in right field and an exterior facade of red brick and Texas granite. The architecture also evokes Texas themes, with stone steer heads overhanging the exterior arches and wrought-iron lone stars adorning the sides of aisle seats. The $191 million stadium has many of the upscale features associated with newer parks, including a small theater, an art gallery, and a baseball museum with over 1,000 artifacts loaned by the National Baseball Hall of Fame.

The Ballpark in Arlington

Opened: April 1, 1994
Home to: Texas Rangers (American League) 1994–present
Capacity: 49,115 (1994)
Greatest Moment: July 28, 1994—Kenny Rogers throws the 14th perfect game in baseball history, defeating the California Angels 4-0.

Far Left: Even manager Ted Williams couldn't build a winning team at Arlington Stadium, as the Rangers lost 100 games in his only season in Texas.

Below: The architecture of The Ballpark in Arlington revolves around a Texas theme, where lone stars and longhorns serve as motifs throughout the stadium.

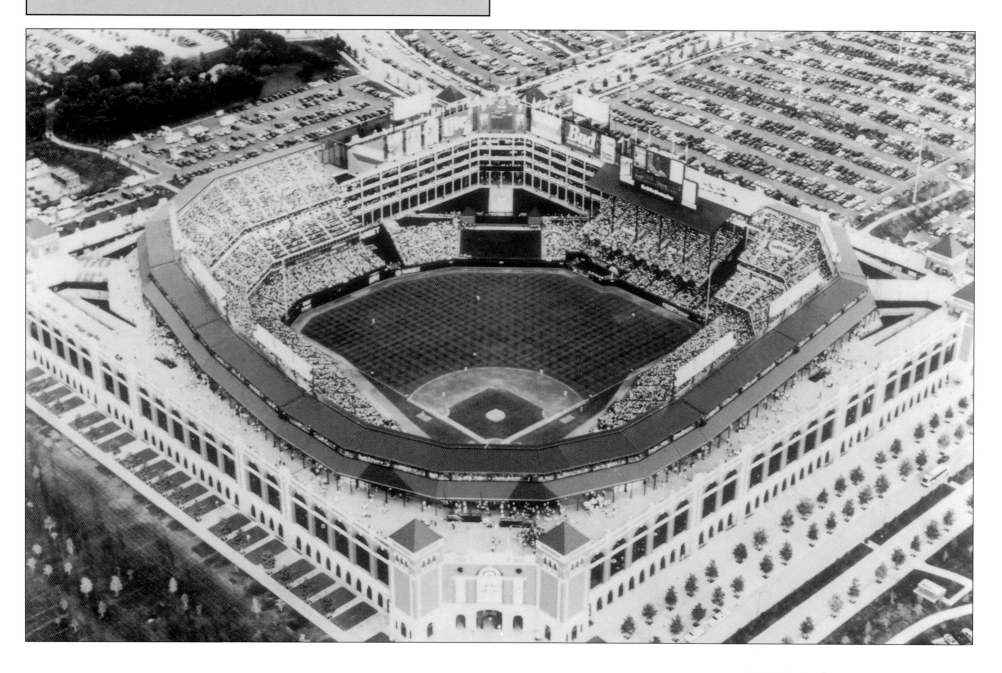

DENVER

Mile High Stadium

Also known as: Bears Stadium (1948–1967)
Opened: 1948
Home to: Colorado Rockies (National League) 1993–1994
Capacity: 19,000 (1960); 76,037 (1993)
Greatest Moment: April 9, 1993—In the first home game in franchise history, Eric Young homers leading off the bottom of the first and the Rockies defeat Montreal, 11-4.

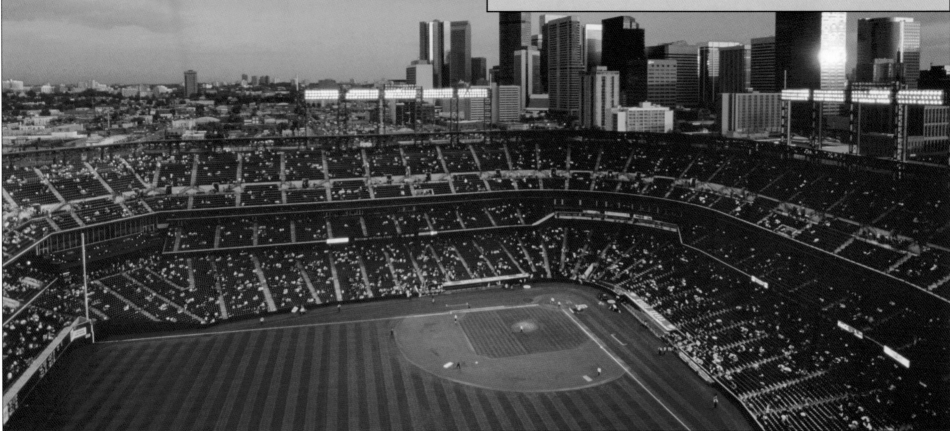

The Colorado Rockies debuted as an expansion franchise in 1993, and while a new baseball-only stadium was constructed, the team spent two years playing at Mile High Stadium, an ex-minor league park that also served as the home of football's Denver Broncos. For baseball, the most notable feature of the park was the number of fans in the seats.

Despite finishing 28 games under .500, the Rockies drew nearly 4.5 million fans in their inaugural season, easily breaking baseball's single-season record. This unexpected surge caused the Rockies to alter construction plans for their new stadium, Coors Field, enlarging it by 6,400 seats. After scientific studies showed that batted balls fly nine percent farther at Denver's elevation, the team made Coors Field one of the most spacious parks in baseball. However, the distant outfield fences resulted in more singles and triples, and did little to deter out-of-control home-run hitting. Offense at Coors Field reached a peak in 1999, when the average score of a game there was 8-7, and a record 303 home runs flew out of the park. Appropriately, the 20th row of seats in the upper deck is painted purple, signifying an elevation of 5,280 feet—exactly one mile above sea level.

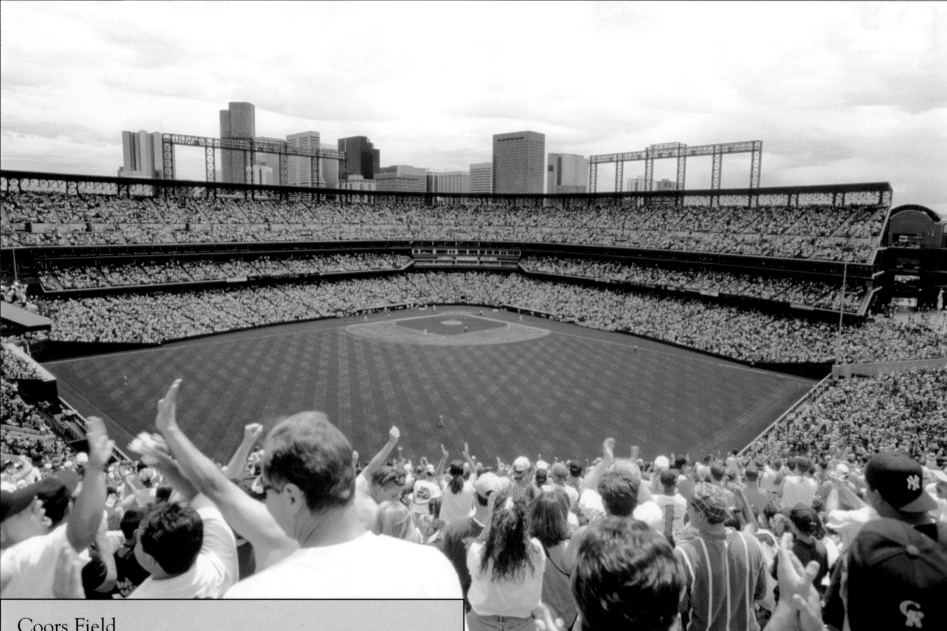

Coors Field

Opened: April 26, 1995
Home to: Colorado Rockies (National League) 1995–present
Capacity: 50,200 (1995); 50,445 (2001)
Greatest Moment: September 17, 1996—In a bizarre counterpoint to Colorado's altitude-generated offense, the Dodgers' Hideo Nomo does the near-impossible: he pitches a no-hitter, defeating the Rockies 9-0.

Above: With the Denver skyline behind home plate and the Rocky Mountains behind the outfield, Coors Field is one of the best settings in baseball, especially for power hitters.

Left: Though its architecture revealed its origins as a football stadium, Mile High Stadium drew more fans in one season than any stadium in baseball history.

DETROIT

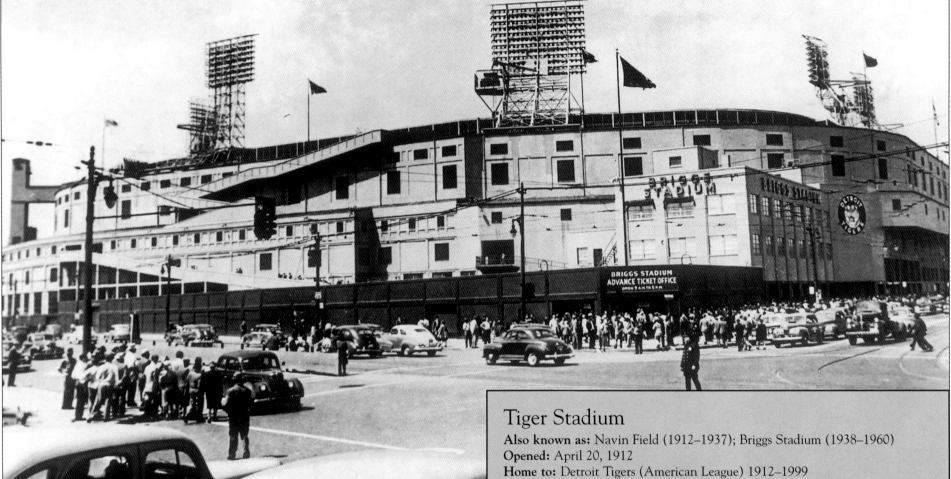

Tiger Stadium

Also known as: Navin Field (1912–1937); Briggs Stadium (1938–1960)
Opened: April 20, 1912
Home to: Detroit Tigers (American League) 1912–1999
Capacity: 23,000 (1912); 52,416 (1996)
Greatest Moment: October 14, 1984—Kirk Gibson's three-run homer in the eigth inning seals Game 5 of the World Series for the Tigers, as they win their first championship since 1968.

The Detroit Tigers' first home was Bennett Park, named for Charlie Bennett, a Detroit catcher whose career had been cut short when he lost both legs after getting run over by a train in 1894. Originally a 5,000-seat park, the Tigers gradually increased its capacity during their occupancy there, and during the 1909 World Series the team erected gigantic strips of white canvas behind the outfield walls to block the view of fans in unauthorized bleachers across the street.

In the winter of 1911–12, the stadium was razed and a new grandstand was built, with the home plate located where left field had once been. The new park was named "Navin Field" after the Tigers'

Above: When car manufacturer Walter Briggs purchased the Detroit Tigers in 1937, he remodeled the stadium and named it after himself.

Right: Until Tiger Stadium closed in 1999, baseball had been played at the corner of Michigan and Trumbull for a hundred seasons.

owner and would eventually be renamed "Briggs Stadium" in 1938 and "Tiger Stadium" in 1961. Appropriately enough, Ty Cobb stole home in the first inning of the first game ever played there. For many years, a 125-foot flagpole stood in play in center field and was said to be the tallest object ever to be part of the field of play in a major league ballpark.

The flagpole was removed after the 1937 season, the same year that an upper deck was constructed over the outfield bleachers. The upper deck actually hung several feet out over the playing field, creating some of the best seats in the major leagues, as Tigers outfielders such as Al Kaline and Kirk Gibson often seemed to be standing directly underneath the fans in the stands. During the 1990s,

the team's owners let the stadium fall into disrepair, hoping it would strengthen their case for a new stadium. Finally in 2000, after a hundred seasons at the corner of Michigan and Trumbull, the Tigers moved into a new $300 million stadium, named "Comerica Park" after a $66 million payment from an investment firm. Its modern amenities and distant outfield fences made the park the polar opposite of cozy Tiger Stadium.

In an era of unprecedented home-run hitting, Comerica's friendliness to pitchers caused the team to lose slugger Juan González to free agency in 2001, and prompted owner Mike Ilitch to suggest moving the fences in. The hubbub died down, however, and for now Comerica remains one of the best pitchers' parks in baseball.

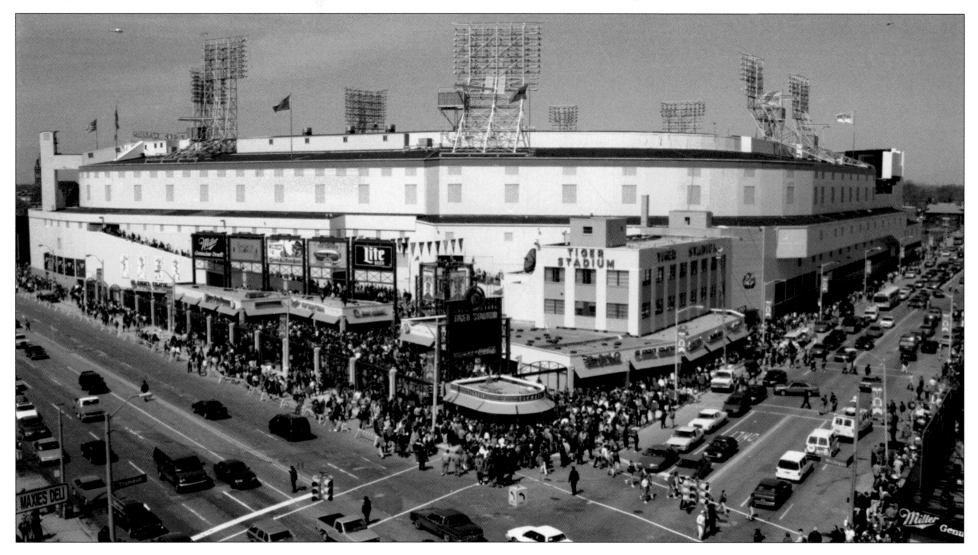

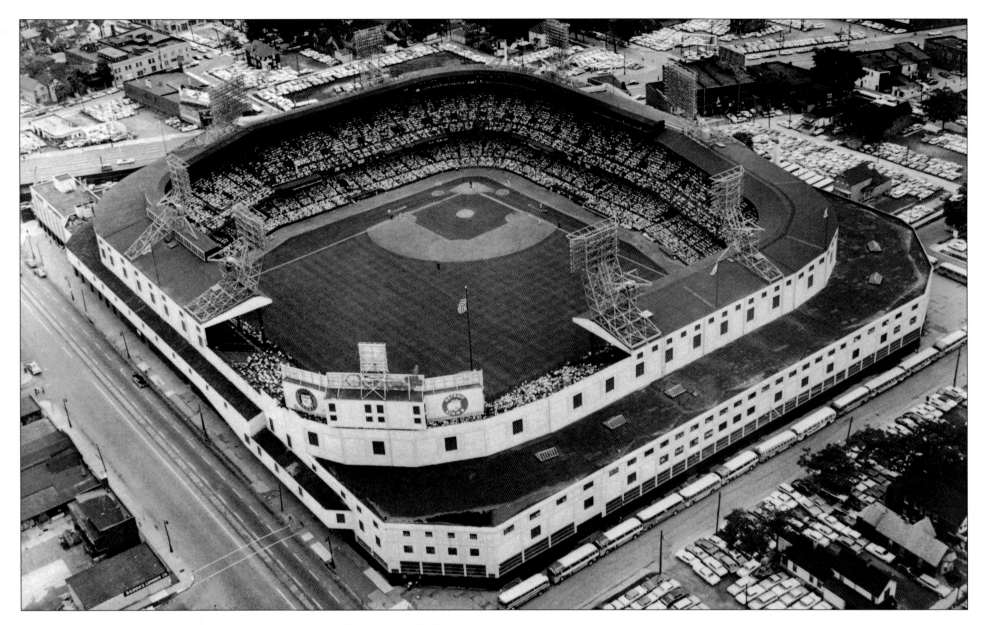

Bennett Park

Opened: April 28, 1896
Home to: Detroit Tigers (American League) 1901–1911
Capacity: 5,000 (1896); 14,000 (1910)
Greatest Moment: April 25, 1901—In the second game in franchise history, the Tigers trail Milwaukee 13-4, but they score 10 runs in the bottom of the ninth to win the game, 14-13.

Above: The Tigers won their first World Series in more than two decades in 1968, the year this photo of Tiger Stadium was taken.

Right: A dazzling scoreboard and unique light fixtures make Comerica Park a wonderful place for both fans and pitchers.

Mack Park

Opened: 1914
Home to: Detroit Stars (Negro Leagues) 1919–1933
Capacity: 9,000
Greatest Moment: May 31, 1923—Rookie center fielder Turkey Stearnes becomes the only Detroit Star ever to hit for the cycle as the Stars defeat the Toledo Tigers 7-6.

Comerica Park

Opened: April 11, 2000
Home to: Detroit Tigers (American League) 2000–present
Capacity: 40,000
Greatest Moment: April 11, 2000—Despite a game-time temperature of thirty-four degrees, Comerica Field hosts a sellout crowd for its debut game against the Seattle Mariners.

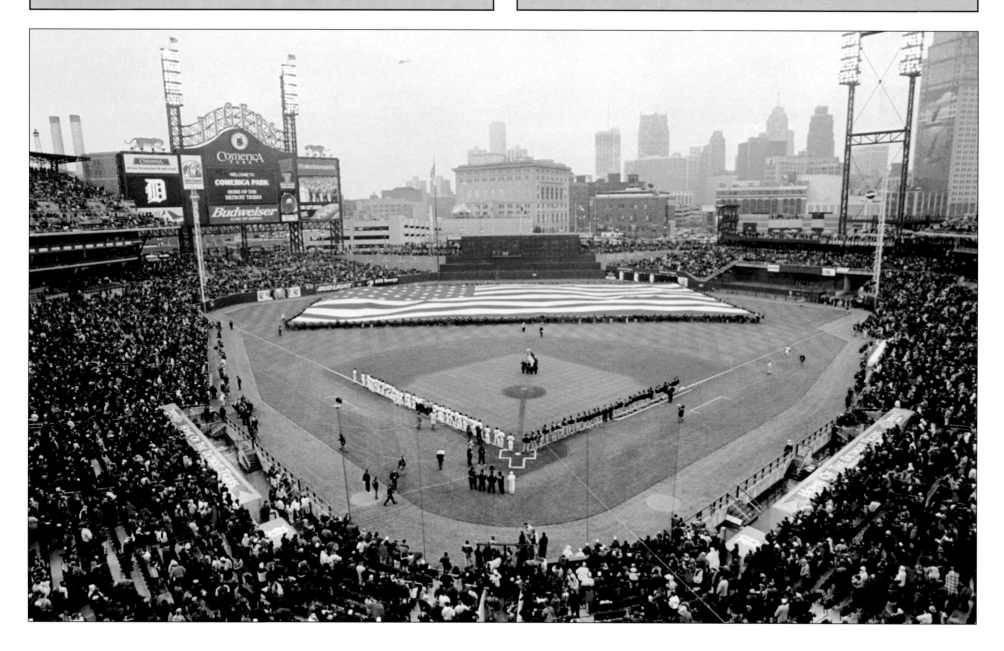

HOUSTON

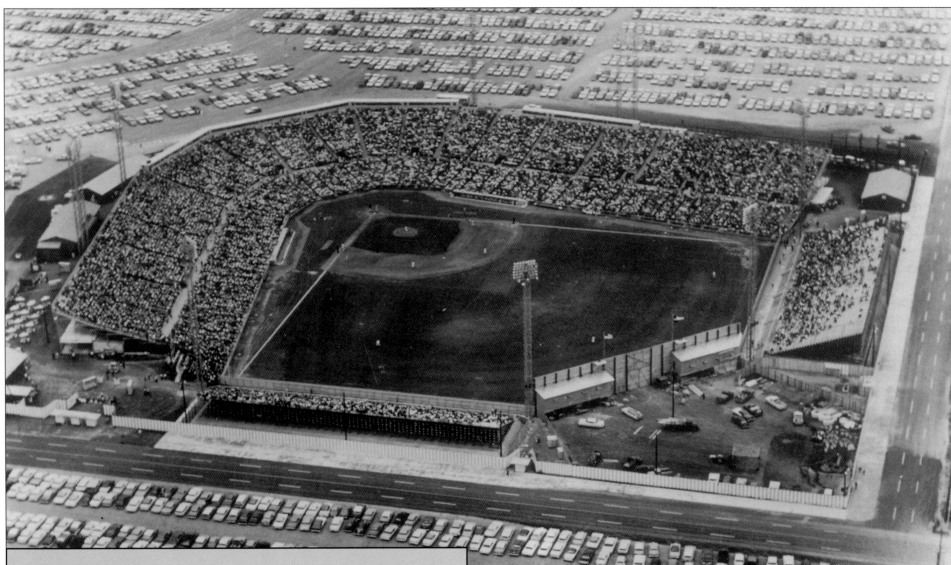

Colt Stadium

Opened: April 10, 1962
Home to: Houston Colt .45s (National League) 1962–1964
Capacity: 32,601 (1962); 33,010 (1964)
Greatest Moment: September 27, 1964—Houston plays its last game at Colt Stadium, finally ridding the world of one of the worst ballparks in major league history.

In 1960, Houston was awarded a National League expansion franchise, the Colt .45s. Houstonians had cheered the minor league Houston Buffaloes at Buff Stadium, but for the Colts, a new stadium was built. Called Colt Stadium, it was one of the worst parks in major league history, with unbearable heat and mosquitoes so large that Sandy Koufax once described them as "twin-engine jobs." Fortunately, Colt Stadium was

Enron Field

Opened: March 30, 2000
Home to: Houston Astros (National League) 2000–present
Capacity: 40,950 (2000)
Greatest Moment: October 4, 2001—After being pitched around for most of a three-game series with the Astros, Barry Bonds hits his 70th home run off Wilfredo Rodriguez, tying Mark McGwire's single-season record.

Left: The heat and infamous mosquitoes of Colt Stadium proved that an open-air ballpark in sweltering Houston was a losing proposition.

Below: When Enron Field was opened in 2000, air conditioning and a retractable roof helped lessen the effect of the Texas heat.

only intended to be a temporary solution until construction was complete on the team's real home, Harris County Domed Stadium. The brainchild of team owner Judge Roy Hofheinz, the $35 million structure was the first domed stadium in the world. When the team moved into the new space-age park in 1965, they were also given a new space-age name: the Houston Astros.

The ballpark, nicknamed the "Astrodome," was called the "Eighth Wonder of the World" by its many supporters, but it was not without its glitches. Outfielders complained that a blinding glare from the roof panels made catching fly balls dangerous. A translucent coating on the panels solved that problem, but created another by reducing the light coming into the dome, which killed the grass. For the Astrodome's

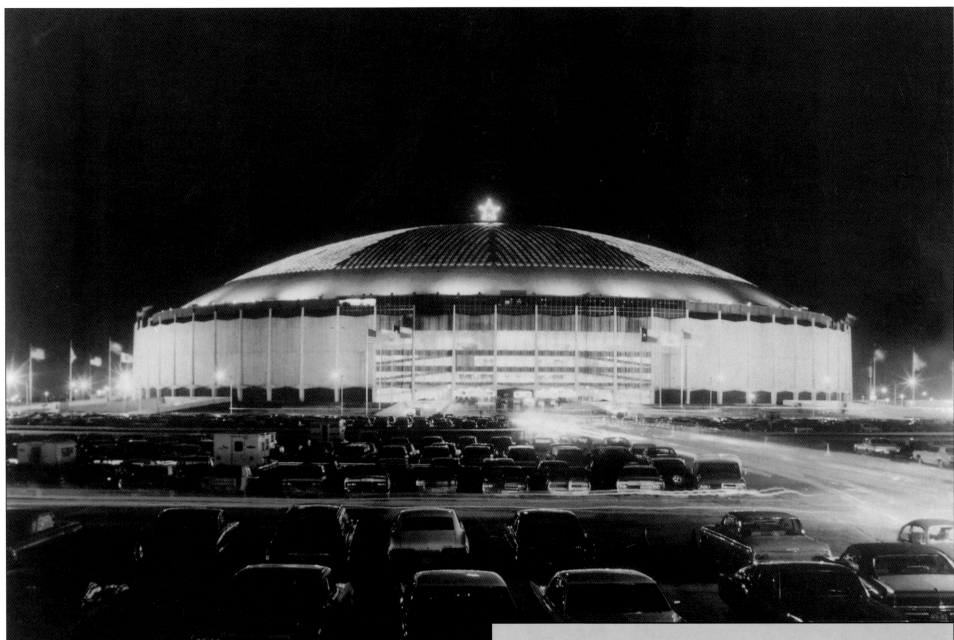

second year, a new synthetic grass made of green plastic was installed. The bane of baseball purists everywhere, the fake grass caught on in both baseball and football, and it is still known as "AstroTurf," even though the Astros no longer play on it.

Another Astrodome innovation was the luxury suite, which Hofheinz introduced to baseball for the first time since Cincinnati's Palace of the

Astrodome

Opened: April 9, 1965
Home to: Houston Astros (National League) 1965–1999
Capacity: 42,217 (1965); 54,816 (1990)
Greatest Moment: April 9, 1965—In an exhibition game between the Yankees and Astros, Mickey Mantle helps usher in baseball's space age by hitting the first-ever home run in the Astrodome.

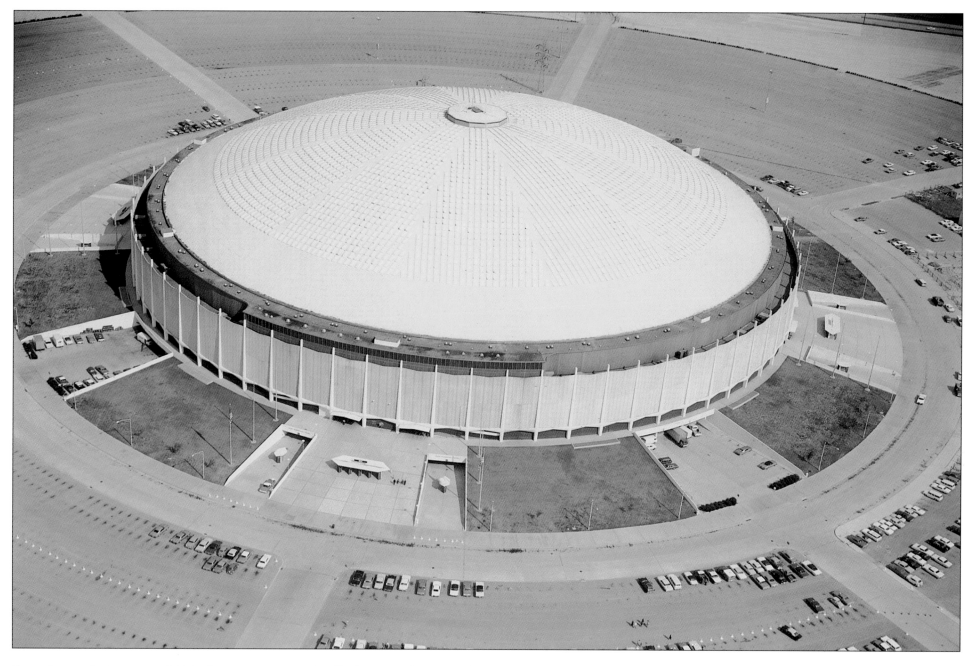

Fans burned down in 1911. It may represent all that is wrong with modern-day ballparks, but as the first domed stadium, the first to use artificial turf, and the first to be air-conditioned, the Astrodome's influence cannot be denied. And though the dome-and-turf stadiums that came afterward may have been awful, the Astrodome itself was always an enjoyable place to watch a game.

Above: Shown here in 1967, the Astrodome also hosted many nonbaseball events, including the 1971 NCAA Final Four and the 1992 Republican National Convention.

Left: The first domed stadium in baseball history was the Astrodome, billed as the "Eighth Wonder of the World" when it opened in 1965.

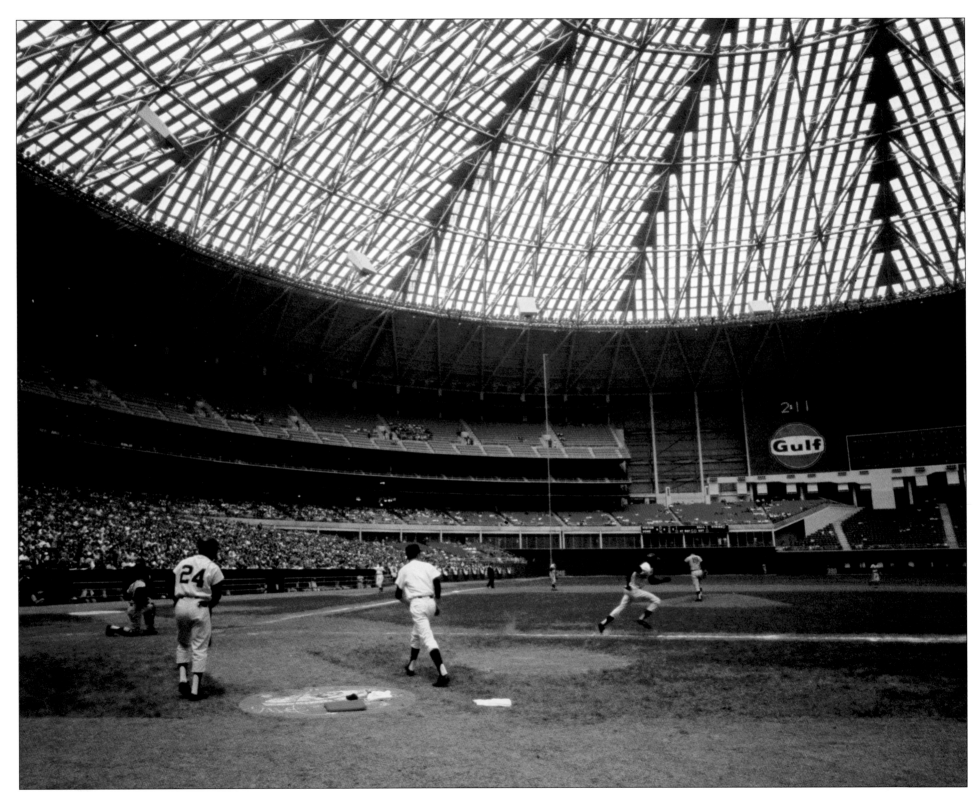

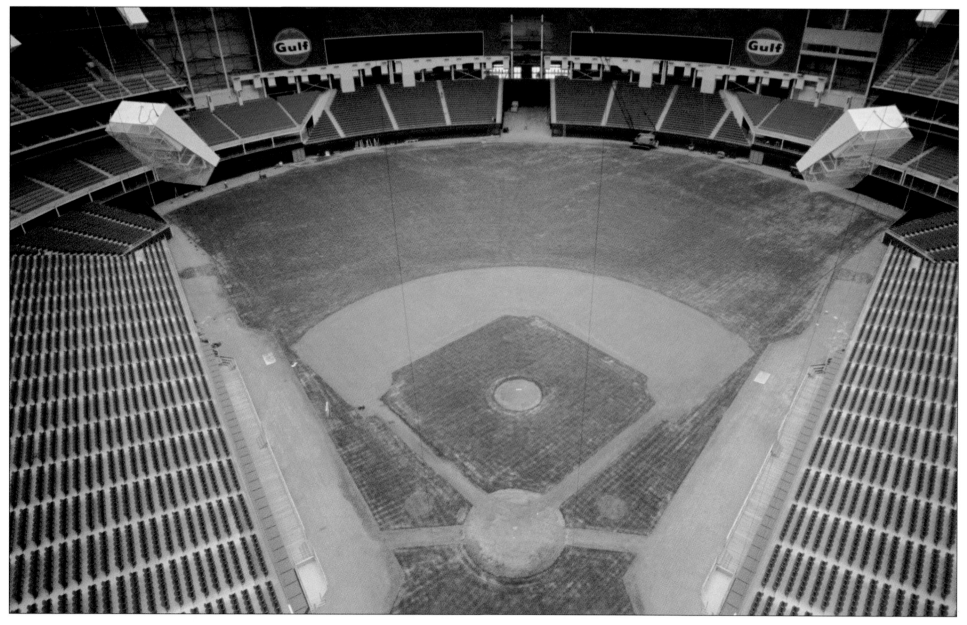

In 2000, after 35 years in the Astrodome, the team moved into a new $248 million stadium. Called "Enron Field," it quickly became known derisively as "Homerun Field" for the long drives given up by Astros pitchers during the park's debut season. Located at Union Station in downtown Houston, the upscale park features a replica 1860s locomotive running behind the outfield wall. It also has a 9,000-ton retractable roof that opens or closes in 12 minutes, allowing the team to enjoy air-conditioned comfort while still playing on real grass.

Above: The Astrodome speakers that towered high above the field were considered to be in play. In 1974, Mike Schmidt hit a mammoth shot that bounced off one of them for a harmless single.

Left: The Astrodome is pictured here in 1965, the only season in which it had real grass instead of artificial turf.

KANSAS CITY

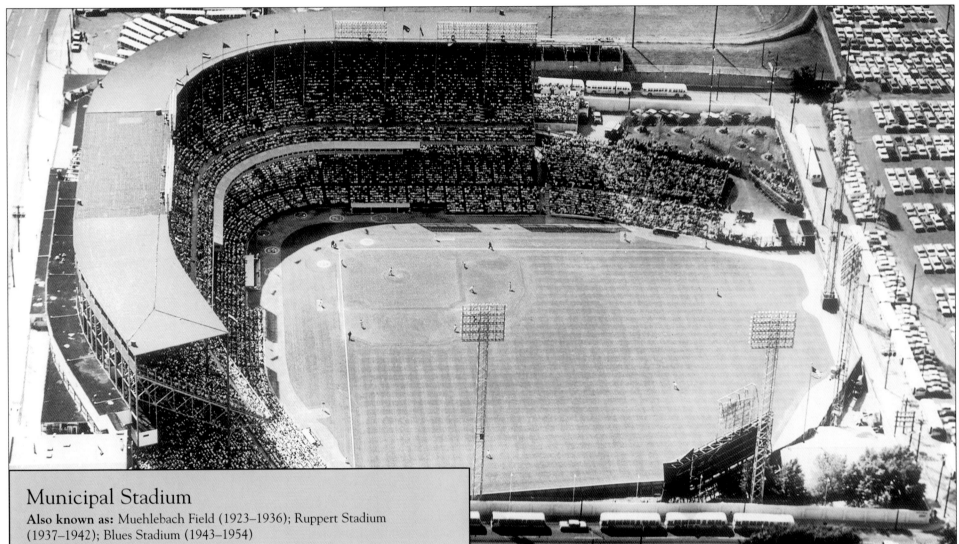

Municipal Stadium

Also known as: Muehlebach Field (1923–1936); Ruppert Stadium (1937–1942); Blues Stadium (1943–1954)

Opened: July 3, 1923

Home to: Kansas City Blues (minor leagues) 1923–54; Kansas City Monarchs (Negro Leagues) 1923–1955; Kansas City Athletics (American League) 1955–1967; Kansas City Royals (American League) 1969–1972

Capacity: 17,476 (1923); 30,296 (1955); 35,561 (1972)

Greatest Moment: August 7, 1930—In one of the first professional night games ever played, the Homestead Grays' Smokey Joe Williams and the Monarchs' Chet Brewer have a pitchers' duel for the ages. Brewer strikes out 19 batters, but Williams fans 27 and wins the game 1-0 in twelve innings.

The major leagues first came to the bustling cowtown of Kansas City in the 1880s, when the Kansas City Cowboys played at Association Park—where a sign on the outfield fence reportedly read, "Please don't shoot the umpire. He is doing the best he can." The city's flings with the major leagues were brief, and until 1950 the two teams that held the city's heart were the Negro League's Kansas City Monarchs and the minor league Kansas City Blues. Both teams played at Muehlebach Field.

It was a stadium which also hosted many significant nonbaseball events over the years, including an appearance by Charles Lindbergh on August 17, 1927, and a Beatles concert on September 17, 1964. Located near the jazz district that often featured performers like Louis Armstrong and Billie Holiday, Muehlebach Field was the site of games 5, 6, and 7 of the inaugural Negro League World Series in 1924. The park was expanded and renamed "Municipal Stadium" when major league base-ball returned to Kansas City in 1965, and eccentric A's owner Charles O. Finley installed bizarre features, such as a petting zoo, in right field.

The A's left after the 1967 season, but a year later were replaced by the expansion Kansas City Royals. The Royals played their first few years in Municipal before moving into the new Royals Stadium, an unrecognized gem that was one of the best major league ballparks built between 1963 and 1991.

Royals Stadium

Also known as: Kauffman Stadium (1993–present)
Opened: April 10, 1973
Home to: Kansas City Royals (American League) 1973–present
Capacity: 40,613 (1973); 40,625 (2001)
Greatest Moment: October 27, 1985—21-year-old Bret Saberhagen pitches an 11-0 shutout in Game 7 of the World Series against St. Louis, and the Royals are crowned world champions for the first time ever.

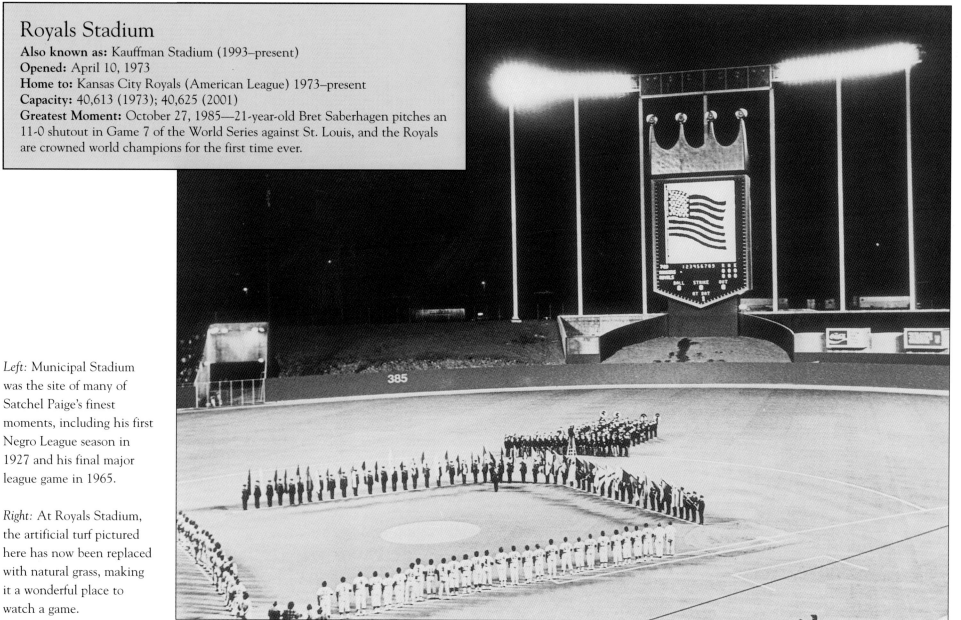

Left: Municipal Stadium was the site of many of Satchel Paige's finest moments, including his first Negro League season in 1927 and his final major league game in 1965.

Right: At Royals Stadium, the artificial turf pictured here has now been replaced with natural grass, making it a wonderful place to watch a game.

LOS ANGELES

Wrigley Field

Opened: 1925
Home to: Los Angeles Angels (Pacific Coast League) 1925–1957; Los Angeles Angels (American League) 1961
Capacity: 22,000 (1965); 20,457 (1961)
Greatest Moment: October 3, 1934—With a record of 137-50, the Angels are so dominating that the league playoffs are canceled, and instead a series is held pitting the Angels against a team of Pacific Coast League all-stars. Los Angeles wins that series, four games to two.

The first major baseball stadium in Los Angeles, Washington Park, opened in 1903, a decade before the first movie was made in Hollywood. It was home to the minor league Los Angeles Angels until 1925, when the team moved into Wrigley Field, a bigger stadium built by Cubs owner Philip Wrigley and designed to look like its namesake in Chicago. (However, the L.A. version was actually the first park to be called "Wrigley Field"—the Chicago version didn't take that name until 1926.) This Wrigley Field had lights as early as 1931, and it was also built California-style, with a white facade and red roof that resembled many of the buildings surrounding it. At the park's entrance stood a 150-foot-tall

memorial clock tower dedicated to ballplayers who died in World War I. The Angels were a perennial power in the Pacific Coast League, featuring players like Jigger Statz, a speedy outfielder who collected 3,356 hits in 18 seasons with the team, and Steve Bilko, who slugged 55 and 56 homers in back-to-back seasons. The Angels' biggest rivals, the Hollywood Stars, also played at Wrigley for a time until their own ballpark, Gilmore Field, was built in 1939.

Left: Until the Colorado Rockies came along, Wrigley Field had the distinction of having produced the most home runs in one ballpark in a season.

Below: The skyline of downtown Los Angeles served as an ideal backdrop for Dodger Stadium, which opened in 1962.

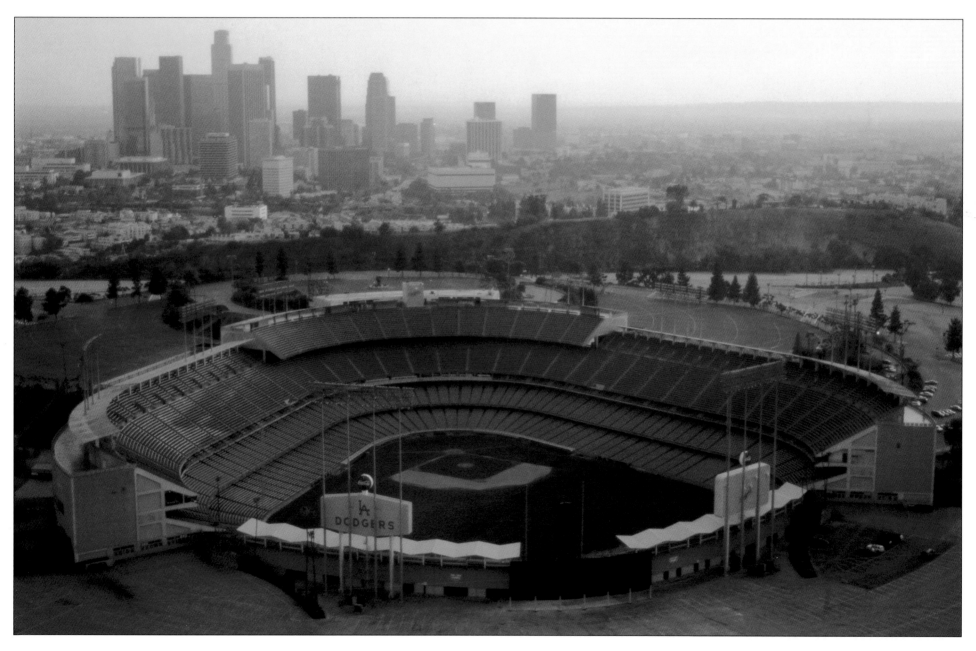

Los Angeles Coliseum

Opened: October 6, 1923
Home to: Los Angeles Dodgers (1958–1961)
Capacity: 93,000
Greatest Moment: May 7, 1959—At an exhibition game against the Yankees, 93,103 fans—the largest crowd to ever attend a professional baseball game— light candles in honor of ex-Dodger catcher Roy Campanella, who had been paralyzed in an auto accident a year earlier.

Right: Dodger Stadium has 16,000 parking spaces, a testament to Los Angeles's automobile culture and poor public transportation system

Below: The Coliseum may have been ill-suited for the national pastime, but it was the largest stadium in baseball history, as evidenced by the 92,706 fans pictured here at Game 5 of the 1959 World Series.

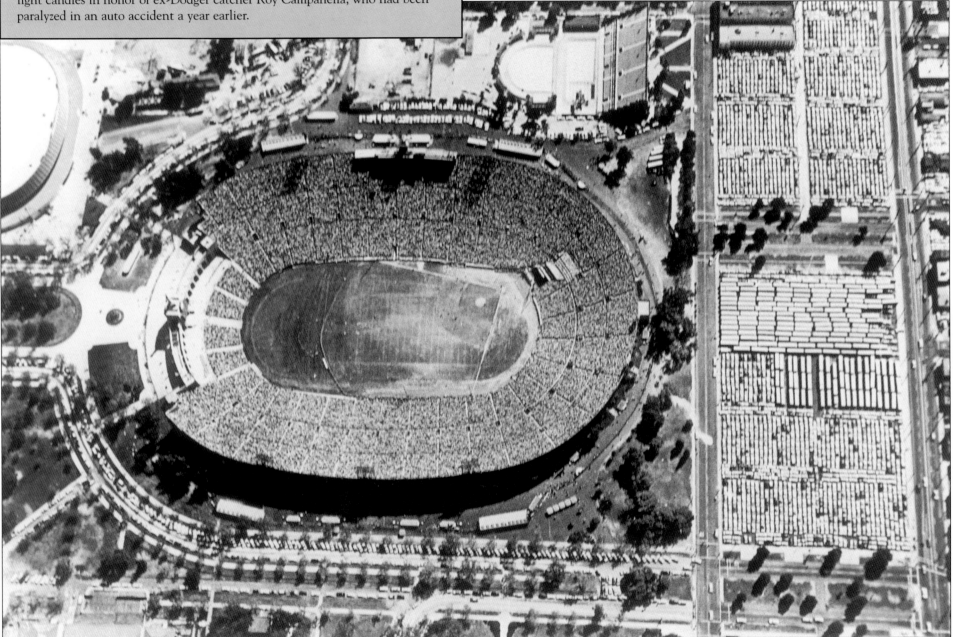

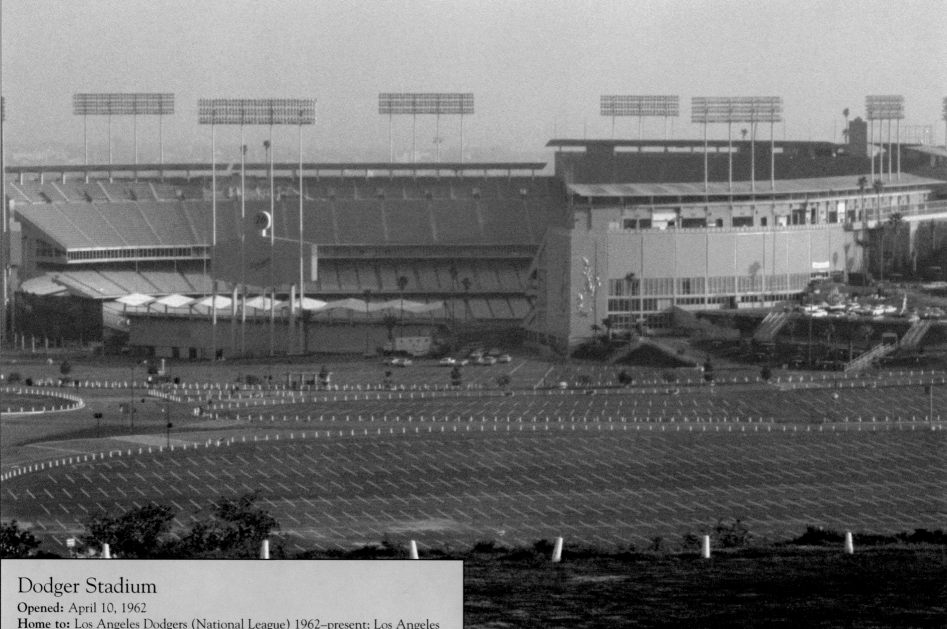

Dodger Stadium

Opened: April 10, 1962

Home to: Los Angeles Dodgers (National League) 1962–present; Los Angeles Angels (American League) 1962–1965

Capacity: 56,000

Greatest Moment: October 15, 1988—With the Dodgers behind by one run and facing Dennis Eckersley, baseball's best relief pitcher, injured slugger Kirk Gibson pinch-hits with two outs in the bottom of the ninth. He hits perhaps the most dramatic home run in baseball history, giving the Dodgers a 5-4 win over Oakland in Game 1 of the World Series.

In 1958, induced by a remarkable offer from the city of Los Angeles that included tax breaks and promises of free land for a stadium, Walter O'Malley moved his Brooklyn Dodgers to Los Angeles. While his dream ballpark was being built, O'Malley's team played in the Los Angeles Coliseum, a cavernous football stadium that had been used for the 1932 Olympics. The stadium's oblong dimensions made it a joke as a baseball park. The 441-foot power alley in right field more or less ended the career of lefty slugger Duke Snider, but other Dodger batters, especially Wally Moon, became adept at hitting pop flies over the tall left field screen only 251 feet away.

With a capacity of 93,000, the Coliseum is the largest park in major league history, and fans straining to see the distant action started bringing their transistor radios to the park so they could listen to broadcaster Vin Scully describe the action. Over their four years in the stadium, the Dodgers smashed every existing baseball attendance record, including most fans in one season (2.25 million in 1960), and most fans at a World Series game (92,706 at Game 5 of the 1959 Series).

In 1962 the club finally moved into its palatial new home, Dodger Stadium. The 300 acres of land it was built on, called Chavez Ravine, had been home to a close-knit community of Mexican-Americans who were reluctant to move to make way for the stadium. They were forcibly evicted by sheriff's deputies and their homes were bulldozed beginning on May 8, 1959, creating a rift between the Dodgers and L.A.'s Mexican-American community that wasn't healed until Fernando Valenzuela's arrival in 1981. The residents' appeal to the U.S. Supreme Court was still pending when O'Malley broke ground for

Right: When construction began in 1959, Mexican-American families were forcibly evicted from Chavez Ravine, causing a rift that lasted for decades.

Far Right: The cool night air deadens even the strongest of drives and makes Dodger Stadium the perfect place for a pitcher.

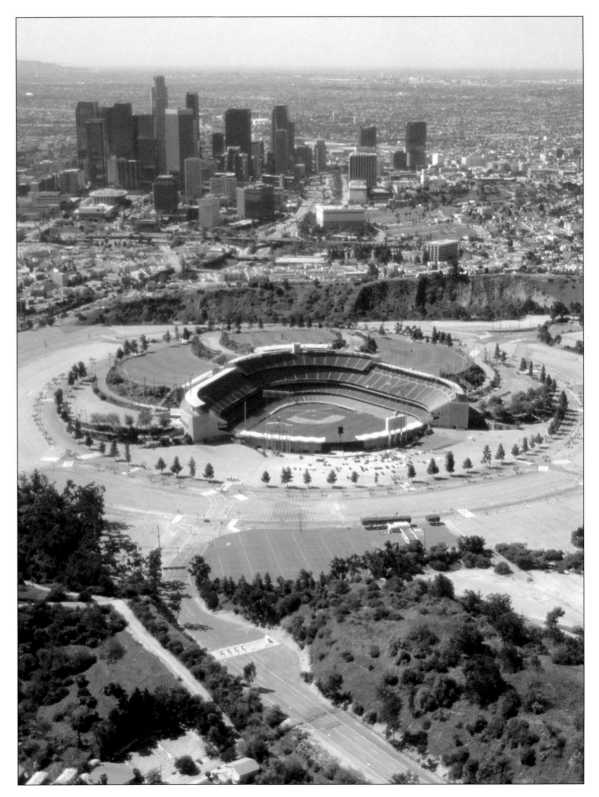

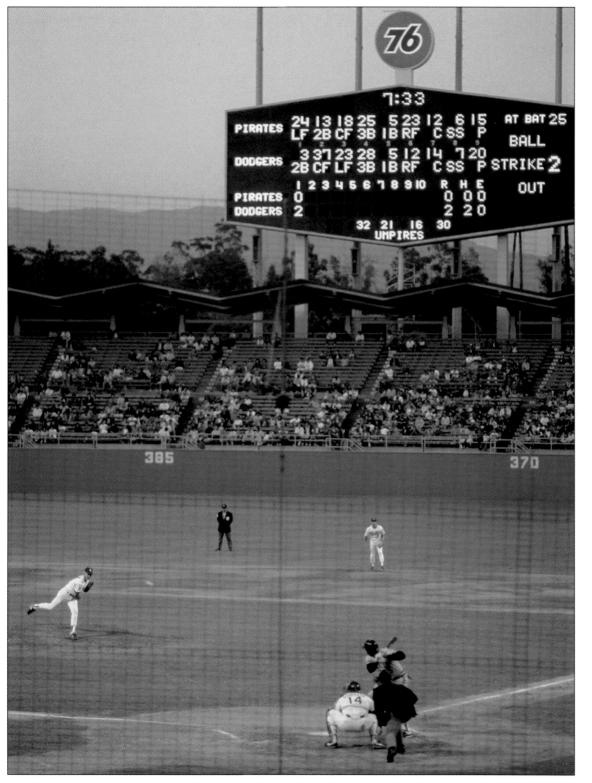

Dodger Stadium on September 17, 1959. When it finally opened in 1962, Dodger Stadium's palm trees, white California stucco, and picturesque setting led many to call it the best ballpark ever built.

According to historian Michael Gershman, O'Malley was "the first modern owner with a clear picture of what the public expected from a ballpark," and fans flocked to Dodger Stadium in even greater numbers than they had to the Coliseum. According to statistical studies by STATS Inc., Dodger Stadium is the most pitcher-friendly park in baseball history, and the Dodgers built a team perfectly suited to such an environment. Behind the pitching of Sandy Koufax and Don Drysdale, and the slap hitting and base stealing of Maury Wills and Willie Davis, the Dodgers won three pennants and two World Series in the stadium's first five years. The Dodgers employed only two managers during the ballpark's first 34 seasons, and like the team itself, Dodger Stadium continued to be the classiest venue in baseball.

By 2001 it was the fourth-oldest stadium in the major leagues, but it still appears as pristine as the day it opened. Perhaps more importantly, it remains one of the most influential ballparks ever, as O'Malley's shrewd politicking in getting his stadium built has become a blueprint for team owners seeking public funding of their private enterprises.

Left: In 1978 Dodger Stadium became the first ballpark to host more than three million fans in one season.

Right: The pine and palm trees behind Dodger Stadium's outfield wall have been copied at other ballparks, including Qualcomm Stadium in San Diego.

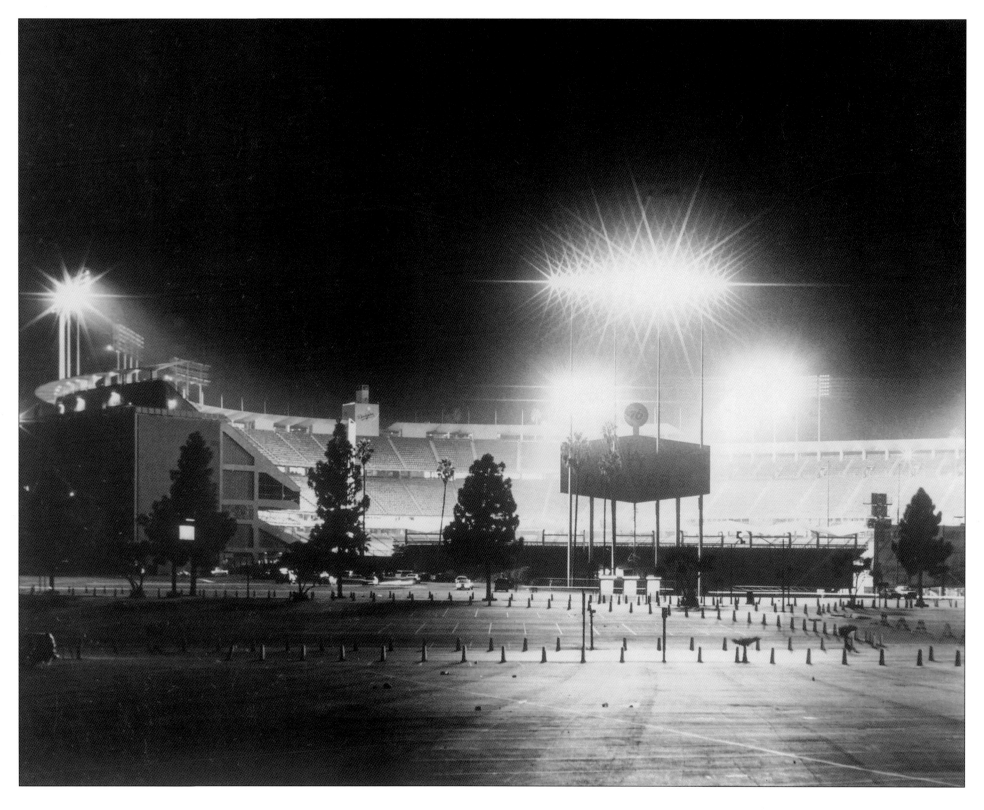

MIAMI

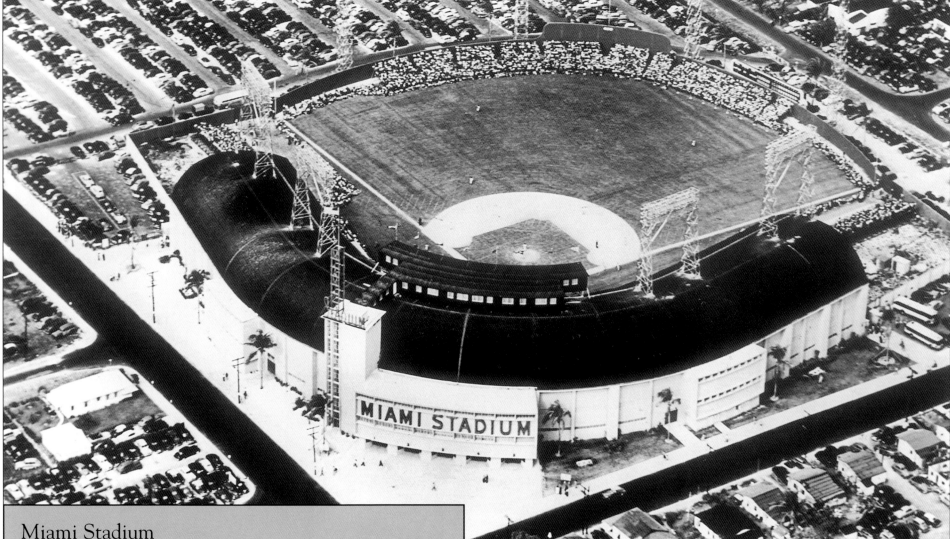

Miami Stadium

Opened: 1949
Home to: Miami Marlins (International League)1956–1960; Miami Marlins
(Florida State League) 1962–1992
Capacity: 13,500 (1960)
Greatest Moment: April 8, 1956—Satchel Paige makes his first appearance
as a Miami Marlin, landing on the field in a helicopter on Opening Day.
Five days later he appears in his first game with the Marlins and pitches a
four-hit shutout.

For most of the twentieth century, the Sunshine State has been baseball's
principal spring-training locale, but South Florida was also the longtime
home of the Miami Marlins, a franchise in the Triple-A International
League. The team's most famous attraction when they played in Miami
Stadium was Satchel Paige, who pitched magnificently in three seasons
with the Marlins (1956–58) after his major league career ended. Major
League Baseball came to the state for the first time in 1993, when the

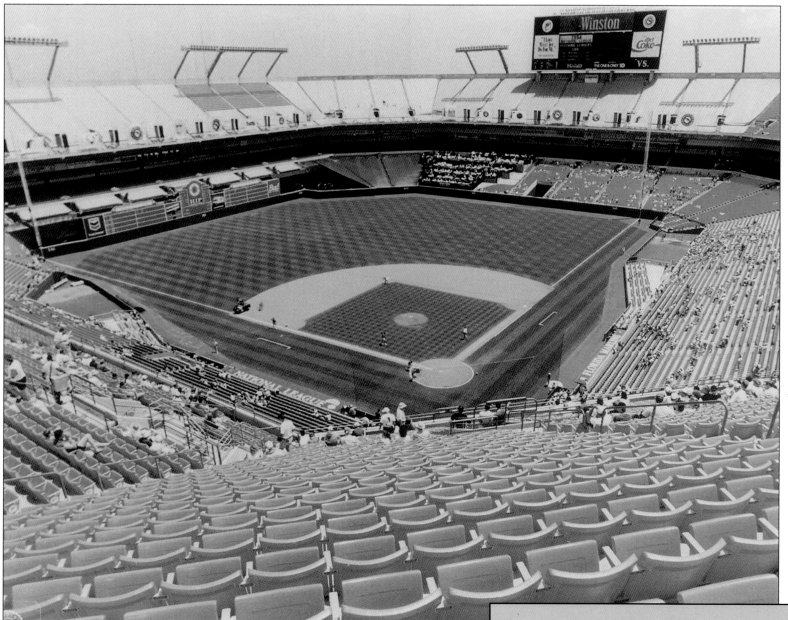

Far Left: Palm trees surround the front entrance of Miami Stadium, which is evocative of its location in South Florida.

Left: The Florida Marlins played before many empty seats at Joe Robbie Stadium after 1997, when they sold off all their star players from a championship-winning team.

Florida Marlins debuted at Joe Robbie Stadium, better known as the home of football's Miami Dolphins. In 1997, the Marlins won the World Series, but the champagne quickly turned bitter as all the team's stars were discarded before the next season as a cost-cutting measure. In recent years the Marlins have tried unsuccessfully to win public support for a new baseball-only stadium, and the future of baseball in Miami remains up in the air.

Joe Robbie Stadium

Also known as: Pro Player Stadium 1996–present
Opened: August 16, 1987
Home to: Florida Marlins (National League) 1993–present
Capacity: 41,855
Greatest Moment: October 26, 1997—In Game 7 of the World Series, Edgar Renteria singles in Craig Counsell in the bottom of the eleventh inning, and the Marlins win the championship in only their fifth season of existence.

MILWAUKEE

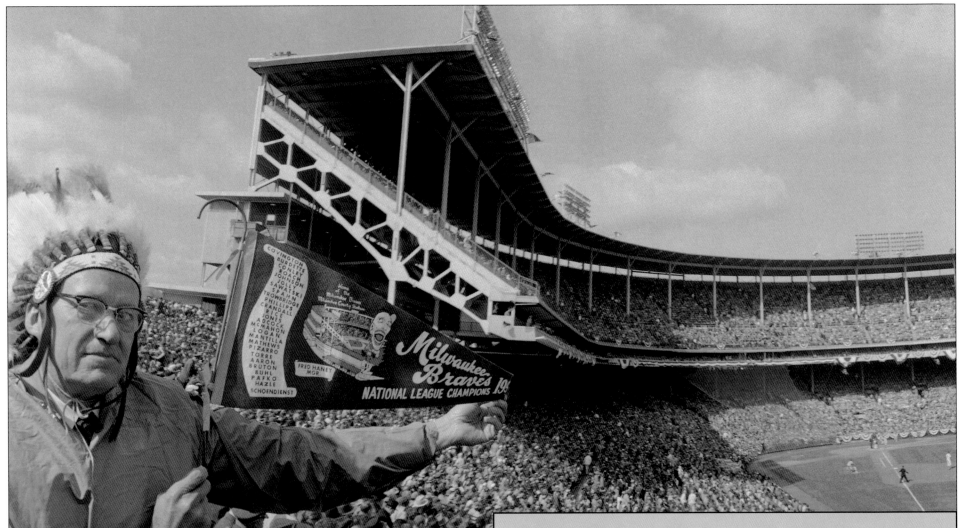

Milwaukee was home to four different major league franchises before 1903, but the only one with a distinguished ballpark was the Milwaukee Brewers of the American Association, who played at Borchert Field in 1891. With improvements over the years, Borchert continued to be used by Milwaukee's minor league teams well into the twentieth century. The park had cozy 266-foot foul lines, and after Bill Veeck bought the minor league Brewers in 1941, he installed a motor to slide the fence back when the Brewers were playing a power-hitting team and forward when they

Borchert Field

Opened: May 20, 1887
Home to: Milwaukee Brewers (American Association) 1891; Milwaukee Bears (Negro National League) 1923; Milwaukee Brewers (minor leagues) 1902–1952
Capacity: 10,000 (1891); 14,000 (1941)
Greatest Moment: May 27, 1944—The Milwaukee Chicks play the first game in franchise history against the South Bend Blue Sox. By the season's end, the Chicks will be champions of the All-American Girls Professional Baseball League.

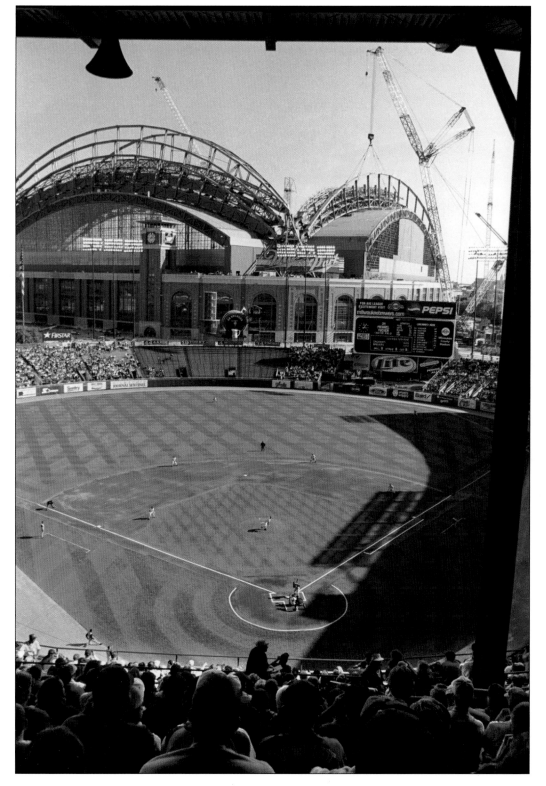

weren't. The practice was eventually outlawed, but Veeck's fan-friendly policies in Milwaukee created a city full of fans hungry for big-league baseball.

County Stadium was built in 1953 when the Boston Braves moved to Milwaukee, becoming the first major league franchise in half a century to relocate. Almost immediately, the park became baseball's most popular location for tailgating, and the Braves set many National League attendance records in their first few seasons there.

But attendance dropped off rapidly in the early 1960s, and after the 1965 season the Braves left for the warm Southern climate of Atlanta. Five years later, however, the Seattle Pilots, a floundering expansion franchise, relocated to Milwaukee and became the Milwaukee Brewers. Accompanying the new team to County Stadium was Bernie the Brewer, a mustachioed mascot whose shtick included dropping himself down a slide and into a barrel of beer after every Milwaukee home run.

Though it may not be reflected in revenue or attendance totals, the Brewers have as loyal a fan base as any team in baseball, and although one writer has accurately described County Stadium as "an old park without an old park's character," it was always cherished by Wisconsinites. Still, it was replaced by a new, publicly financed $400 million stadium in 2001. Naming rights for the park were sold to the Miller Brewing Company for $41.2 million, although it was unclear how much extra the company had to pay for the team's adoption of the Miller Beer logo on its caps and jerseys. Billed as the largest construction project in Wisconsin history, Miller Park contains 500,000 tons of steel and concrete, and features 2,000 stereo speakers, 550 television monitors, and 70 luxury boxes. When its retractable roof is closed, the park can also be heated up to thirty degrees warmer than the outside temperature, enabling more fans to attend games in April and September when Wisconsin weather is often harsh.

Far Left: A Braves fan shows his team colors at County Stadium during Game 3 of the 1957 World Series. The Braves lost the game but won the Series, four games to three.

Left: Miller Park is seen rising in the background as the Brewers play their final game at County Stadium on September 28, 2000.

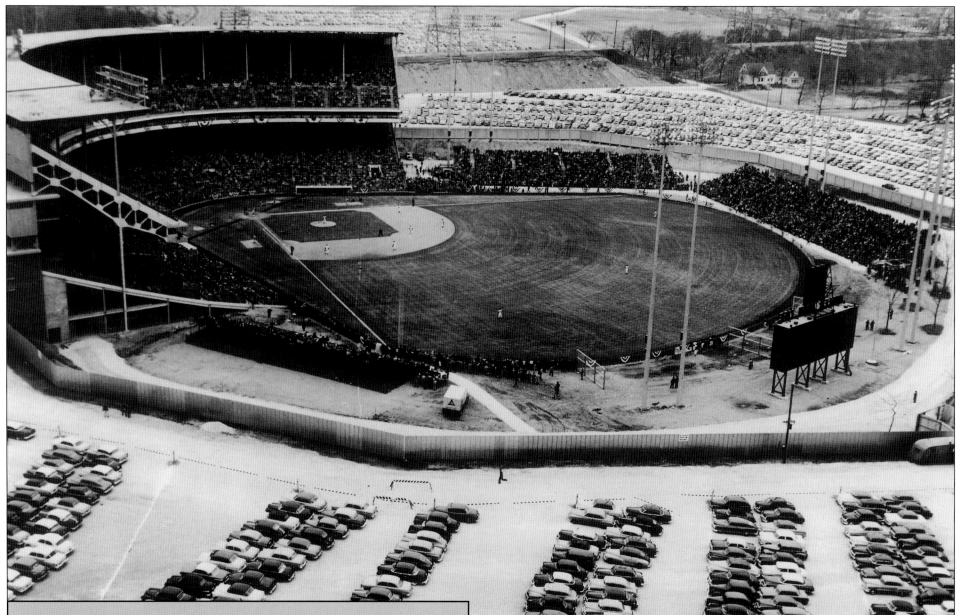

County Stadium

Opened: April 6, 1953
Home to: Milwaukee Braves (National League) 1953–1965; Milwaukee Brewers (American and National Leagues) 1970–present
Capacity: 35,911 (1953); 53,192 (1996)
Greatest Moment: May 26, 1959—Pittsburgh's Harvey Haddix pitches the best game in baseball history with twelve perfect innings against the Braves, but it isn't enough, as he gives up a run in the thirteenth to lose the game, 1-0.

Far Left: County Stadium is packed with fans as it often was during the 1950s, when the Braves set numerous attendance records.

Left: Miller Park is cause for celebration as this state-of-the-art stadium features a retractable roof that keeps out the cold weather in April and September.

Miller Park

Opened: April 6, 2001
Home to: Milwaukee Brewers (National League) 2001–present
Capacity: 42,400
Greatest Moment: September 21, 2001—Brewers batters set an all-time strikeout record with their 1,269th whiff of the season when slugger Geoff Jenkins goes down swinging in the eigth inning.

MINNEAPOLIS/ST. PAUL

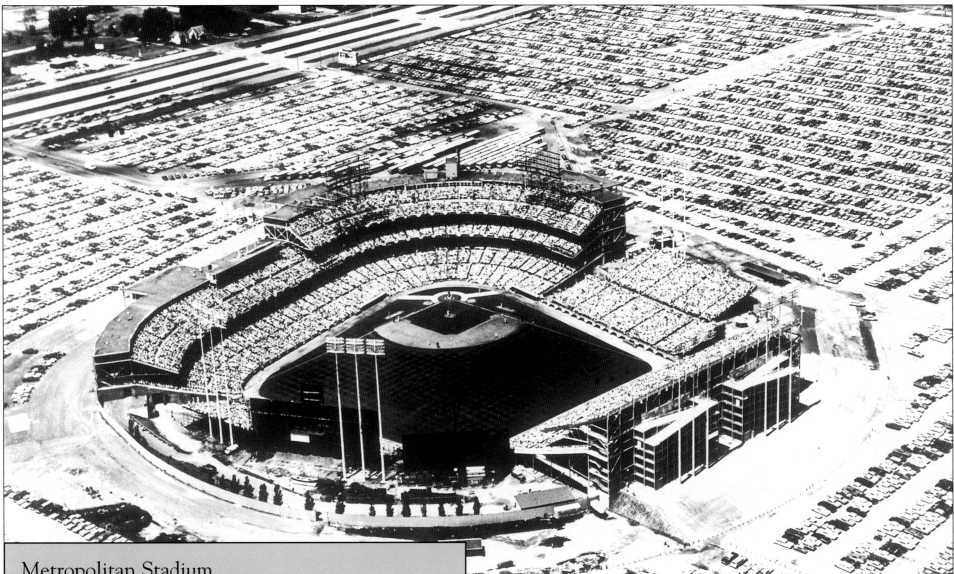

Metropolitan Stadium
Opened: April 24, 1956
Home to: Minnesota Twins (American League) 1961–1981
Capacity: 30,637 (1961); 45,919 (1975)
Greatest Moment: August 10, 1971—Beloved Twin Harmon Killebrew becomes the tenth man in baseball history to hit 500 home runs, as his first-inning drive off Baltimore's Mike Cuellar puts Minnesota ahead 1-0.

Above: Metropolitan Stadium, which opened in 1956, was built on the site of a former cornfield.

Right: The Hubert H. Humphrey Metrodome, built in 1982, looks suspiciously like a car safety air bag.

Minnesota's first major league team was the St. Paul Saints, who played in the Union Association in 1884. Though the Saints secured Fort Street Grounds as their home ballpark, the team folded after only nine games, all on the road. It would be another 77 years before a Minnesota major league team finally got a chance to play a home game.

For much of the early twentieth century, the Twin Cities had twin minor league franchises: the Minneapolis Millers and St. Paul Saints. On holidays, the teams would often play a two-stadium doubleheader, with one game held at Nicollet Park in Minneapolis, and the other across the Mississippi River at St. Paul's Lexington Park. Unfortunately, Minnesota's major league parks have been far less distinguished. The Twins inhabited Metropolitan Stadium, often said to be the most poorly maintained park in the majors, from 1961 through 1981. The stadium was abandoned in 1981, and its site became the Mall of America, the largest shopping center in the world. Since 1982, the Twins have played in the Hubert H. Humphrey Metrodome, a colossal structure best known for its right field wall, nicknamed the "Big Blue Baggy." The Twins have been campaigning for a new park for almost a decade, but despite threats that the team could be dissolved, Minnesotans declined to approve funding for a new stadium.

Hubert H. Humphrey Metrodome

Opened: April 6, 1982
Home to: Minnesota Twins (American League) 1982–present
Capacity: 54,711 (1982); 48,678 (1994)
Greatest Moment: October 27, 1991—Capping off one of the best World Series ever played, Minnesota's Jack Morris pitches a ten-inning shutout in Game 7, defeating John Smoltz and the Atlanta Braves, 1-0.

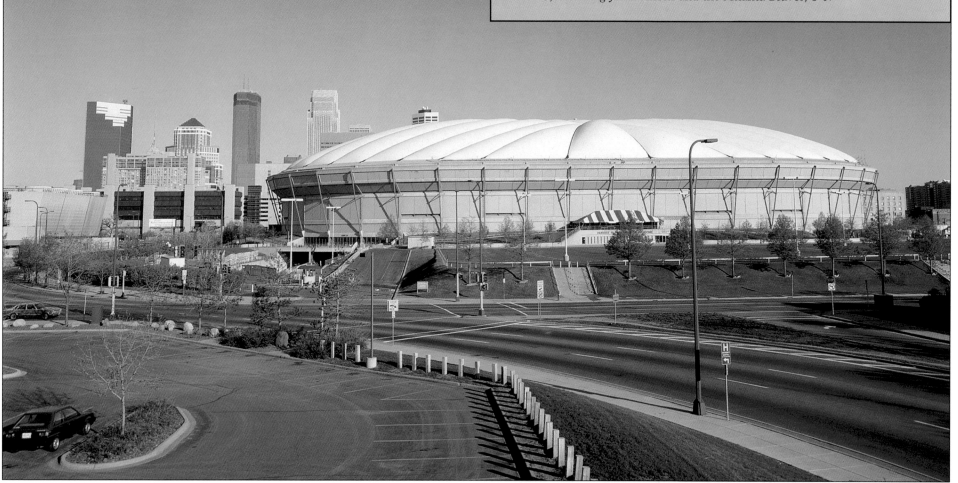

MONTREAL

Parc Jarry
Opened: April 14, 1969
Home to: Montreal Expos (National League) 1969–1976
Capacity: 3,000 (1968); 28,465 (1969)
Greatest Moment: April 14, 1969—The Expos defeat the St. Louis Cardinals 8-7 in the first Major League Baseball game ever played outside the U.S.

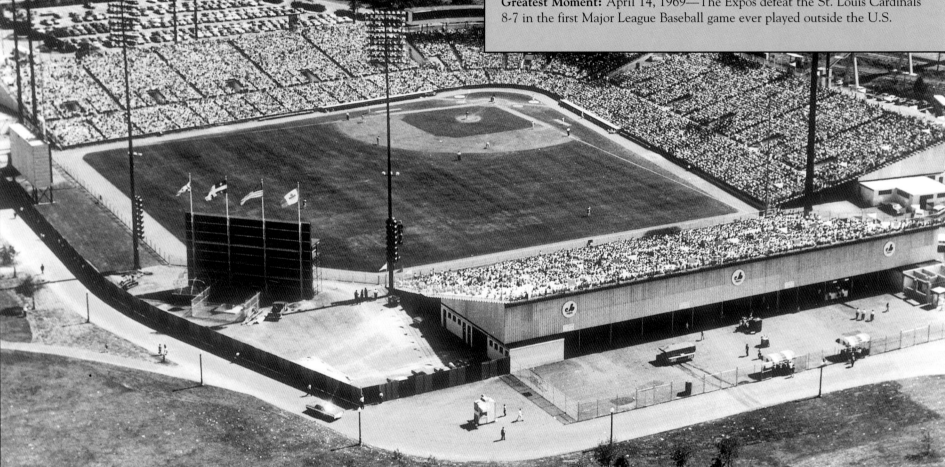

Baseball in Montreal was in dire straits as the twentieth century ended, but this has not always been the case. For years residents enthusiastically supported the Montreal Royals, a top Brooklyn farm club that consistently put winning teams on the field at Delormier Downs. One of their most popular players was Jackie Robinson, who broke pro baseball's color barrier with Montreal in 1946.

That October, after leading Montreal to victory in the Little World Series, Robinson left Delormier Downs for the last time. As he walked down the street he was mobbed by affectionate Quebeckers. In the *Montreal Courier* the next day, Sam Maltin wrote that "It was probably the only day in history that a black man ran from a white crowd with love instead of lynching on its mind." Montreal's major league parks, unfortunately, have not been so beloved.

When the Expos began in 1969, they spent eight years playing in Parc Jarry, a small community field that was expanded for major league use. In 1977, the team moved into Stade Olympique (Olympic Stadium), a concrete doughnut built for the 1976 Olympics, and nicknamed "The Big Owe" for its ever-ballooning cost. The stadium has been plagued by numerous structural problems over the years, including falling roof panels, loose beams, and a retractable dome that stopped working.

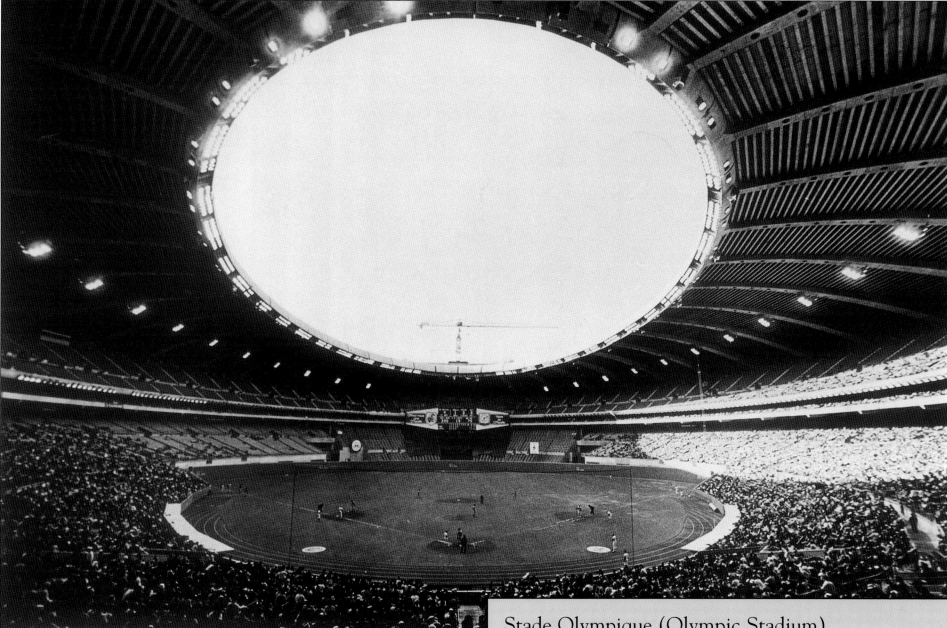

Above: Nicknamed "The Big Owe" by local fans, Stade Olympique has been plagued by financial and structural problems since its opening in 1976.

Left: When "Les Expos" came to Montreal in 1969, Parc Jarry was expanded from a small community park of 3,000 to a major league stadium with a capacity of 28,000.

Stade Olympique (Olympic Stadium)

Opened: July 17, 1976
Home to: Montreal Expos (National League) 1977–present
Capacity: 58,838 (1977); 43,739 (1992)
Greatest Moment: October 19, 1981—In the fifth and deciding game of the National League Championship Series, Rick Monday hits a game-winning homer off Steve Rogers in the ninth inning to send the Los Angeles Dodgers to the World Series.

NEW YORK

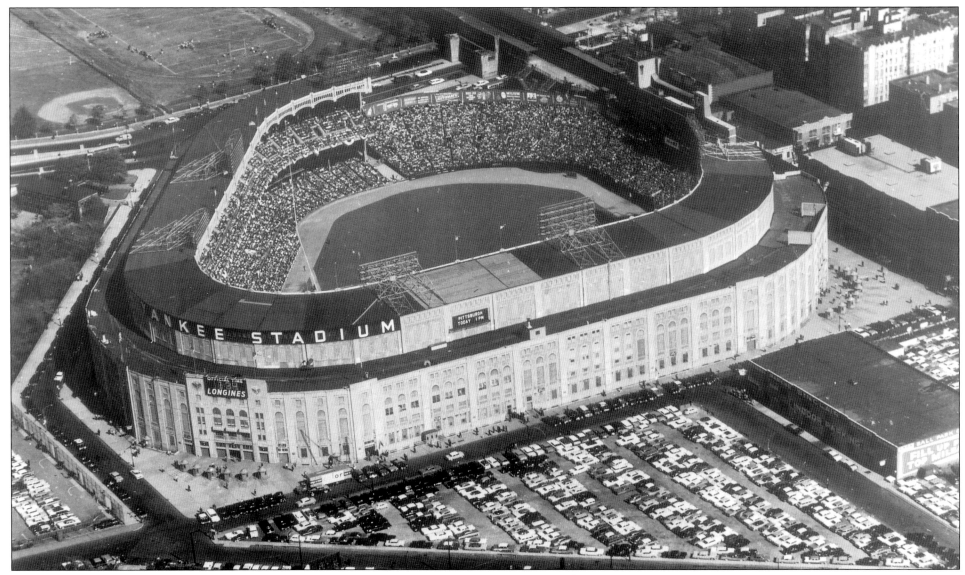

New York hosted four different major-league teams before 1900, and at least ten different ballparks in the city have been used for major-league baseball. One of the first significant ballgrounds in Manhattan was the original Polo Grounds on Fifth Avenue between 110th and 112th Streets. It really was a polo ground originally, and was first used for baseball in 1880. It contained two separate baseball fields, with only a

Above: Constructed in 1923, Yankee Stadium attracted 70,001 fans for the third game of the 1960 World Series pictured here. The Yankees crushed the Pirates 10-0.

Right: When Yankee Stadium was renovated in 1974 and 1975, the monuments in center field were taken out of play and the famous copper frieze was replaced by a smaller version in the outfield.

canvas fence separating them. In 1883, the park was home to two competing teams: the New York Giants, who played on the southeast diamond, and the New York Metropolitans, who played on the inferior and garbage-strewn southwest field. The teams occasionally played home games at the same time, so fans had to choose which game to watch.

In 1886, the Mets moved to the St. George Grounds on Staten Island, a cricket venue that also hosted dramatic plays and frequent stagings of Buffalo Bill's Wild West Show. The Mets' owner, Erastus Wiman, also owned Staten Island Amusement Park and the Staten Island Ferry, and a round-trip ferry ride was included in the price of a ticket to the ball game. Even better, throughout the 1886 season, baseball fans had a close-up view of the creation of the Statue of Liberty, which was being assembled on Bedloe's Island just beyond the left field fence. At the time, St. George was the fanciest baseball park ever built. The complex featured marching bands, illuminated geysers, hanging brass lamps in the grandstand, and tennis courts. A "ladies' refreshment parlor" stood in the

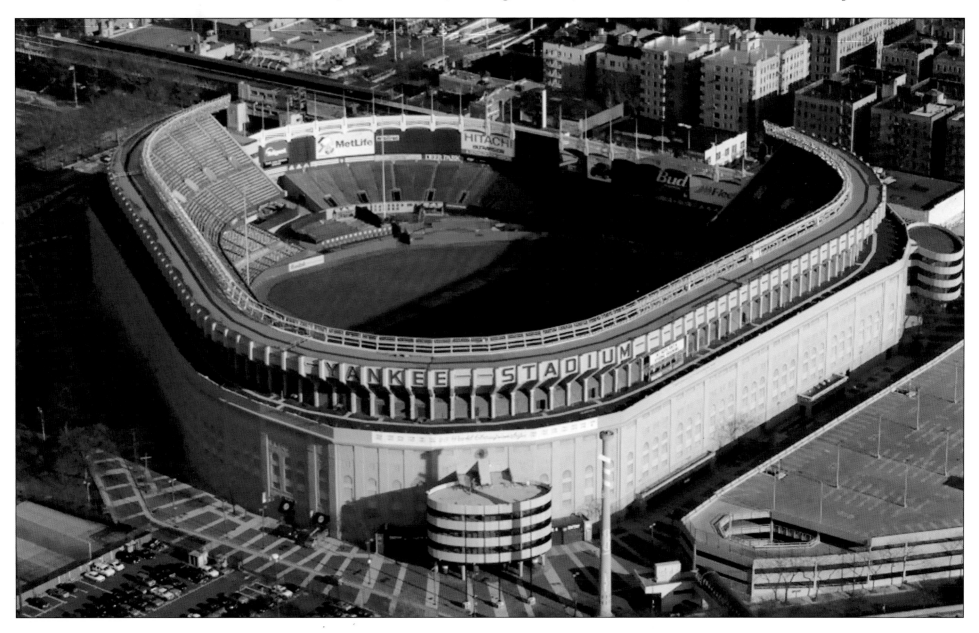

center of the grandstand, and a full-service restaurant was located under the north end of the stands. "Music, fireworks, and unlimited beer and ice cream are to be the attractions," the *Sporting Life* wrote just before the park opened.

St. George had a circus atmosphere about it—sometimes literally, as on one instance when a group of elephants and camels escaped onto the playing field during the Philadelphia Athletics' batting practice. The park was only used for three seasons, and after 1889 Staten Island would never host big-league ball again. However, more than a century later the minor league Staten Island Yankees brought baseball back to the island,

St. George Grounds

Opened: April 22, 1886
Home to: New York Metropolitans (American Association) 1886–1887; New York Giants (National League) 1889
Capacity: 5,000
Greatest Moment: June 13, 1887—O. P. Caylor, a *New York Tribune* sportswriter, takes over as manager of the Mets. He manages the team from the press box and continues to write daily newspaper reports as he guides the team to a seventh-place finish, 50 games out of first place.

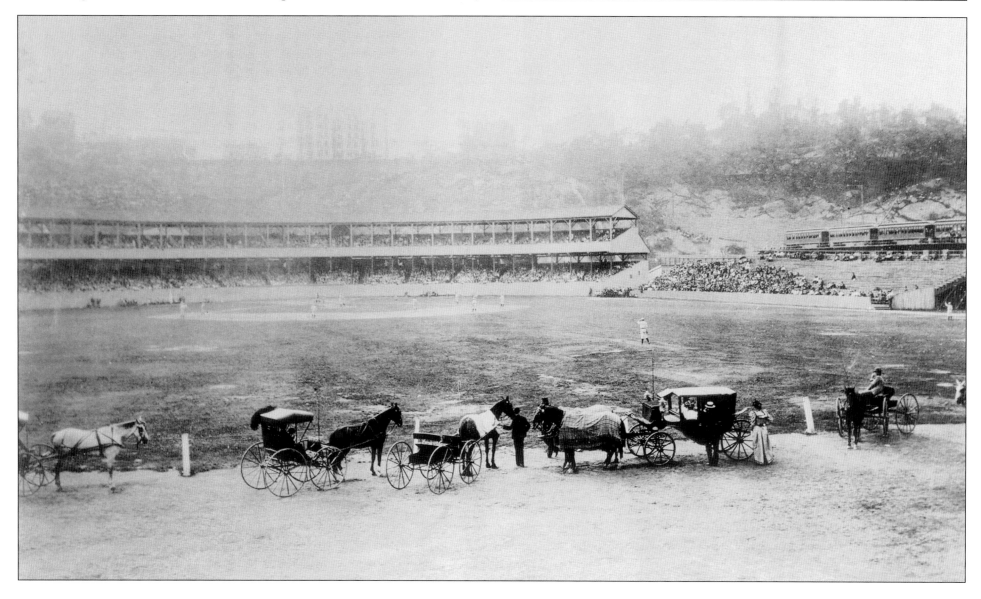

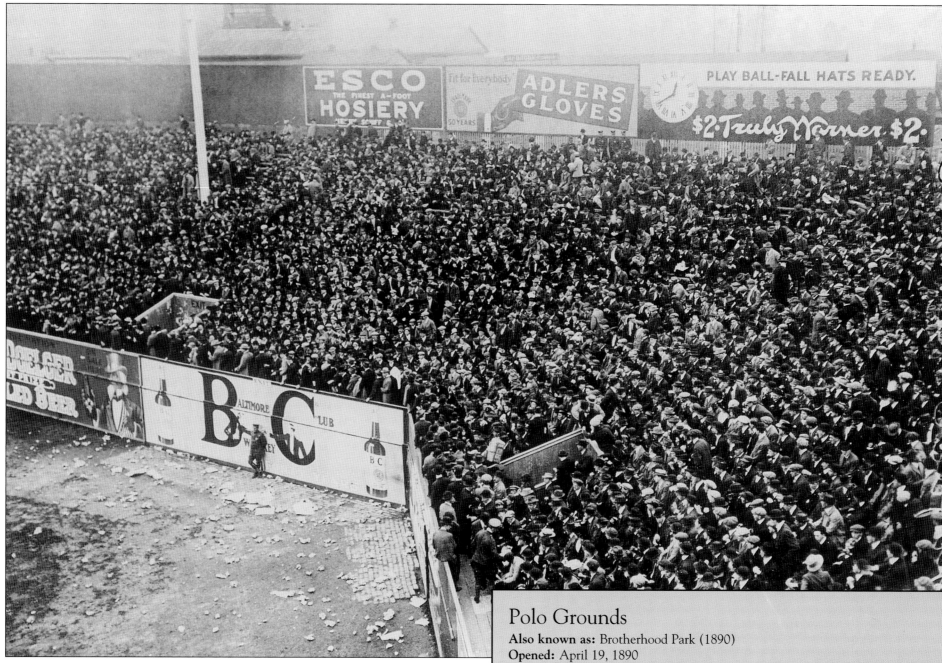

ESCO
THE FINEST A-FOOT
HOSIERY

Fit for Everybody
50 YEARS

ADLERS
GLOVES

PLAY BALL-FALL HATS READY.

$2. Truly Warner $2.

BALTIMORE CLUB
B C
WHISKEY

Above: A security guard is posted on the right field corner at the Polo Grounds in order to control the unruly bleacher fans.

Left: In the early days of the Polo Grounds, some well-heeled fans watched the game from their carriages parked in deep center field.

Polo Grounds

Also known as: Brotherhood Park (1890)
Opened: April 19, 1890
Home to: New York Giants (Players League) 1890; New York Giants (National League) 1891–1911
Capacity: 16,000 (1891)
Greatest Moment: September 23, 1908—In the middle of a tight pennant race with the Cubs, Giants rookie Fred Merkle forgets to touch second base on the game-winning hit, a mistake that eventually loses the pennant for the Giants.

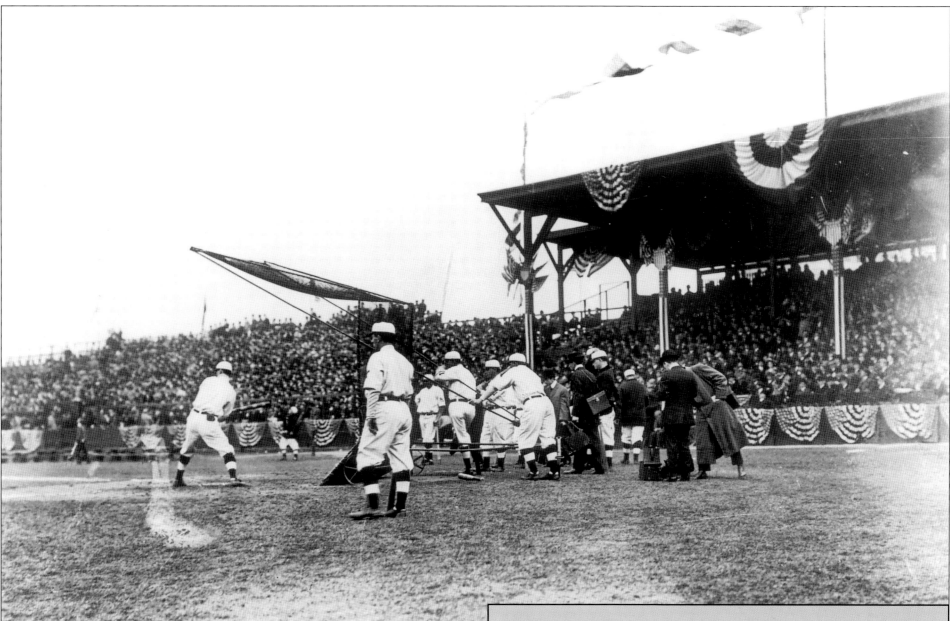

Above: Highlanders' right fielder Wee Willie Keeler looks on as a teammate takes batting practice at Hilltop Park. Bunting on the grandstand indicates that it was either Opening Day or a holiday.

Left: At Hilltop Park on June 15, 1909, White Sox batter Billy Sullivan fouls off a pitch from New York's Rube Manning in the top of the fifth inning. Highlanders' first baseman Hal Chase is ready to pounce on the ball.

Hilltop Park

Opened: April 30, 1903
Home to: New York Highlanders (American League) 1903–1912
Capacity: 15,000
Greatest Moment: October 10, 1904—On the final day of the season, New York's Jack Chesbro, winner of 41 games that year, throws a ninth-inning spitball that gets past the catcher for a wild pitch, giving both the game and the pennant to Boston.

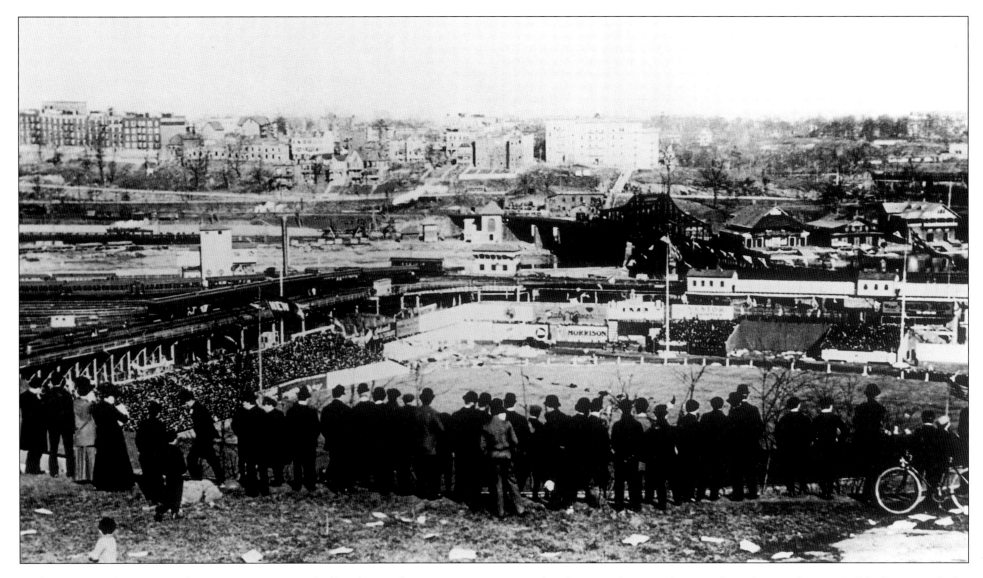

and in 2001 they opened a new 7,000-seat ballpark on the same site where the St. George Grounds once stood.

The New York Giants, meanwhile, moved into a second version of the Polo Grounds in 1889, and a third in 1891. The latter park, situated below Coogan's Bluff at the corner of Eighth Avenue and 159th Street in Harlem, served as the team's home until 1911. Owner John Brush pioneered several innovations, including a phone messaging system, which made it easier for Wall Street businessmen to attend weekday games, and a running track behind the center field fence where fans could park their carriages while they watched the game. When the stadium was full—as on October 8, 1908, when an estimated 250,000 fans tried to

attend—those without tickets gathered atop Coogan's Bluff to watch for free. It was also here that Harry M. Stevens single-handedly revolutionized ballpark concessions by popularizing scorecards and inventing the hot dog. This third Polo Grounds burned to the ground on April 14, 1911, due to the fact that it was made entirely of wood, but construction began immediately on a fourth.

By the end of the 1911 season, the fourth and final version of the Polo Grounds was complete with a horseshoe-shaped, steel-and-concrete grandstand, and a capacity of 34,000. It was one of the most ornate stadiums ever built, and the decor included an Italian marble facing all the way around the upper deck, which was engraved with the coat of

Left: Giants' fans gather on Coogan's Bluff to watch a game in the early 1900s. Yankee Stadium is yet to be built in the 1920s just across the Harlem River, near the tree-lined spot on the right-hand side.

Below: Bobby Thomson's swing on October 3, 1951 results in the most famous home run in baseball history. The dotted line marks the trajectory of the ball.

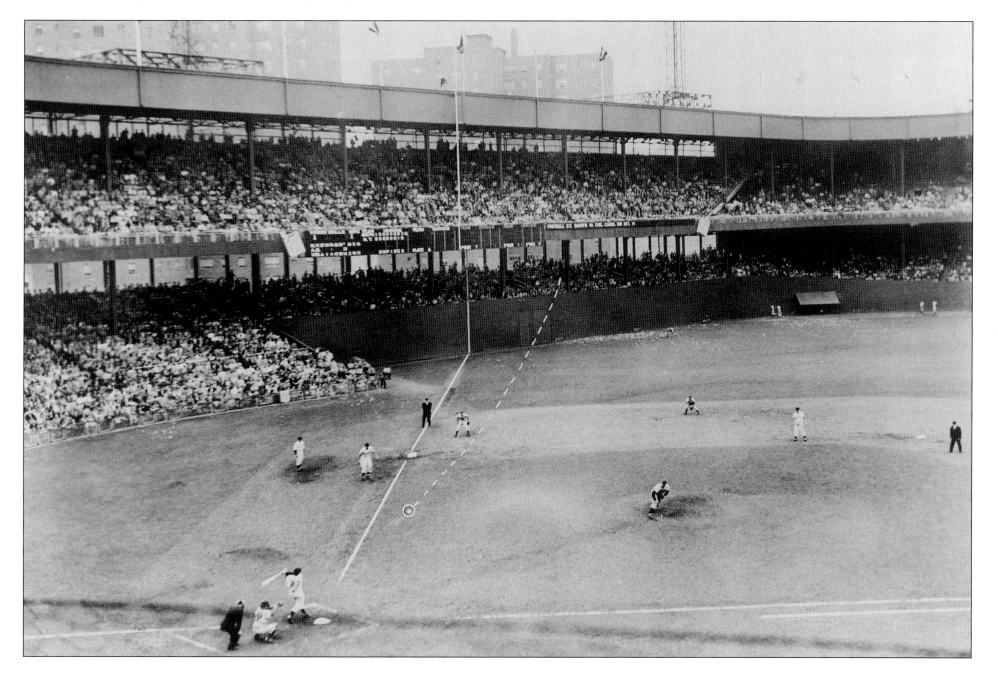

arms of each city in the National League. The Polo Grounds had the deepest center field in baseball, but with a right field line just 257 feet away from home plate, it was a haven for left-handed sluggers.

From 1913 through 1922, the Giants shared the Polo Grounds with the Yankees, and it was here, not Yankee Stadium, where Babe Ruth had his greatest seasons. He slugged .796 from 1920 to 1922 while the Yankees were the Giants' tenants. The stadium was the site of many memorable moments, including Ray Chapman's fatal beaning by Carl Mays in 1920, Willie Mays's dazzling catch in the 1954 World Series, and what is described as Bobby Thomson's "Shot Heard 'Round the World" in the 1951 playoff against Brooklyn. During the latter season, the Giants were aided by an intricate sign-stealing scheme in which infielder Hank Schenz and coach Herman Franks sat in the Giants' clubhouse in dead center field, observing the opposing catchers' signals

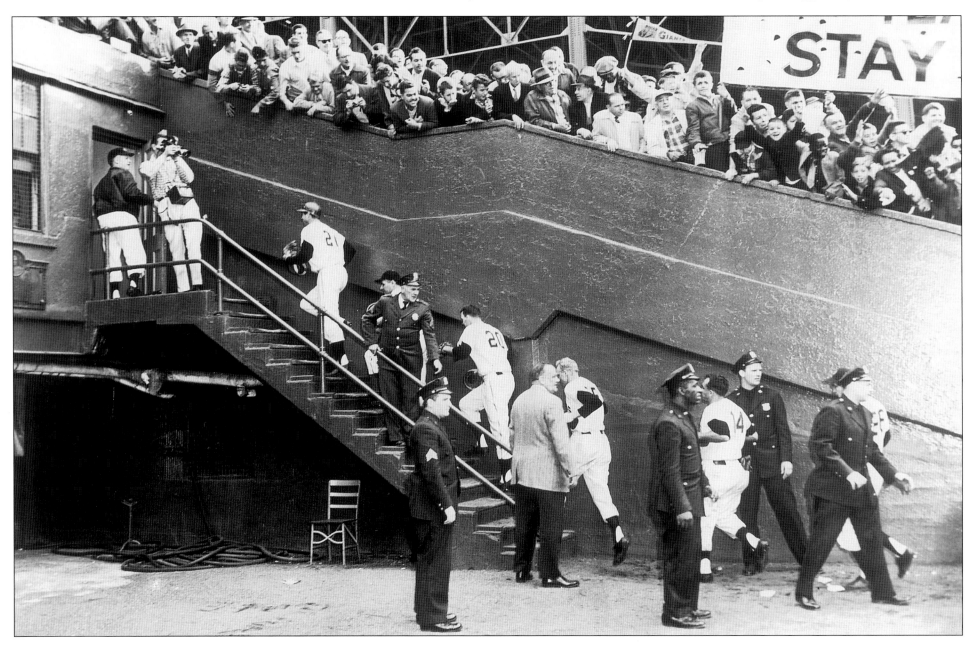

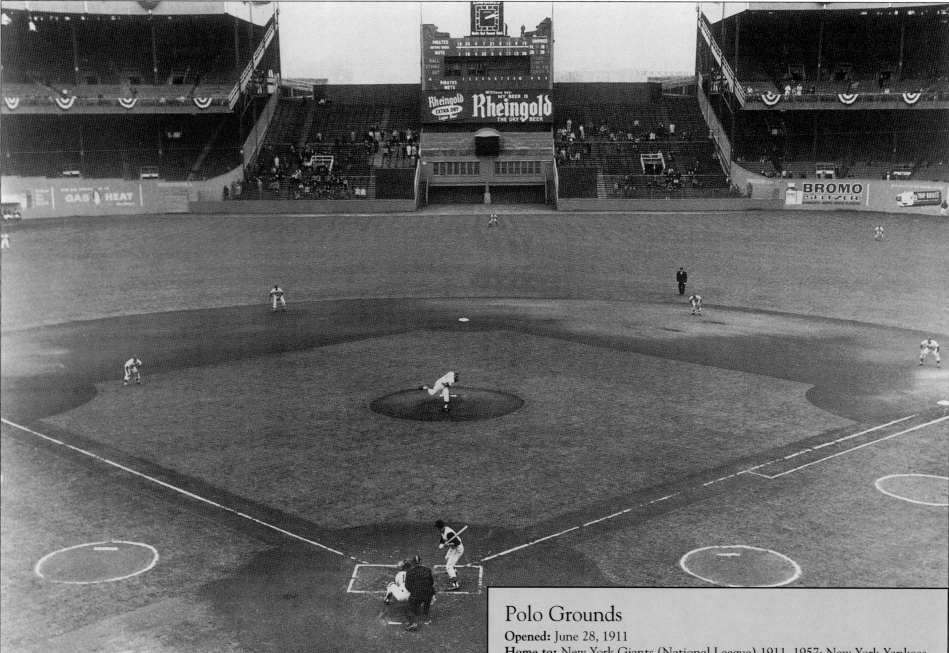

Left: The New York Giants walk up the steps to the center field clubhouse on September 29, 1957, after playing their last game at the Polo Grounds.

Above: The New York Mets and Pittsburgh Pirates face off in an early 1960s game at the Polo Grounds.

Polo Grounds

Opened: June 28, 1911

Home to: New York Giants (National League) 1911–1957; New York Yankees (American League) 1913–1922; New York Mets (National League) 1962–1963

Capacity: 34,000 (1911); 56,000 (1953)

Greatest Moment: October 3, 1951—Bobby Thomson hits "The Shot Heard 'Round the World," the most famous home run in baseball history. The ninth-inning shot off Brooklyn's Ralph Branca wins the National League pennant for the Giants.

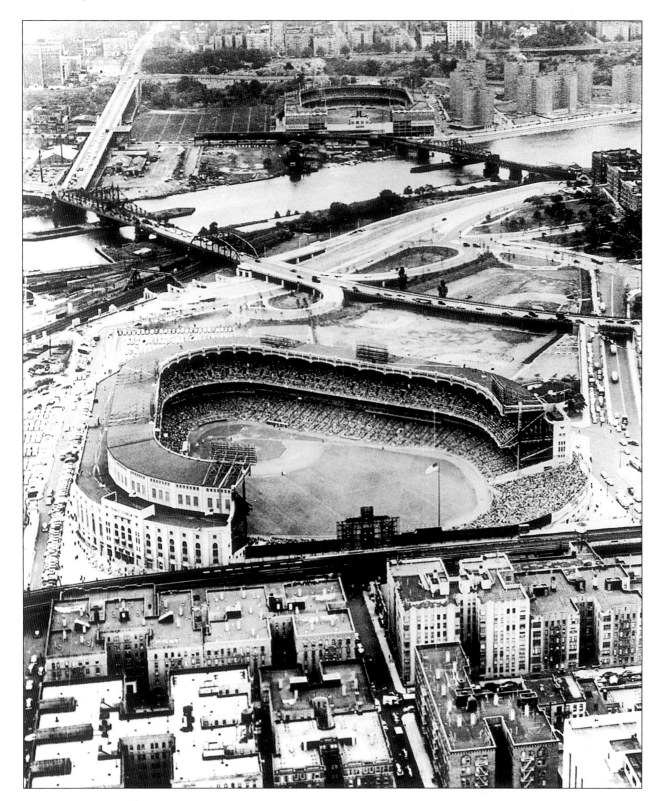

through a telescope, and relaying them electronically to Giants' batters.

In 1956, with their attendance figures suffering badly, Giants owner Horace Stoneham was talked into moving to San Francisco by Walter O'Malley. The last occupants of the Polo Grounds were the New York Mets, an expansion team designed to replace the Dodgers and Giants, who played here (badly) under manager Casey Stengel in 1962 and 1963. A housing project now sits on Coogan's Bluff where the ballpark once was.

Meanwhile, the New York Highlanders, who would become known as the Yankees in 1913, began playing in the Washington Heights section of Manhattan in 1903. The name Highlanders was a reference to their home at Hilltop Park, located on an outcropping overlooking the Hudson River at 168th and Broadway. The park's dimensions were cozy, and according to a statistical study by STATS Inc., it was the most hitter-friendly park in baseball history until the Colorado Rockies joined the National League in 1993.

By 1911, less than a decade after it opened, the Highlanders were planning to replace Hilltop Park with a floating ballpark in the Harlem River, a scheme that never worked out. Hilltop was one of the few wooden ballparks of its era that never burned down, but was abandoned in 1913 when the Yankees moved to the much more spacious Polo Grounds. After a decade there, the Giants, tired of being beaten in attendance by their rivals, asked the Yankees to leave. Yankees owner Jacob Ruppert decided the team needed a new park of its own anyway—one big enough to hold all the fans who wanted to see Babe Ruth play.

The Yankees built their new stadium in the Bronx just across the Harlem River from the

Yankee Stadium

Opened: April 18, 1923
Home to: New York Yankees (American League) 1923–1973, 1976–present
Capacity: 58,000 (1923); 71,699 (1937); 57,545 (1980)
Greatest Moment: July 4, 1939—In a poignant farewell to Yankee fans, the dying Lou Gehrig calls himself "the luckiest man on the face of the earth." His words remain the most famous speech in baseball history.

Far Left: Yankee Stadium with Polo Grounds in the distance. When the Yankees were evicted from the Polo Grounds in 1922, they decided to build their own stadium just across the river.

Below: More than 74,000 fans attended the grand opening of Yankee Stadium on April 18, 1923. Some scaffolding is visible, a sign that workers had not yet finished painting the exterior.

Polo Grounds. Though hardly the best ballpark ever built, Yankee Stadium is easily the most famous. Its occupants won 26 World Series in their first 76 seasons there, thanks to a seemingly endless string of great players that included Ruth, Lou Gehrig, Joe DiMaggio, Mickey Mantle, and Yogi Berra. It was the first stadium to have the word "stadium" in its name and was a colossal structure unlike anything baseball fans had ever seen, completely enclosed all the way around with enough seats for 82,000 fans. Among its unique features were a sculptured copper frieze circling the top of the grandstand, and later three stone monuments to Yankee greats, namely Ruth, Gehrig, and manager Miller Huggins, on the field of play in center field.

In 1974 and 1975, the Yankees shifted their home games to Shea Stadium while a massive renovation of Yankee Stadium was completed. Although the project cost $55 million—about twenty times the stadium's original cost—it accomplished little more than stripping the stadium of its character and turning it into a gaudy

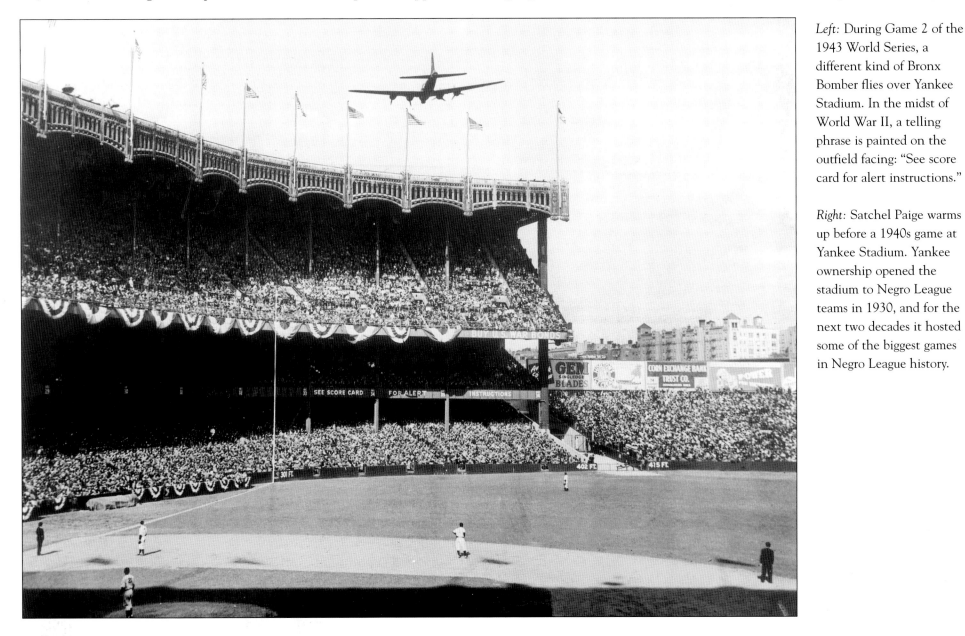

Left: During Game 2 of the 1943 World Series, a different kind of Bronx Bomber flies over Yankee Stadium. In the midst of World War II, a telling phrase is painted on the outfield facing: "See score card for alert instructions."

Right: Satchel Paige warms up before a 1940s game at Yankee Stadium. Yankee ownership opened the stadium to Negro League teams in 1930, and for the next two decades it hosted some of the biggest games in Negro League history.

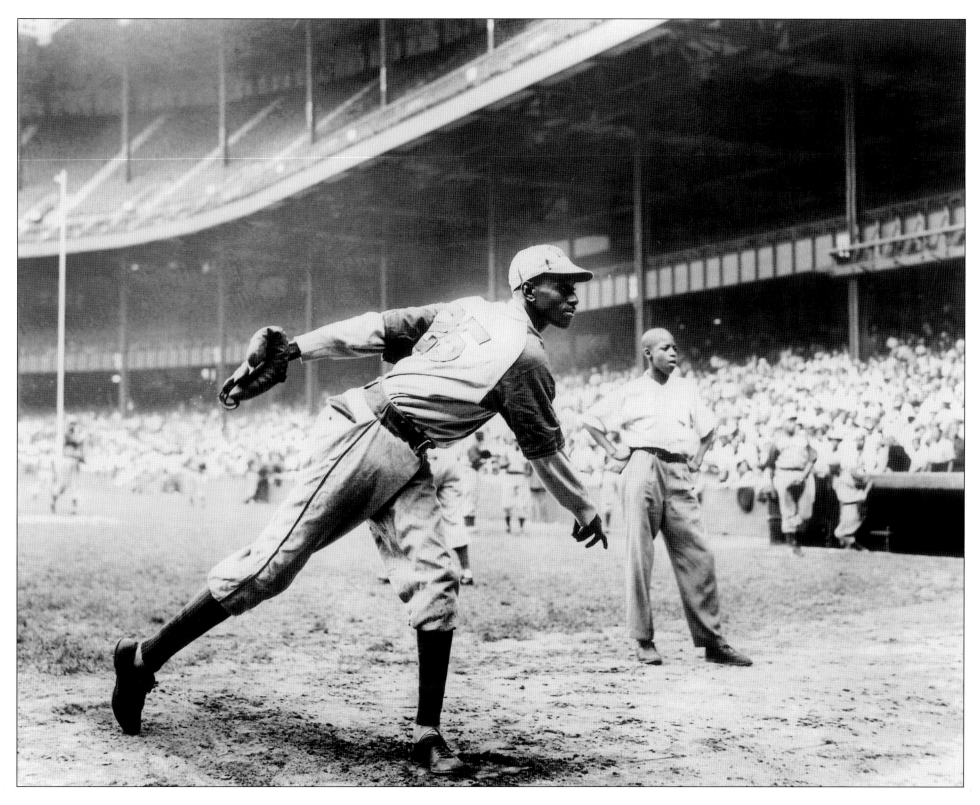

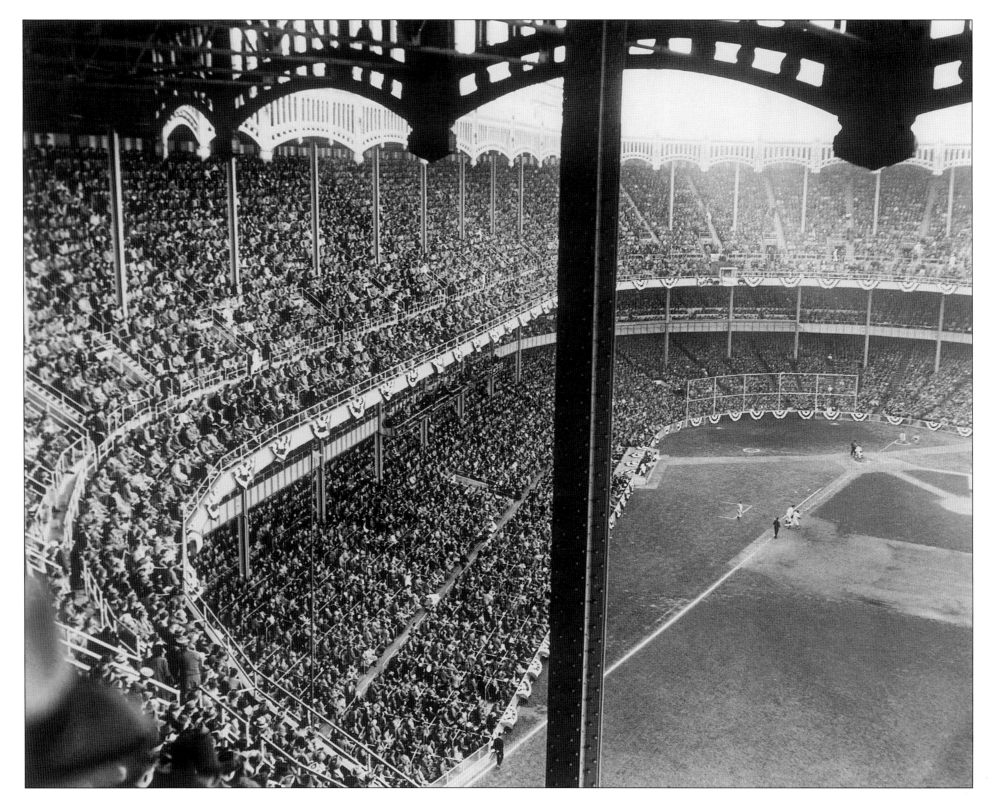

Left: The Yankees and Dodgers face off in Game 1 of the 1947 World Series. Jackie Robinson, taking his lead off first base, has just become the first African-American to play in the Fall Classic.

Right: Yogi Berra (left) and Roy Campanella played against each other in five World Series at Yankee Stadium, including the 1953 Series pictured here.

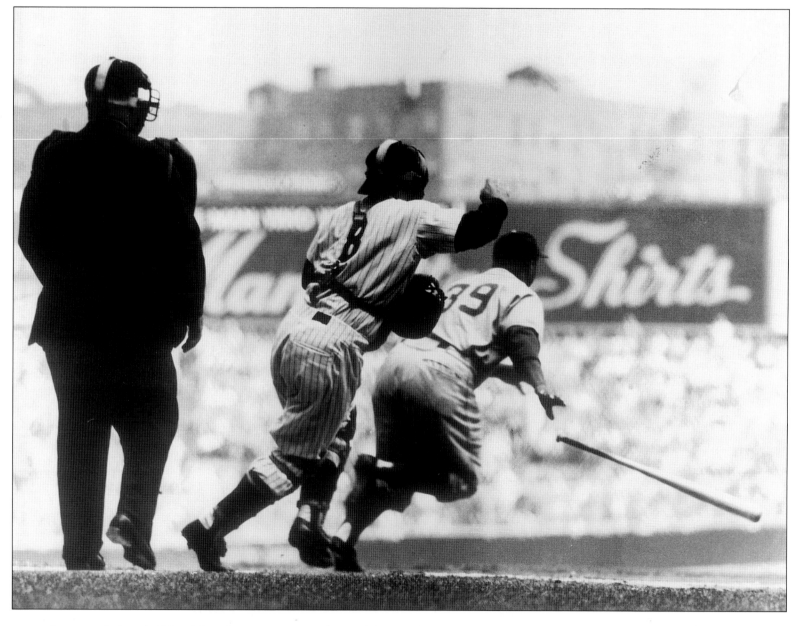

replica of the multipurpose stadiums of the 1970s. The fences were moved in, the hallowed monuments removed from the field of play, and the signature copper frieze torn down and replaced with an inferior plastic version. Over the last three decades of the twentieth century, the Yankees continued to enjoy success on the field and at the box office, but the stadium was just a shell of its former self.

The New York Mets entered the National League as an expansion franchise in 1962, and although they could do little to assuage the city's

loss of the Dodgers and Giants, the team quickly developed a following of its own. After playing their first two years at the Polo Grounds, the Mets moved into brand-new Shea Stadium. It was built in Flushing Meadow on the same site that Walter O'Malley had indignantly refused for a proposed Dodgers ballpark in the 1950s. Shea's most distinctive feature was its huge scoreboard, and the gigantic top hat in front of it, from which a lighted "big apple" emerged after every Mets home run. Shea is one of the noisiest ballparks in the major leagues, thanks both to its

raucous fans and the airplanes taking off from nearby La Guardia Airport. The architecture was patterned after Dodger Stadium, but New Yorkers soon gave Shea Stadium a character of its own. Shea was where baseball fans first started bringing homemade banners and signs to ball games, giving the stadium a homey feel that had been lacking in New York baseball since the Dodgers left Ebbets Field.

Left: At 5:30 a.m. Yankee fans build a fire to keep warm as they wait to buy bleacher tickets for World Series Game 2 on October 5, 1961.

Right: Built for the Mets in 1964, Shea Stadium is the only major league ballpark ever located in the borough of Queens.

Shea Stadium

Opened: April 17, 1964
Home to: New York Mets (National League) 1964–present; New York Yankees (American League) 1974–75
Capacity: 55,000 (1964)
Greatest Moment: October 25, 1986—In Game 6 of the World Series, a ninth-inning grounder by Mookie Wilson rolls through the legs of Boston first baseman Bill Buckner, as the Mets win 3-2 to force a decisive seventh game.

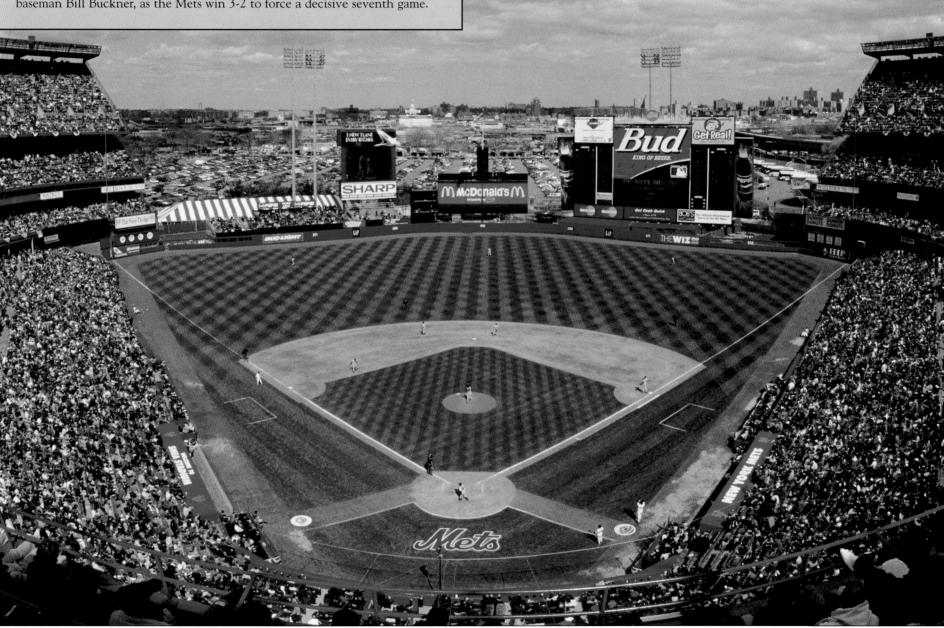

OAKLAND

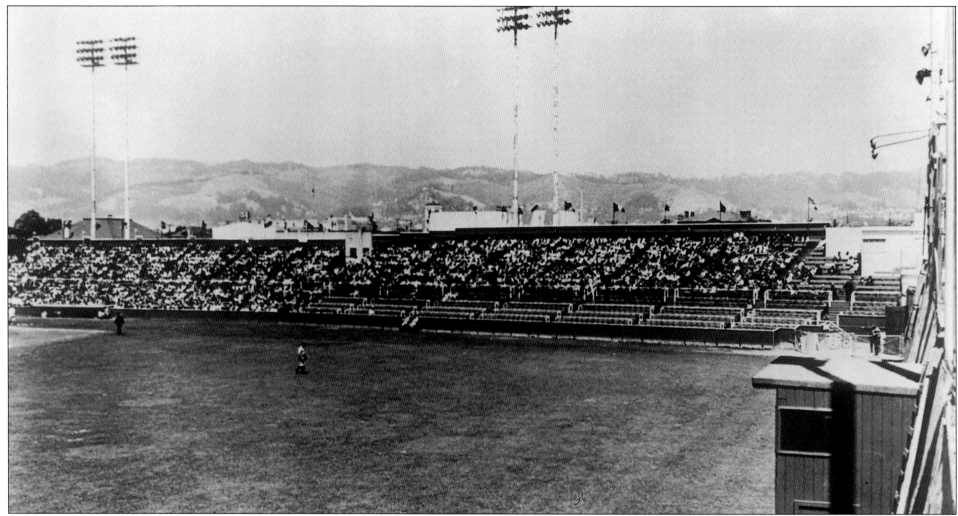

For much of the 1900s, East Bay baseball fans flocked to see the Pacific Coast League's Oakland Oaks play at Oaks Ball Park in the nearby suburb of Emeryville. The team won four Pacific Coast League championships there, including one in 1948 with a squad famously dubbed the "Nine Old Men," managed by Casey Stengel and featuring aging superstars such as Ernie Lombardi, Cookie Lavagetto, and Dario Lodigiani. The franchise moved away in 1957, but a decade later the major league Kansas City Athletics relocated to the Oakland Coliseum. Despite being a circular, multipurpose stadium, the Coliseum was an enjoyable place to

Oaks Park

Opened: 1913
Home to: Oakland Oaks (Pacific Coast League) 1913–1957
Capacity: 7,000
Greatest Moment: May 28, 1916—Jimmy Claxton, an African-American passing as a Native American, makes his pitching debut for the Oaks. His true heritage was discovered and he was released after two games, but he remained the last African-American to play in the majors until Jackie Robinson.

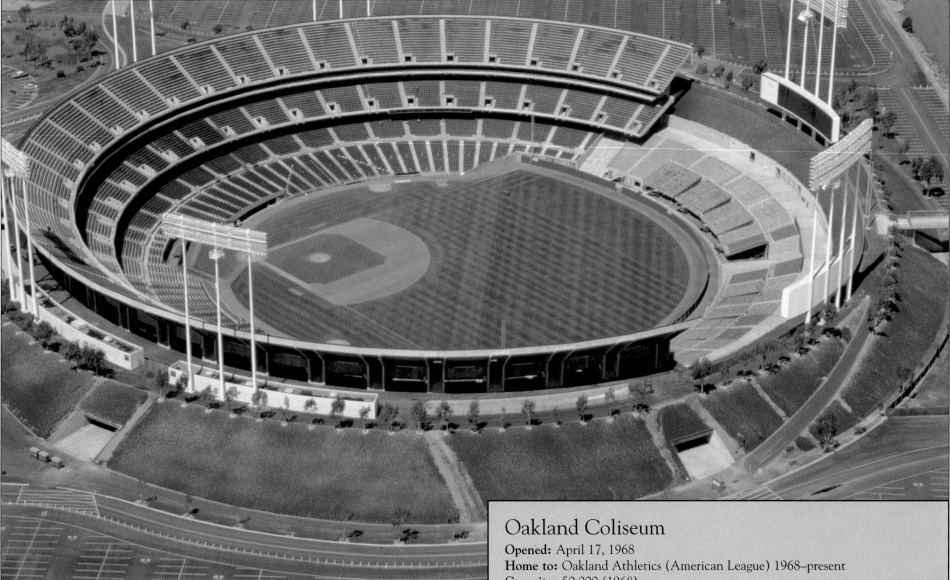

Oakland Coliseum

Opened: April 17, 1968
Home to: Oakland Athletics (American League) 1968–present
Capacity: 50,000 (1968)
Greatest Moment: May 8, 1968—In only the eleventh game ever played at the Coliseum, its status as a pitcher's park is cemented when A's pitcher Catfish Hunter throws a perfect game against the Minnesota Twins.

watch baseball, and with the most foul territory in the major leagues, it was a pitchers' haven. In 1996, Los Angeles Raiders owner Al Davis promised to move his football team back to Oakland if he got a bigger stadium. The Coliseum was remodeled, and 22,000 seats were added to accommodate this.

The renovations forced the A's to relocate some of their home games to Las Vegas and also resulted in the complete enclosure of their once-open ballpark, making it far less appealing for baseball fans who derisively nicknamed it the "Al Davis Coliseum."

Above: In 1995, a renovation for the NFL's Raiders resulted in the closure of the open spaces in the outfield stands seen in this photo of the Oakland Coliseum.

Left: The Oakland Oaks played at Oaks Park in the suburb of Emeryville, where Walter "Duster" Mails, Artie Wilson, and other PCL stars became heroes.

PHILADELPHIA

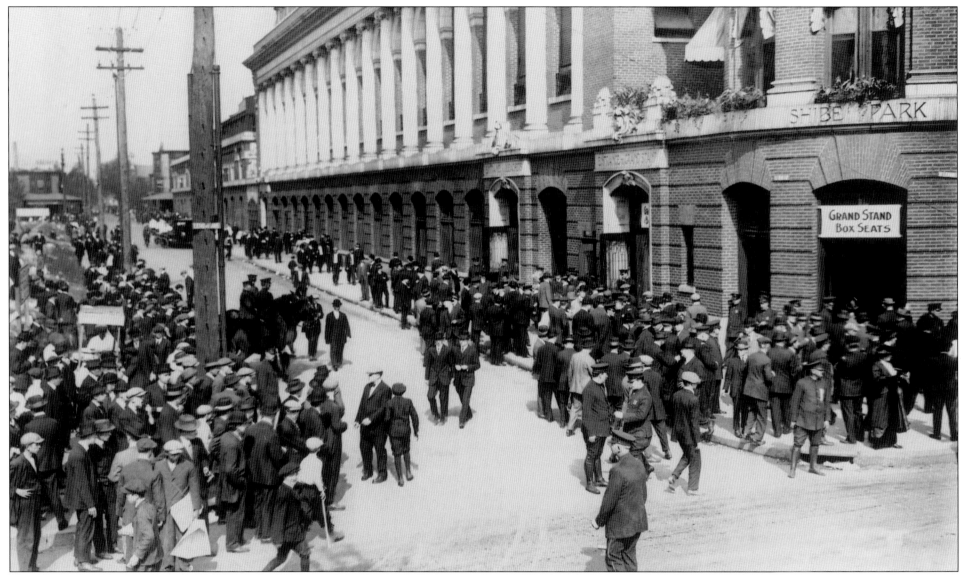

Along with New York and Boston, Philadelphia was one of the first three major cities where baseball caught on, and its first professional team was the Philadelphia Athletics, charter members of the National Association in 1871. Philadelphia teams played at many ballparks over the next three decades. These included Jefferson Street Grounds, which was the site of the first game in National League history and featured a swimming pool

behind the outfield fence, a curiosity which would be echoed by Phoenix's Bank One Ballpark more than a century later.

In 1895, after their previous home burned down, the Philadelphia Phillies constructed the Baker Bowl, a tiny park that they would call home for the next 44 seasons. The park was nicknamed "the Hump" because it was built on an elevated piece of ground in order to allow for

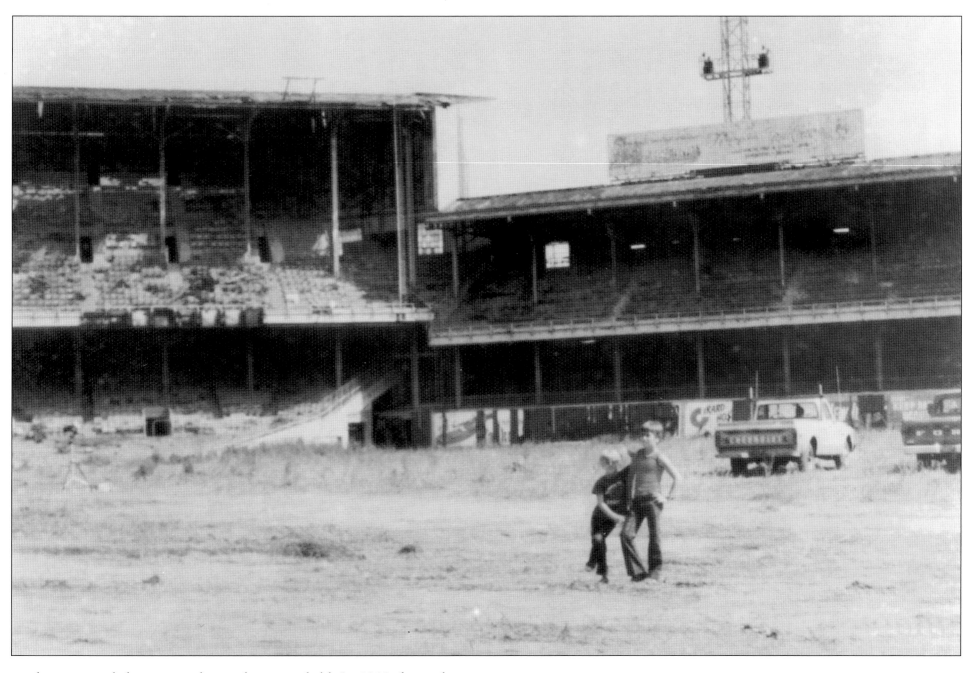

a subway tunnel that ran underneath center field. In 1903 the park was abandoned temporarily so it could be repaired after a section of stands collapsed during a game, killing 12 people.

During the 1920s and 30s, Baker Bowl had the smallest capacity of any major league park, but it didn't hurt the Phillies much since they were so awful that few fans wanted to see them play anyway. The park

Above: Two boys survey damage from the fire that partially burned Shibe Park in 1971 after the Phillies moved out. The park was demolished in 1976.

Left: Fans gather outside five-year-old Shibe Park before the start of the 1914 World Series.

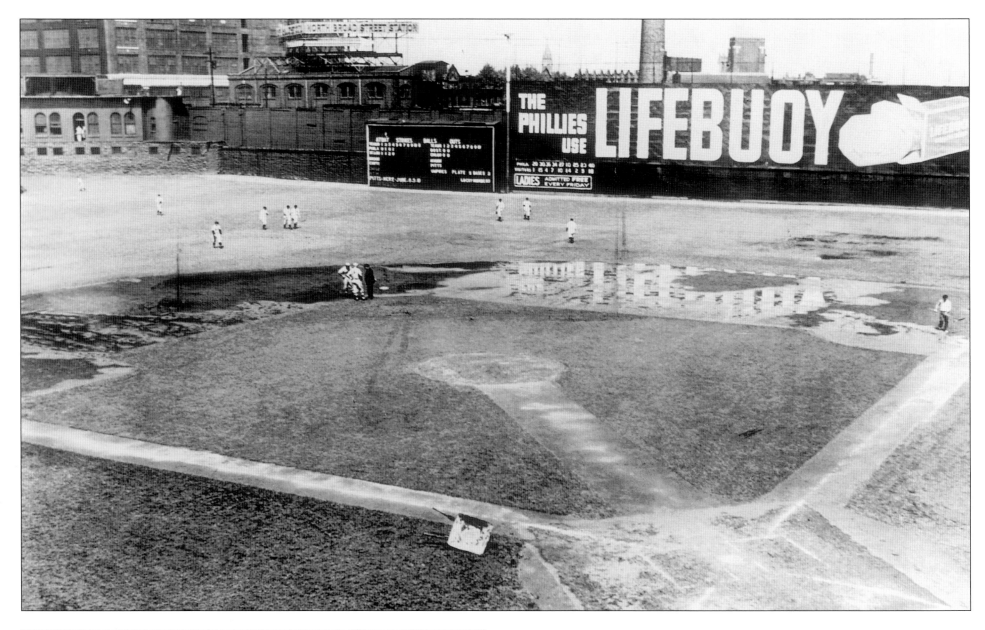

Baker Bowl

Opened: May 2, 1895
Home to: Philadelphia Phillies (National League) 1895–1938
Capacity: 18,000 (1895); 18,800 (1930)
Greatest Moment: October 3, 1924—In the first Negro League World Series game ever played, future Hall of Famer Bullet Rogan pitches an eight-hitter, and the Kansas City Monarchs beat Hilldale 6-2.

was also one of the smallest in terms of field size and had a right field fence only 280 feet away from home plate. This enabled Phillies right fielder Chuck Klein to win the Triple Crown in 1933, and to set a modern record with 44 outfield assists in 1930.

On April 12, 1909, the Philadelphia Athletics unveiled Shibe Park, one of the most influential stadiums in baseball history. Wooden ballparks were burning down at an alarming rate, and team owner Ben Shibe decided to build a new $300,000 stadium of steel and concrete with

materials never before used extensively in ballparks. The result was a 23,000-seat baseball palace that inspired many imitators, as every major league stadium since Shibe has been constructed with steel and concrete. The park had perhaps the most notable exterior of any park ever built, and a French Renaissance rotunda at its corner housed Connie Mack's office.

In 1925, Mack, by then owner of the team, added an upper deck to the bleachers and moved the outfield fences in to better suit his power-hitting team. It worked, as the home runs of Jimmie Foxx and Al Simmons helped the A's win three consecutive American League pennants

Shibe Park

Also known as: Connie Mack Stadium (1953–1970)
Opened: April 12, 1909
Home to: Philadelphia Athletics (1909–1954); Philadelphia Phillies (1938–1970)
Capacity: 23,000 (1909); 33,500 (1925); 33,608 (1961)
Greatest Moment: October 12, 1929—In Game 4 of the World Series, the Athletics are losing 8-0 in the seventh inning, but mount a tremendous comeback to beat the Cubs 10-8. They win the series two days later.

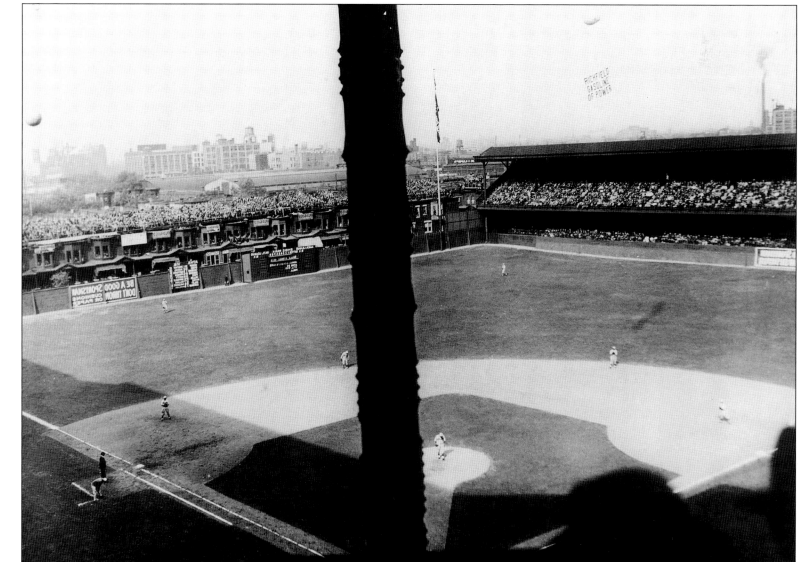

Left: Rain puddles cover the playing field in this 1932 photo of Baker Bowl. The park's 280-foot right field fence was an inviting target for left-handed sluggers.

Right: Game 6 of the 1930 World Series at Shibe Park. It is the bottom of the third inning, and Al Simmons is about to crush a pitch into the upper deck to give the Athletics a 3-0 lead. (Note: This photo is reversed; the upper-deck grandstand was actually in left field.)

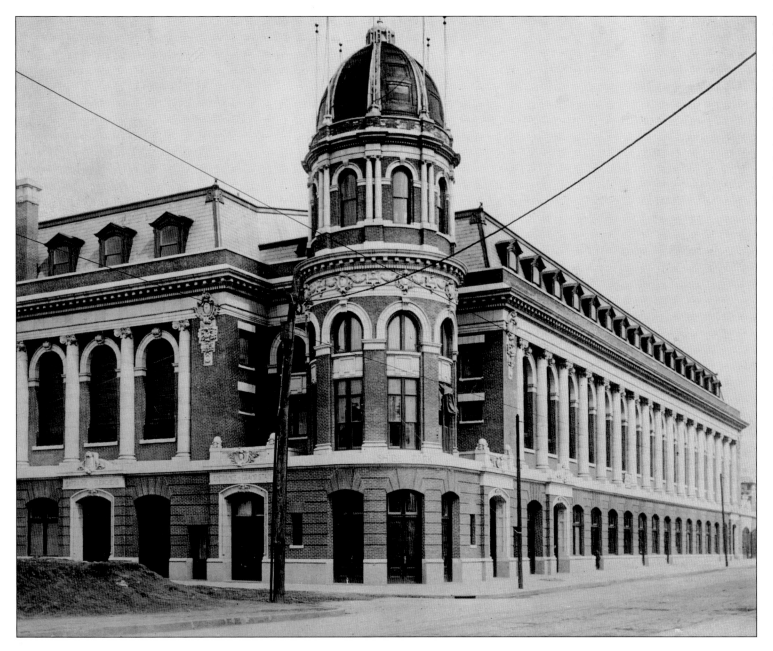

Left: One of Shibe Park's distinctive features was the rotunda at the corner of 21st and Lehigh, which housed Connie Mack's office.

Right: Veterans Stadium was home to the Phillies when they won their only world championship in 1980.

from 1929–31. Owners of homes behind Shibe's right field fence were able to watch the games for free, and some landlords even charged admission—fans paid as much as $30 to sit in the unauthorized bleachers for the 1930 World Series. The Athletics, who wanted such profits for themselves, finally installed a 38-foot right field wall in 1935 that put a stop to the practice. In 1953, the park was renamed "Connie Mack Stadium" after the man who was the Athletics' manager in 42 of their 46 seasons

there. The A's, however, left for Kansas City after the 1954 season, leaving the Philadelphia Phillies, who had moved there in 1938, as the only residents of Connie Mack Stadium. In 1971, they moved into Veterans Stadium, an undistinguished cookie-cutter park that by the turn of the twenty-first century was one of the worst stadiums in the majors. In 2001, the city of Philadelphia approved plans for a baseball-only stadium next to Veterans Stadium, scheduled to open in 2004.

Veterans Stadium

Opened: April 10, 1971
Home to: Philadelphia Phillies (National League) 1971–present
Capacity: 56,317 (1971); 62,418 (2001)
Greatest Moment: October 21, 1980—The Phillies beat Kansas City in World Series Game 6 to win the only championship in franchise history. The key play is made by Pete Rose, who catches a foul pop-up after catcher Bob Boone drops it.

PHOENIX

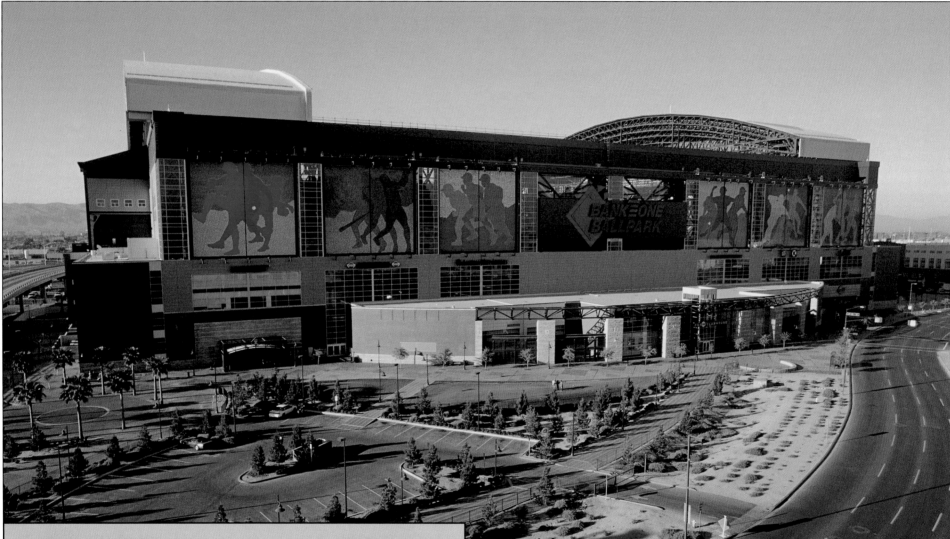

Bank One Ballpark

Opened: March 31, 1998
Home to: Arizona Diamondbacks (National League) 1998–present
Capacity: 49,033
Greatest Moment: November 4, 2001—In the bottom of the ninth in Game 7 of the World Series, Luis Gonzalez hits a bases-loaded single to cap a two-run rally against the Yankees' relief ace, Mariano Rivera, giving the Diamondbacks a 3-2 victory and their first world championship.

Phoenix had big-league aspirations as early as 1992, when the posh suburb of Scottsdale built an upscale stadium in the hopes of attracting a major league team—perhaps the San Francisco Giants, who used the ballpark as their spring training headquarters.

However, the Giants stayed put, and fully fledged, big-league baseball didn't arrive until 1998, when the Arizona Diamondbacks opened Bank One Ballpark. Nicknamed "the BOB," the $354 million

stadium features air conditioning and a retractable roof to protect fans from the searing Arizona heat. The facility has multiple fast-food restaurants, a farmer's market, and a swimming pool behind the center field fence. It is more an amusement park than a ballpark.

However, it was the first stadium in more than 50 years to bring back the traditional dirt path that ran between the pitcher's mound and home plate.

Above: The Dodgers' Raul Mondesi bats at Bank One Ballpark against Armando Reynoso on April 13, 1999.

Far Left: Its murals and boxy shape make Bank One Ballpark look more like a basketball arena from the outside than a baseball park.

PITTSBURGH

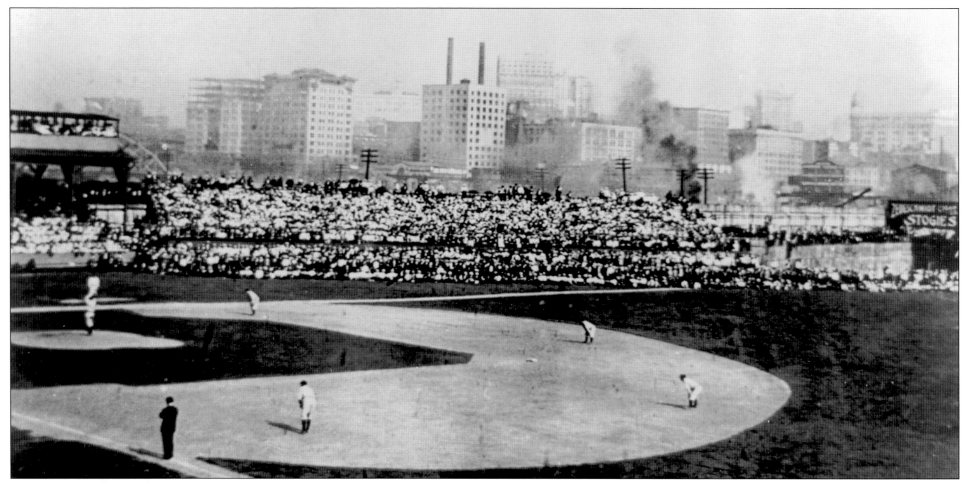

Exposition Park

Opened: May 9, 1882

Home to: Pittsburgh Alleghenys/Pirates (American Association 1882–1883, National League 1891–1909); Pittsburgh Unions (Union Association) 1884; Pittsburgh Burghers (Players League) 1890; Pittsburgh Rebels (Federal League) 1914–1915

Capacity: 16,000 (1914)

Greatest Moment: May 2, 1909—Pirates shortstop Honus Wagner sets a record by stealing second, third, and home in succession for the fourth time in his career.

The first ballpark of note in Pittsburgh was Exposition Park, which was built in 1882 at the confluence of the Allegheny and Monongahela Rivers, on the exact same site where Three Rivers Stadium was built nearly a century later. At the time, the site was actually located in Allegheny City, not Pittsburgh, so the franchise became known as the "Pittsburgh Alleghenys."

It was a picturesque setting, as fans could watch barges floating down the Allegheny River behind the left field fence and see the smokestacks of downtown Pittsburgh just on the other side. The Alleghenys moved in 1884 to nearby Recreation Park, which was believed to be the only major league ballpark with a monkey buried directly underneath home

plate. (The deceased primate had been a pet of catcher Fred Carroll.) The major leagues returned to a refurbished Exposition Park in 1890, when the Pittsburgh Burghers of the rebel Players League played there. For that one season, two competing major league teams played only three blocks apart in Allegheny City. The Burghers went out of business after only one season, and in 1891 their rivals, the Alleghenys, returned to Exposition Park, where they became the Pirates.

In 1909, with help from his friend Andrew Carnegie, Pirates owner Barney Dreyfuss purchased a plot of land in the Schenley Farms area of

PNC Park

Opened: April 9, 2001
Home to: Pittsburgh Pirates (National League) 2001–present
Capacity: 38,000
Greatest Moment: June 27, 2001—After being ejected from the game, enraged Pirates manager Lloyd McClendon literally steals first base, pulling it out of the ground and taking it into the clubhouse with him. A replacement bag is soon found, and the game continues.

Left: The smokestacks of Pittsburgh rise behind Exposition Park as the Pirates face the New York Giants on August 23, 1904.

Right: Located on almost exactly the same site as Exposition Park, PNC Park features the Roberto Clemente bridge behind the outfield wall, connecting it with downtown Pittsburgh.

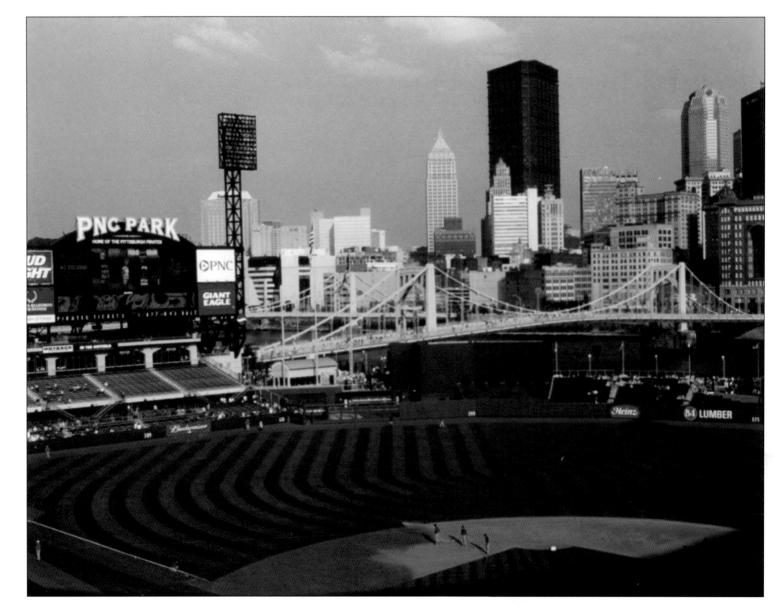

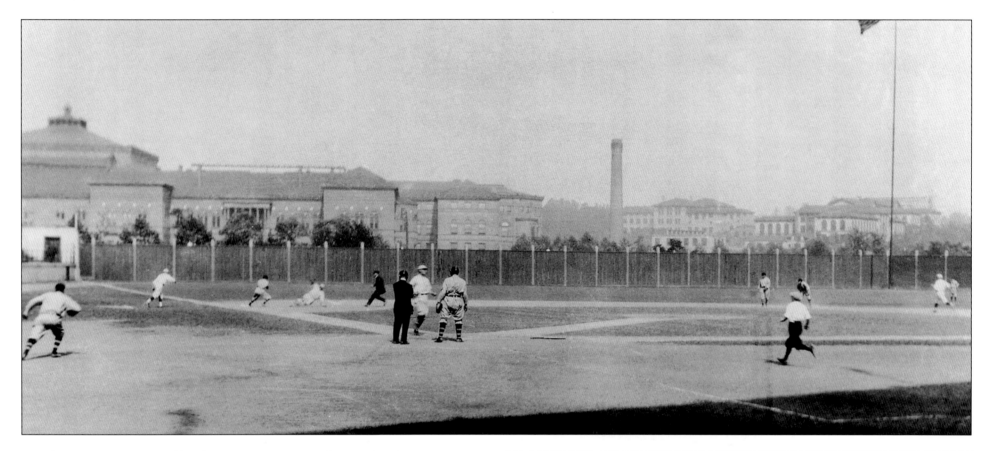

Pittsburgh for a new ballpark. As its name implies, Schenley Farms was a rural area, and the new stadium, Forbes Field, was so far away from downtown Pittsburgh that fans nicknamed it "Dreyfuss's Folly." Forbes was the second concrete-and-steel stadium ever built, after Philadelphia's Shibe Park, and was the first ballpark to contain elevators and umpires' dressing rooms.

It was one of the most spacious parks in baseball, so much so that when slugger Hank Greenberg's contract was sold to the Pirates in 1947, he refused to report unless the team moved the fences in. The Pirates shifted the bullpens to the left field corner, effectively shortening the home run distance by 30 feet. At first it was dubbed "Greenberg Gardens," but then the fenced-off area was renamed "Kiner's Korner" when Ralph Kiner led the National League in home runs seven straight times. However, the park remained a nightmare for many hitters, including the great Roberto Clemente, whose power numbers were curtailed by playing 16 years at Forbes Field. The Pirates left Forbes in 1970, and although the park was torn down, home plate and a portion of the outfield wall were preserved as part of the University of Pittsburgh campus.

Forbes Field

Opened: June 30, 1909
Home to: Pittsburgh Pirates (National League) 1909–1970; Homestead Grays (Negro Leagues) 1939–1948
Capacity: 23,000 (1909); 35,000 (1960)
Greatest Moment: October 13, 1960—In Game 7 of the World Series against the Yankees, the Pirates' Bill Mazeroski breaks a ninth-inning tie by hitting a Ralph Terry pitch over the left field wall. It was the first time the World Series had ended on a home run.

Above: A Pirates' base runner slides into third base at Forbes Field during a 1911 game against Brooklyn.

Right: Many things changed at Forbes Field between 1911 and the late 1960s, when this photo was taken, but the buildings of Schenley Park were still visible behind the left field wall.

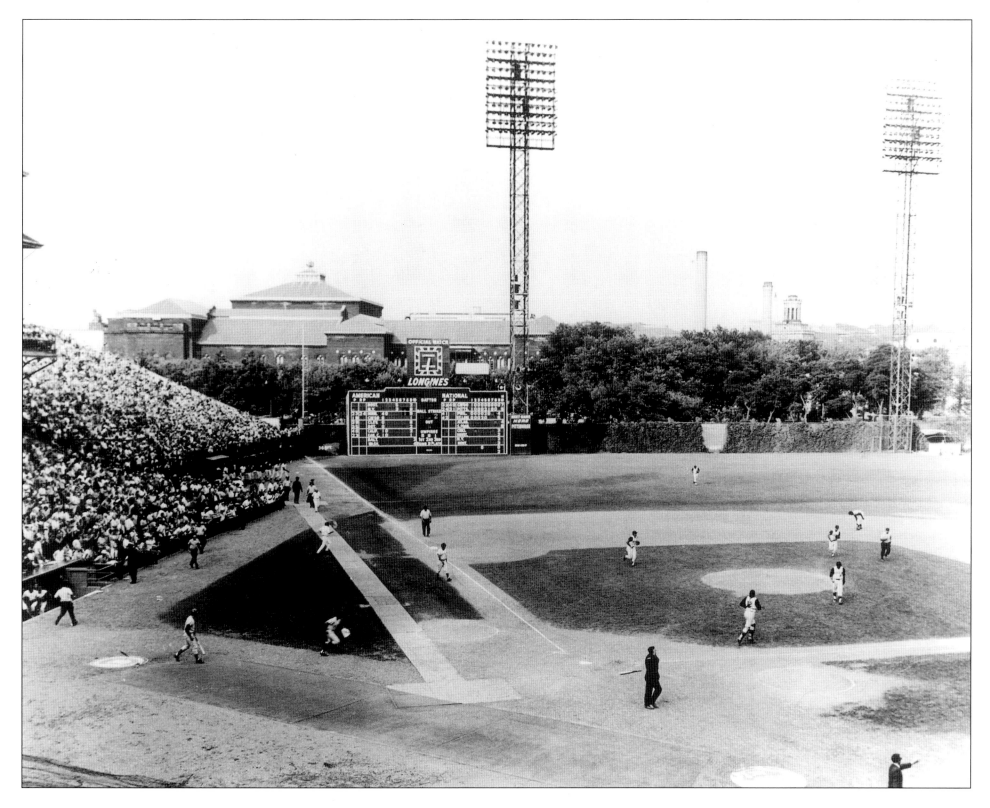

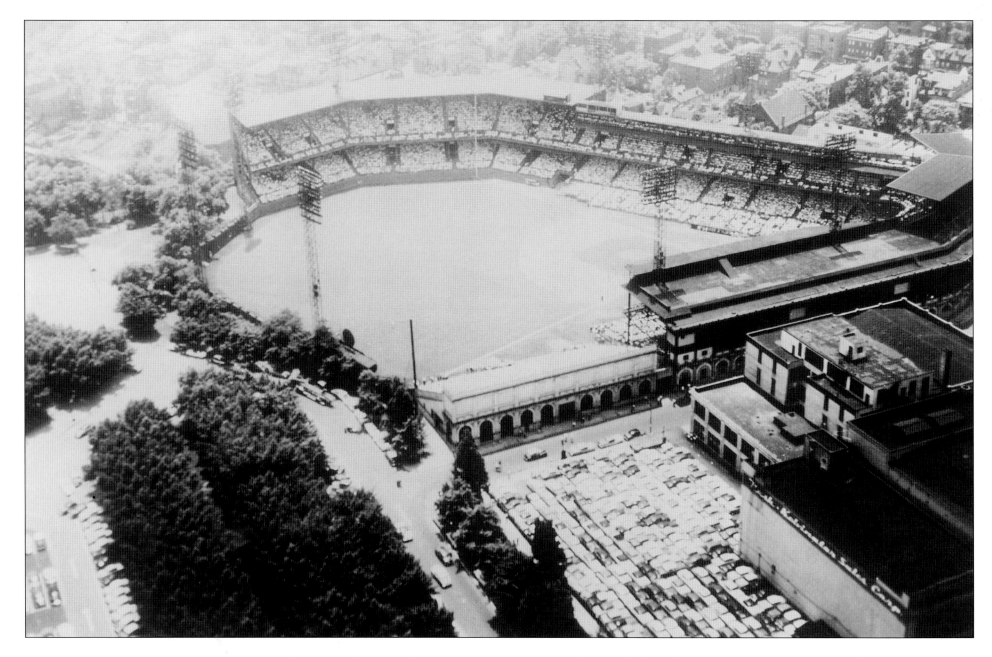

Perhaps more than any other city in America, Pittsburgh also has a long and rich history of Negro League baseball. The Pittsburgh Keystones, an early team in the Negro National League, played at Ammon Field in the Hill District. The most famous team was the Homestead Grays, who started as a team of steelworkers in the nearby town of Homestead, and evolved into the most powerful team in the Negro League. Led by Josh Gibson and Buck Leonard, the Grays, who often played at Forbes Field when the Pirates were out of town, won nine consecutive pennants in the 1930s and 1940s. On May 7, 1932, an unusual doubleheader at Forbes featured the Pirates and Phillies in the first game and a Negro League contest between the Grays and Hilldale Giants in the second. In 1932, a new Negro League franchise, the Pittsburgh Crawfords, was founded by the African-American gangster Gus Greenlee. The team was named after the Crawford Grille, a famous

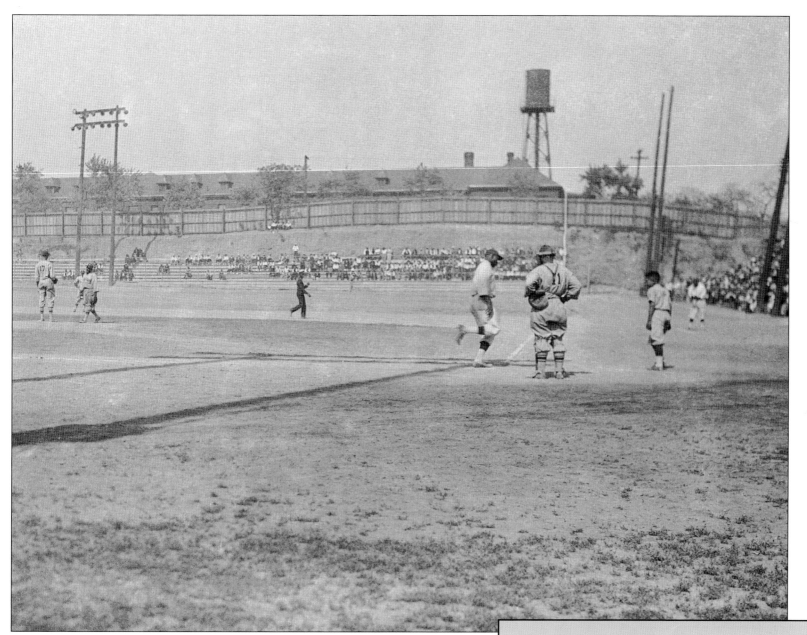

Far Left: The tree-lined spot behind where Bill Mazeroski's homer cleared the left field wall at Forbes Field is now part of the University of Pittsburgh campus.

Left: Noted photographer Charles "Teenie" Harris snapped this picture of Greenlee Field during the 1930s, when more than 200,000 fans paid to see Crawfords games.

Greenlee-owned nightspot that featured live entertainment by the likes of Billie Holiday and John Coltrane. Greenlee mercilessly raided other teams for their best players, building a conglomeration of superstars that included Hall of Famers Gibson, Cool Papa Bell, Satchel Paige, Oscar Charleston, and Judy Johnson. In 1933, Greenlee built a stadium, Greenlee Field, only a few blocks away from the Crawford Grille. It was the only black-owned stadium in baseball, and the Crawfords played

Greenlee Field

Opened: April 29, 1932
Home to: Pittsburgh Crawfords (Negro Leagues) 1932–1938; Homestead Grays (Negro Leagues) 1932–1933, 1935–1938
Greatest Moment: July 16, 1932—Satchel Paige pitches a no-hitter against the New York Black Yankees and also get two hits himself, as the Crawfords win 6-0.

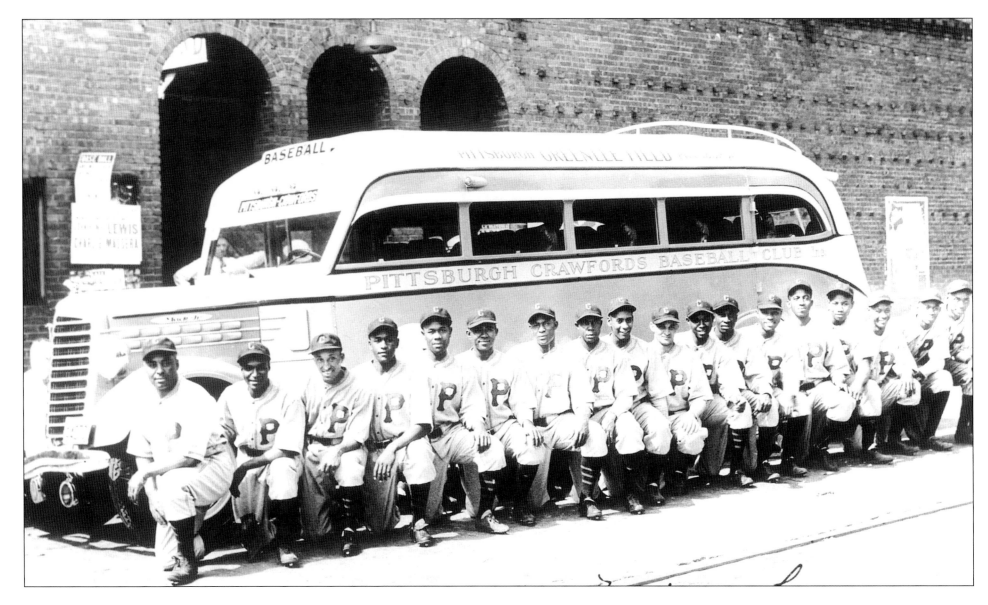

there until 1938, when financial losses forced Greenlee to disband the team and tear down the ballpark.

In the middle of the 1970 season, the Pittsburgh Pirates played their last game at Forbes and moved into a new downtown ballpark, Three Rivers Stadium. Though it was an unimaginative multipurpose stadium, its picturesque location at Three Rivers Point made it one of the best of the cookie-cutter parks. The Pirates won two world championships there before moving to a new stadium in 2001. Naming rights for the new park were sold to PNC Bank for $30 million. PNC Park is an intimate

Above: The Pittsburgh Crawfords pose with their team bus in front of Greenlee Field. Notable players include Oscar Charleston (far left), Cool Papa Bell (12th from left), and Josh Gibson (15th from left).

Right: Three Rivers Stadium may not have been as quaint as Forbes Field, but its setting was much more picturesque and centrally located.

park where the highest seat is only 88 feet above the playing field, and is one of the best ballparks ever constructed.

The terra-cotta front entrance is graced by a statue of Honus Wagner first erected at Forbes Field in 1955, and the striking Pittsburgh skyline and Allegheny River are visible behind the outfield wall. The Roberto Clemente Bridge connects the park with downtown Pittsburgh, enabling fans to walk to the game after work.

Three Rivers Stadium

Opened: July 16, 1970
Home to: Pittsburgh Pirates (National League) 1970–2000
Capacity: 50,500 (1970); 58,729 (1990)
Greatest Moment: September 30, 1972—In what turns out to be the last at-bat of his career, Roberto Clemente hits a double against the New York Mets for his 3,000th career hit. He later tragically dies in a plane crash on New Year's Eve.

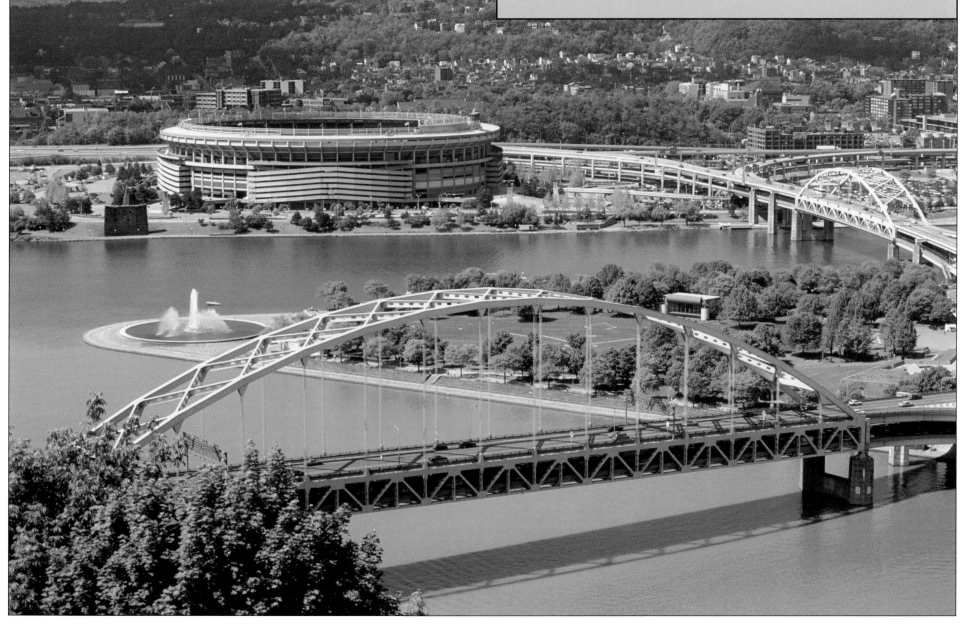

ST. LOUIS

Robison Field

Also known as: Sportsman's Park II (1893–1898); League Park (1899–1916); Cardinal Field (1917–1919)
Opened: April 27, 1893
Home to: St. Louis Cardinals (National League) 1893–1920
Capacity: 14,500 (1893); 21,000 (1909)
Greatest Moment: July 15, 1901—22-year-old Giants pitcher Christy Mathewson throws a no-hitter against the Cardinals, saving his own gem with a spectacular defensive play in the sixth inning.

The St. Louis Browns (today's Cardinals) were the class of the American Association in the 1880s, and they also played in one of the league's best facilities, Sportsman's Park. The team's owner, Chris Von Der Ahe, was a saloonkeeper by trade, and he was furious when he found out the park would have a covered grandstand, since more sunshine meant thirstier patrons. He solved the problem by converting an old house in the right field corner into a beer garden featuring lawn bowling, handball courts, and picnic tables.

At first, any ball hit into the beer garden was considered in play, but in 1888 the rule was changed and those hits became automatic home

Right: Mark McGwire heads home after hitting his 61st home run in 1998. Changes in Busch Stadium since 1966 include the addition of "Big Mac Land" in the left field stands.

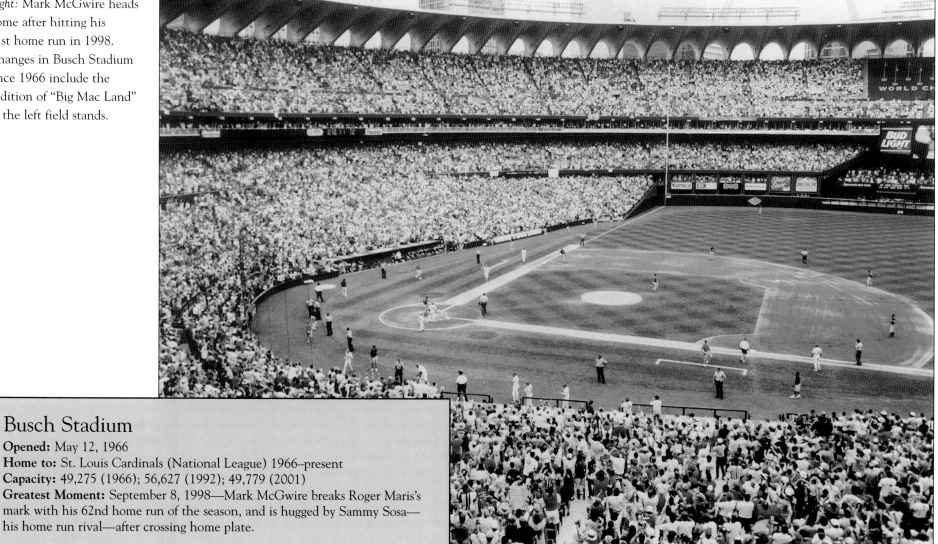

Busch Stadium

Opened: May 12, 1966
Home to: St. Louis Cardinals (National League) 1966–present
Capacity: 49,275 (1966); 56,627 (1992); 49,779 (2001)
Greatest Moment: September 8, 1998—Mark McGwire breaks Roger Maris's mark with his 62nd home run of the season, and is hugged by Sammy Sosa— his home run rival—after crossing home plate.

runs. Soon afterward the Browns moved to a new park, Robison Field, which had a wooden roller coaster encircling the outfield. This new park was best known for catching on fire, which it did in 1898 and 1901, but the team continued to use the field until 1920.

In the 1920s, African-American fans watched the St. Louis Stars play at Stars Park, a small wooden ballpark at the corner of Compton Avenue and Market Street. The Stars, members of the Negro National League, were one of the few Negro League teams to own their own ballpark. At first the grandstand was open to the sun, but a roof was later built to provide shade. A wooden fence surrounded Stars Park, and as Cool Papa Bell remembered, "People almost cut that fence down by cutting peepholes in it." A house sat 400 feet away down the right field line, while a wooden car shed in the left field corner limited the distance there to 269 feet. That short distance was tempered by a 30-foot-high wall, but it still enabled Stars shortstop Willie Wells to set a single-season record with 27 homers in 88 league games in 1929.

An American League franchise moved to town in 1902, usurping the Browns' nickname and setting up shop at the corner of Grand Avenue and Dodier Street, where Von Der Ahe's original Sportsman's Park had stood. The new Browns built a new steel-and-concrete grandstand there

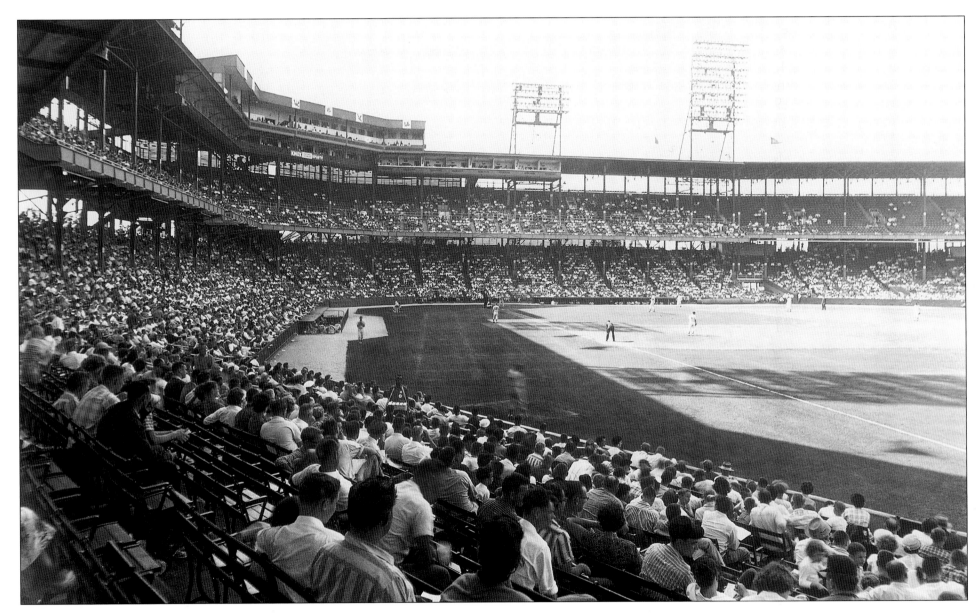

Stars Park

Opened: July 9, 1922
Home to: St. Louis Stars (Negro National League) 1922–1931
Capacity: 10,000
Greatest Moment: In 1930, the Stars and Kansas City Monarchs meet in the first night baseball game ever played in the city of St. Louis. While many players from the major league Cubs and Cardinals sit in the audience, the Stars win 4-0.

in 1909, and the Cardinals moved in to share the park in 1920. For the next 34 years, Sportsman's Park served as home ballpark for both teams. The years were good ones for the Cardinals, who won ten pennants there, and bad ones for the Browns, who finished last ten times. In 1912, a section of bleachers was built behind the right field wall. This section, which was screened off so fans couldn't catch home run balls, was designated as the area for African-American fans until May 1944, when Sportsman's Park became the last major league ballpark to integrate. The stadium's most intriguing figure in the 1950s was Bill Veeck, who lived

in an apartment under the grandstand while he owned the Browns. Sportsman's Park was the site of some of his most audacious stunts, including one on August 24, 1951 when he passed out "Yes" and "No" signs to 1,100 fans—including Connie Mack—and let them manage the game by popular vote. In 1953, Veeck sold the Browns and the team moved to Baltimore, leaving the Cardinals as the only tenants of Sportsman's Park.

In 1966, the Cardinals also left Sportsman's Park, moving to Busch Stadium, a new multipurpose facility in downtown St. Louis. The cookie-cutter stadium had artificial turf throughout the 1970s and 1980s, but natural grass returned in the 1990s, and Busch Stadium became one of the most enjoyable places to see a game. The park is dominated by arches: the famous Gateway Arch looms over left field, echoed by miniature arches ringing the top of the stadium's upper deck. After Mark McGwire joined the Cardinals in 1997, the upper deck in left field was dubbed "Big Mac Land" thanks to a corporate sponsorship deal with McDonald's, and was marked by a prominent set of golden arches.

Sportsman's Park I

Also known as: Grand Avenue Grounds
Opened: May 21, 1881
Home to: St. Louis Browns (American Association 1882–1891, National League 1892)
Capacity: 6,000 (1882); 12,000 (1886)
Greatest Moment: October 23, 1886—The Browns' Curt Welch scores on a wild pitch in the tenth inning of Game 6, giving the American Association its only win over the National League in the nineteenth-century World's Series.

Sportsman's Park III

Also known as: Busch Stadium (1954–1966)
Opened: April 23, 1902
Home to: St. Louis Browns (American League) 1902–1953; St. Louis Cardinals (National League) 1920–1966
Capacity: 18,000 (1907); 24,040 (1909); 34,000 (1921); 30,500 (1954)
Greatest Moment: August 19, 1951—In the second game of a doubleheader, the Browns send 3'7" Eddie Gaedel up to bat as a publicity stunt. Facing the Detroit Tigers' Bob Cain, he walks on four pitches.

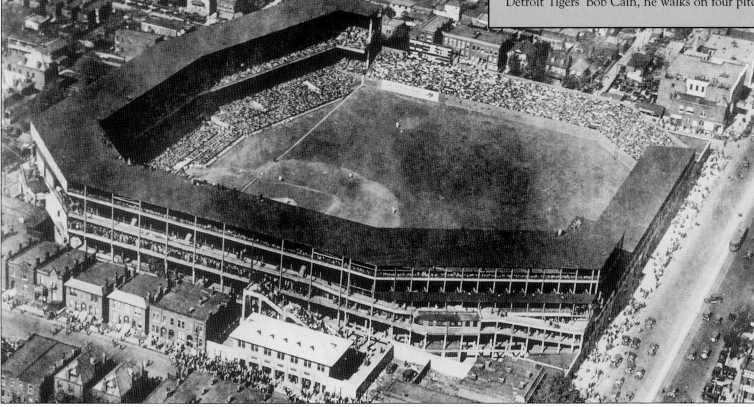

Far Left: Both the Cardinals and the Browns used Sportsman's Park from 1920–1953.

Left: Baseball was first played on the site of Sportsman's Park in 1866 by the Cyclones, the Morning Stars, and the Empires.

SAN DIEGO

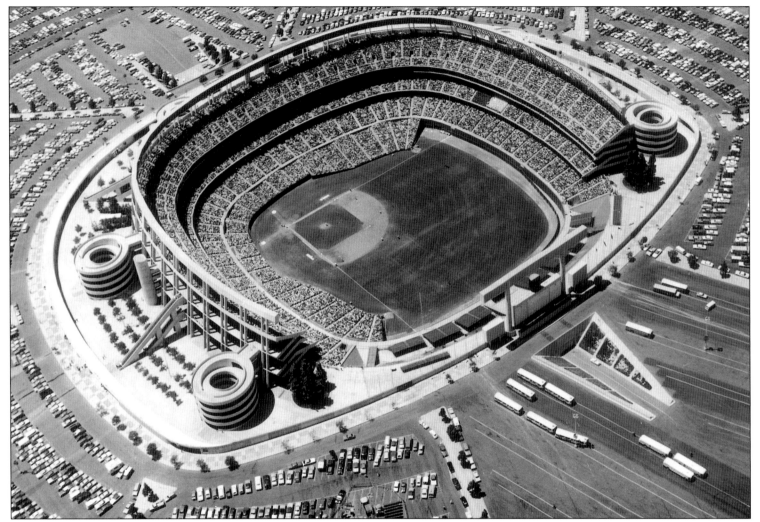

Left: Built in 1967, Jack Murphy (now Qualcomm) Stadium was almost indistinguishable from similar parks in Atlanta and elsewhere.

Right: Though the Padres have had few winning teams there, Qualcomm has hosted many prestigious football events, including Chargers home games and Super Bowl XXXII.

Though the major leagues didn't arrive until 1969, the minor league San Diego Padres thrived at Lane Field, an 8,000-seat ballpark on the San Diego waterfront. The park hosted many future stars, including a young pitcher-outfielder named Ted Williams, who played for the Padres in their first two years at Lane Field. Ravaged by termites, the park closed after the 1957 season, but the Padres stayed in San Diego until their major league successors came to town in 1969. The major league Padres played at Jack Murphy Stadium, a multipurpose facility named after a local sportswriter. In 1997, the stadium's naming rights were sold to

Qualcomm, a technology company, for $18 million. The following year, less than a month after the Padres played in the World Series, San Diego voters approved funding for a new stadium. The controversial 46,000-seat park would be located in downtown San Diego on the same site where Lane Field once stood, and would incorporate the landmark Western Metal Supply Building as part of the left field wall. Construction started on February 10, 2000, but was halted later that year after a number of legal challenges. After these legal issues were resolved, San Diego's city council voted to resume construction to open in time for the 2004 season.

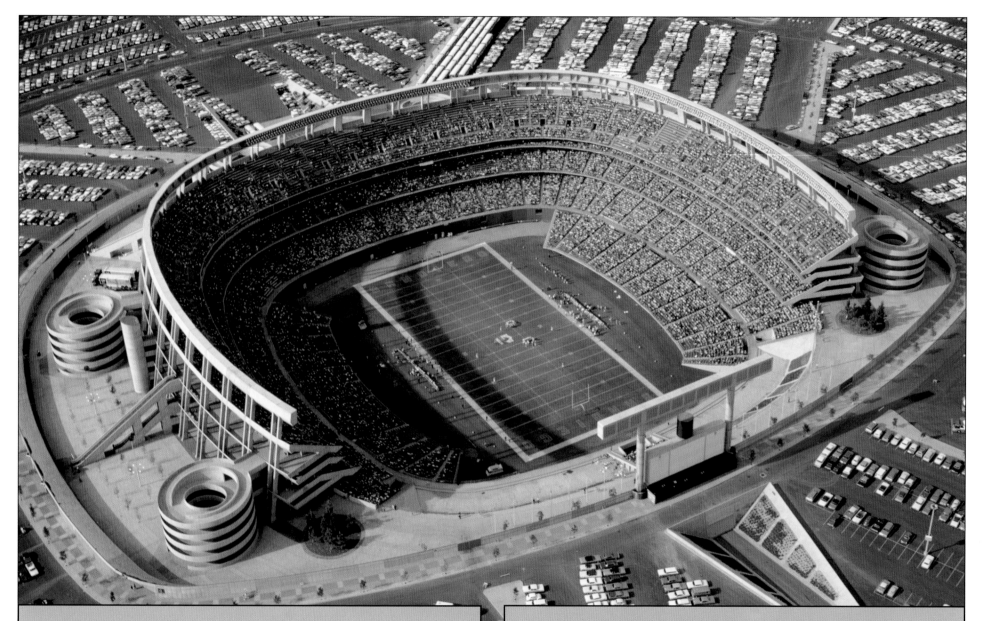

Lane Field

Opened: March 31, 1936
Home to: San Diego Padres (Pacific Coast League) 1936–1957
Capacity: 8,000
Greatest Moment: September 6, 1936—Only a week after his 18th birthday, rookie Ted Williams collects a single, double, and stolen base, and also makes a spectacular catch to rob an opposing batter of a home run, as the Padres sweep a crucial doubleheader from the Sacramento Solons.

Qualcomm Stadium

Also known as: San Diego Stadium (1967–1980); Jack Murphy Stadium (1997–present)
Opened: August 20, 1967
Home to: San Diego Padres (National League) 1969–present
Capacity: 44,790 (1973); 67,544 (1997)
Greatest Moment: October 6, 1984—In Game 4 of the NLCS, Steve Garvey hits a two-run, ninth-inning homer to win the game and send the series to a deciding fifth game.

SAN FRANCISCO

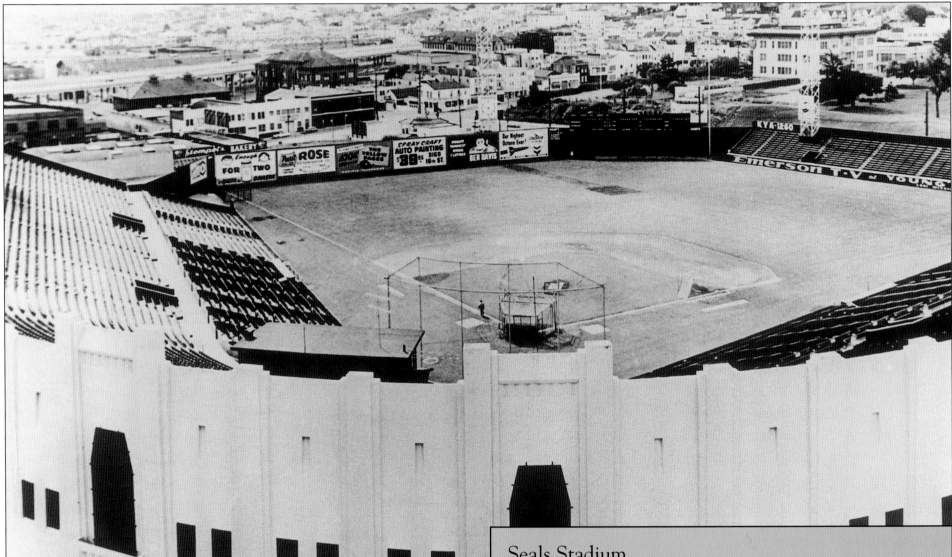

As in many cities, the early history of San Francisco baseball is one of wooden ballparks burning down and being built back up, including Recreation Park, which was destroyed by fire after the earthquake of 1906. The city's first enduring ballpark was Seals Stadium, which was built at the outset of the Great Depression, and housed the most prestigious team in minor league baseball for more than a quarter of a

Seals Stadium

Opened: March 13, 1931
Home to: San Francisco Seals (Pacific Coast League) 1931–1957;
San Francisco Giants (National League) 1958–1959
Capacity: 15,000 (1931)
Greatest Moment: April 15, 1958—In the first major league game ever played on the West Coast, rookie Orlando Cepeda homers in his second major league at-bat as the Giants beat the Los Angeles Dodgers 8-0.

century. The venerable San Francisco Seals won 15 Pacific Coast League championships, including seven at Seals Stadium. Located at the corner of 16th and Bryant Streets, about 12 blocks southwest of where Pacific Bell Park stands today, Seals Stadium was considered a marvel. It had an emerald-green facade and an architecture evocative of the California mission style.

Such legendary players as Lefty O'Doul, Earl Averill, and the three DiMaggio brothers called it home. In 1957, the Seals won one last championship there before leaving town to make way for the San Francisco Giants. The major league club played at Seals Stadium for two years until its new ballpark was completed at Candlestick Point on San Francisco Bay. The site where Seals Stadium once stood has now become a grocery store, and the ghosts of Seals players are said to still haunt the premises.

The new stadium, called Candlestick Park, had perhaps the most picturesque setting of any ballpark ever built, but it was a miserable place

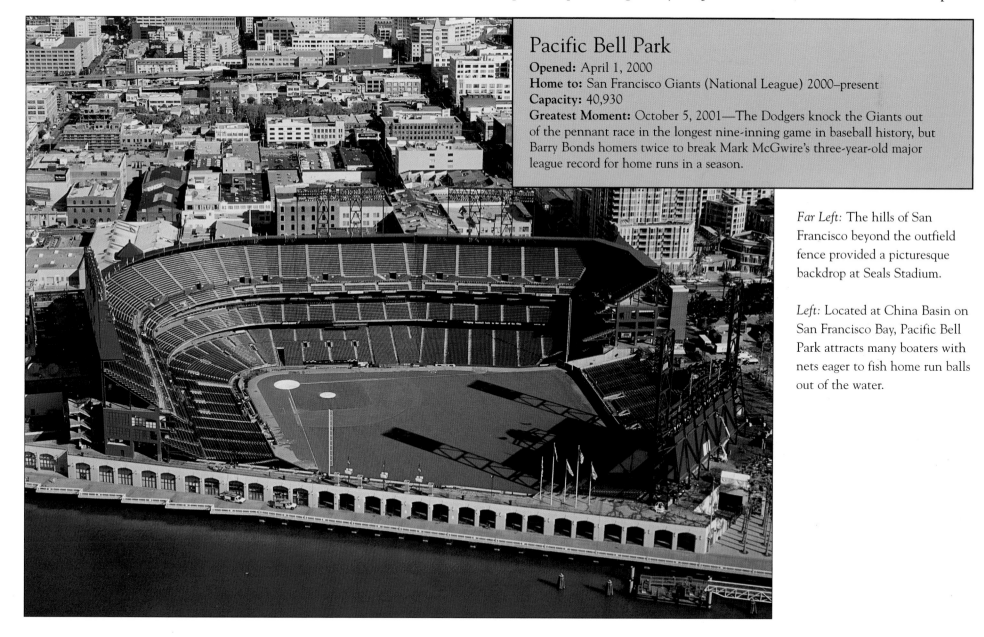

Pacific Bell Park
Opened: April 1, 2000
Home to: San Francisco Giants (National League) 2000–present
Capacity: 40,930
Greatest Moment: October 5, 2001—The Dodgers knock the Giants out of the pennant race in the longest nine-inning game in baseball history, but Barry Bonds homers twice to break Mark McGwire's three-year-old major league record for home runs in a season.

Far Left: The hills of San Francisco beyond the outfield fence provided a picturesque backdrop at Seals Stadium.

Left: Located at China Basin on San Francisco Bay, Pacific Bell Park attracts many boaters with nets eager to fish home run balls out of the water.

Right: When the Giants came to San Francisco in 1958, they used Seals Stadium as a temporary home for two years until Candlestick Park was completed.

Far Right: Candlestick Park's location near the water made it prone to vicious winds and freezing weather.

to see a baseball game. The Giants failed to accurately survey San Francisco Bay's wind patterns before building the park, and with the gusts routinely whipping into the stadium, they ended up with the coldest, windiest, and dreariest ballpark in major league history.

The team soon realized its mistake, and in 1960 installed the first heating system in an outdoor ballpark, but the system failed to work and the Giants were never able to repair it. The wind was so strong that Giants pitcher Stu Miller was even blown off the pitching mound during the 1961 All-Star Game. Still, the Giants tried to make the park work as much to their advantage as possible, sometimes resorting to gamesmanship such as soaking the basepaths when the Dodgers and base-stealing wonder Maury Wills visited in 1962.

The most shocking event in the park's history came in 1989 when, half an hour before the start of Game 3 of the World Series, an earthquake rocked San Francisco. With wind, cold, fog, and earthquakes,

Candlestick Park was affected by the natural calamities of its setting like no ballpark before or since.

In 2000, the Giants moved from one of the worst parks in major league history to one of the best. This time, the team commissioned painstaking studies of wind patterns before starting construction, and Pacific Bell Park, although it sits even closer to the bay than Candlestick did, shares few of its predecessor's weather problems. The grandstand provides spectacular views of the Berkeley Hills across San Francisco Bay, and the bay itself lies only 450 feet away from home plate, so a long drive to right field can land in the water. (There were 20 splash homers in the park's first two seasons, 15 of them by Barry Bonds.)

A public promenade runs just behind the left field wall, where fans without tickets can watch the game free of charge through openings in the fence. A ferry boat service also docks near the promenade, where it shuttles fans from the East Bay back and forth to the ballpark.

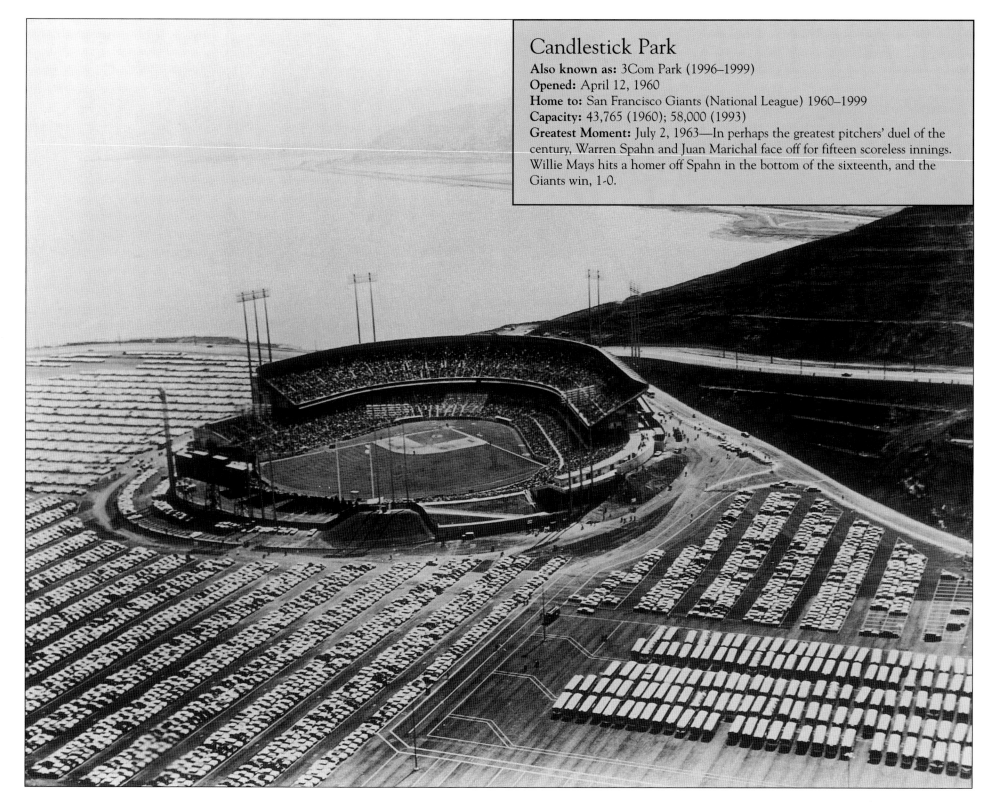

Candlestick Park

Also known as: 3Com Park (1996–1999)
Opened: April 12, 1960
Home to: San Francisco Giants (National League) 1960–1999
Capacity: 43,765 (1960); 58,000 (1993)
Greatest Moment: July 2, 1963—In perhaps the greatest pitchers' duel of the century, Warren Spahn and Juan Marichal face off for fifteen scoreless innings. Willie Mays hits a homer off Spahn in the bottom of the sixteenth, and the Giants win, 1-0.

SEATTLE

The first Seattle ballpark of note was Sick's Stadium, longtime home of the Pacific Coast League's Seattle Rainiers. "That was a beautiful stadium up there," longtime Rainiers shortstop Artie Wilson remembered. "It was a major league stadium, too—it was better than a lot of the big league clubs." Sick's Stadium was a genuine major league stadium for one season, when it hosted the short-lived Seattle Pilots, but the old ballpark

was gone by 1977, when the expansion Seattle Mariners were born and started playing in the Kingdome.

The Kingdome was a massive structure that was considered by some to be the worst park in baseball, and was replaced in midseason 1999 by Safeco Field, a pitcher-friendly stadium featuring a retractable roof to protect fans from the region's frequent rain.

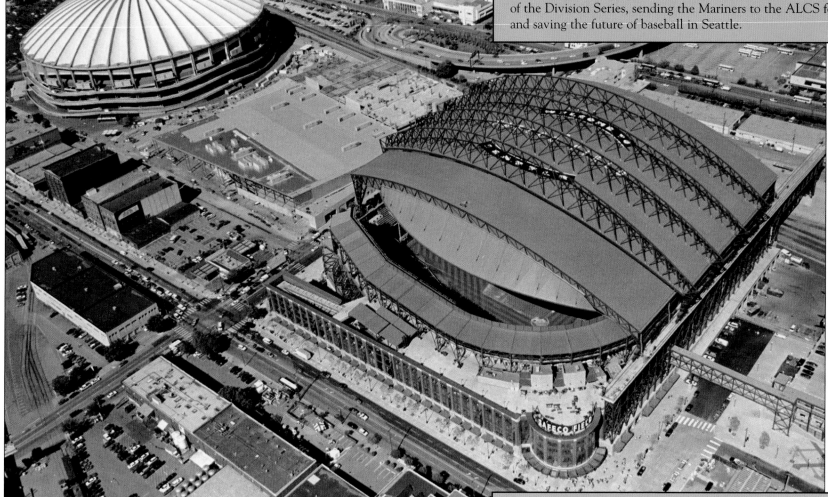

Kingdome

Opened: April 9, 1976
Home to: Seattle Mariners (American League) 1977–1999
Capacity: 59,166
Greatest Moment: October 8, 1995—An eleventh-inning hit by Edgar Martinez drives in Ken Griffey Jr. with the winning run in the decisive game of the Division Series, sending the Mariners to the ALCS for the first time and saving the future of baseball in Seattle.

Safeco Field

Opened: July 15, 1999
Home to: Seattle Mariners (American League) 1999–present
Capacity: 47,116
Greatest Moment: July 11, 2001—At the All-Star Game, Cal Ripken, who had announced his retirement at the end of the season, hits a home run in the third inning and is named the game's MVP.

Above: A roofed stadium is necessary to prevent rainouts in Seattle, but the retractable roof of Safeco Field (right) is much more appealing to fans than the permanent lid of the Kingdome (left).

Left: Sick's Stadium is pictured here in 1941, 28 years before its lone season as a major league ballpark. Fans could also enjoy a good view of Mt. Rainier.

TAMPA/ST. PETERSBURG

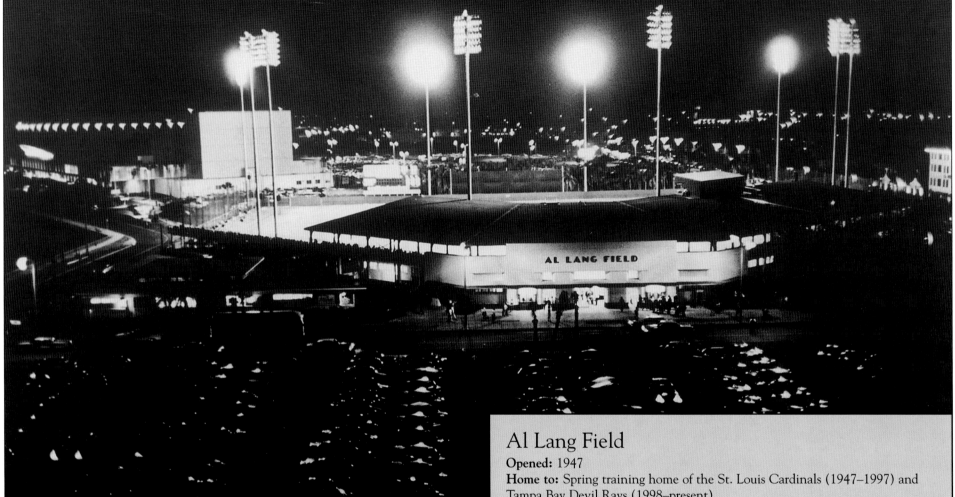

Al Lang Field

Opened: 1947
Home to: Spring training home of the St. Louis Cardinals (1947–1997) and Tampa Bay Devil Rays (1998–present)
Capacity: 6,000 (1960); 7,000 (2001)
Greatest Moment: March 12, 1947—The stadium is officially dedicated in a grand ceremony with appearances by Cardinals owner Sam Breadon, Yankees president Larry MacPhail, and Commissioner Albert "Happy" Chandler.

The Tampa Bay area is home to one of baseball's most picturesque spring training stadiums, Al Lang Field, which sits on the St. Petersburg waterfront at the foot of First Street. Built in 1946, the stadium was renovated in 1976 and 1999, and still serves as a spring training site for the Devil Rays, and the home of their farm club in the Florida State League.

In 1990, the city of St. Petersburg constructed a 45,000-seat dome in the hope of luring a major league team such as the Chicago White Sox or San Francisco Giants. The move finally paid off in 1998, when the

Above: Al Lang Field was the spring training home of the Cardinals for many years, and now houses a Devil Rays farm team.

Right: Its lopsided roof makes Tropicana Field one of the few asymmetrical domes in existence.

Tampa Bay Devil Rays arrived, but by then baseball was moving away from domed stadiums, making Tropicana Field (as it was named after the juice company paid $46 million) something of an anomaly.

It was ludicrously dubbed "the Ballpark of the Twenty-first Century" by team owner Vince Naimoli, but attendance was poor. Prior to the 2000 season, the ballpark's atmosphere was improved with the addition of FieldTurf, a new kind of artificial turf that more closely resembles real grass.

Tropicana Field

Also known as: Florida Suncoast Dome (1990–1993); Thunderdome (1993–1996)
Opened: 1990
Home to: Tampa Bay Devil Rays (American League) 1998–present
Capacity: 45,200
Greatest Moment: August 7, 1999—Wade Boggs becomes the first player to hit a home run for his 3,000th hit, and after circling the bases, kneels down and kisses home plate.

TORONTO

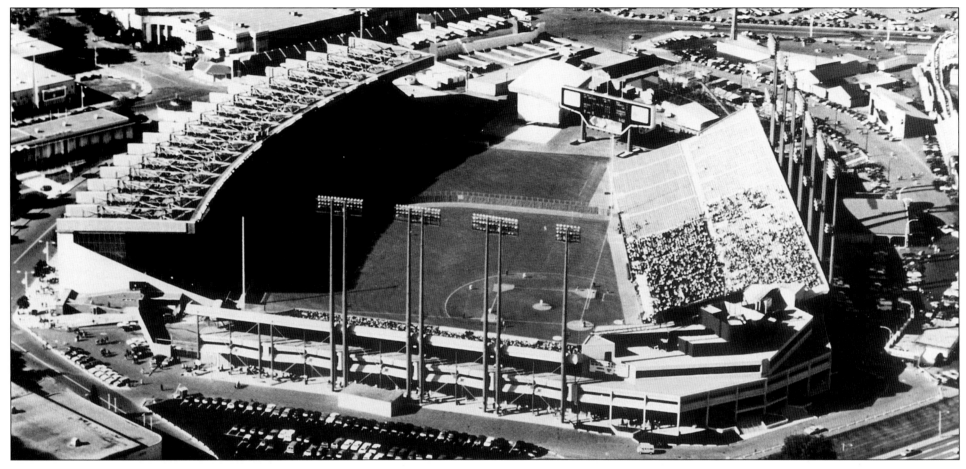

Exhibition Stadium

Opened: 1959
Home to: Toronto Blue Jays (American League) 1977–1989
Capacity: 25,303 (1959); 43,737 (1978)
Greatest Moment: April 7, 1977—The Blue Jays play their first game in franchise history, which is also reportedly the first major league game ever played with the field covered in snow.

American League baseball came to Canada for the first time in 1977, when the Toronto Blue Jays were established as an expansion franchise. For their first 12 years, the Blue Jays played at Exhibition Stadium, which had been built as a football stadium in 1959. Large openings on either side of the park created a wind tunnel of sorts, which in 1984 caused the only game ever called on account of wind. In 1989, the team moved to SkyDome, which at the time was the most state-of-the-art ballpark ever built. Located next to the famous CN Tower, the park featured a Hard Rock Cafe, a built-in hotel with rooms overlooking the outfield, and a retractable roof. However, it was built just prior to the ballpark renaissance of the 1990s, and by the turn of the twenty-first century, SkyDome was a decadent but curiously outdated ballpark.

Left: Exhibition Stadium was built for football, which resulted in a vast unused area behind the right field fence when playing baseball there.

Below: The base of the CN Tower looms over right field at SkyDome, while the windows of the stadium's built-in hotel surround the scoreboard in center field.

SkyDome

Opened: June 5, 1989
Home to: Toronto Blue Jays (American League) 1989–present
Capacity: 50,516 (2001)
Greatest Moment: October 23, 1993—Joe Carter's ninth-inning homer ends Game 6 as the Blue Jays win their second consecutive world championship. Carter is only the second player ever to end the World Series with a home run.

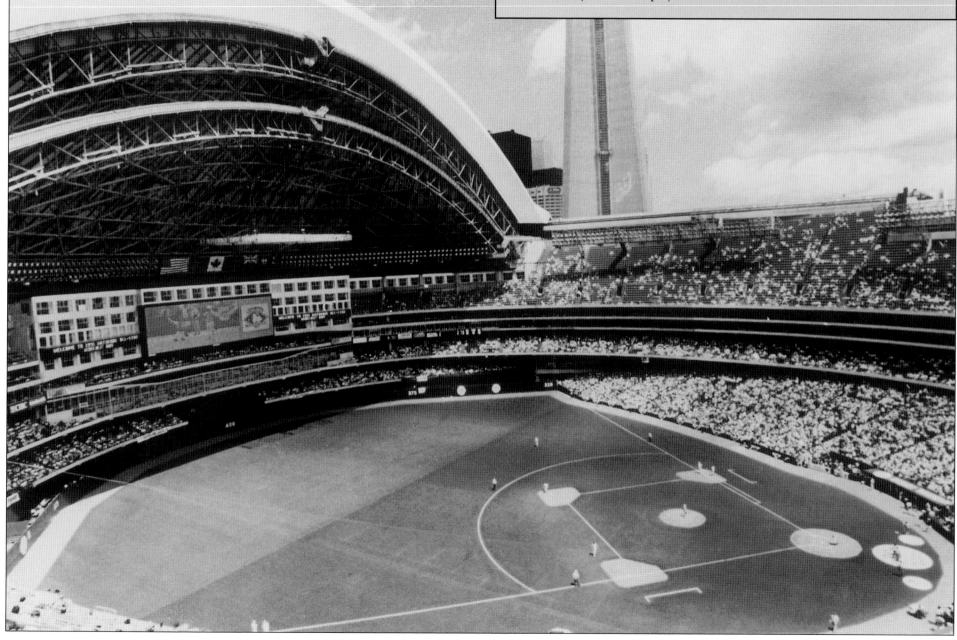

WASHINGTON, D.C.

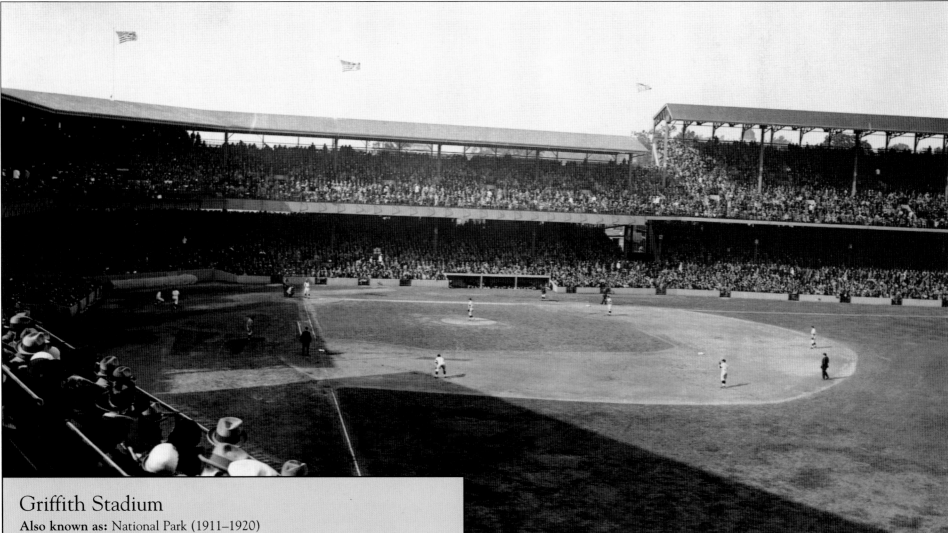

Griffith Stadium

Also known as: National Park (1911–1920)
Opened: April 12, 1911
Home to: Washington Senators (American League) 1911–1960;
Homestead Grays (Negro Leagues) 1937–1948; Washington Senators
(American League) 1961
Capacity: 32,000 (1921); 27,550 (1961)
Greatest Moment: October 10, 1925—In World Series Game 3, Washington
right fielder Sam Rice tumbles into the stands while chasing a long fly. He
emerges a few moments later with the ball and the play is ruled an out,
resulting in a controversial 4-3 win for the Senators.

Three different major league teams called Washington home during the
nineteenth century, occupying a plethora of ballparks, including one,
Capitol Grounds, located across the street from the U.S. Capitol on the
site where the Robert A. Taft Memorial now stands.

The first D.C. park to last more than a decade was National Park,
built in 1911. In 1920, the stadium was renamed after Senators' owner
Clark Griffith, the only man in major league history to serve as a player,

manager, and owner for at least twenty years each. Griffith Stadium's left field line was an astounding 407 feet away, making it an extremely tough park for right-handed batters, a circumstance which helped Washington's Walter Johnson become arguably the greatest pitcher in baseball history. It wasn't until 1957—four years before the park's demise—that a Senators player hit 30 home runs in a season. During the 1930s and 1940s, the Senators shared the park with the Negro Leagues' Homestead

Above: As the scoreboard reveals, Griffith Stadium was used for football after the Senators left, but it eventually fell into disrepair and was demolished in 1965.

Far Left: Griffith Stadium was built and expanded in stages, which is one reason why the outfield stands were taller than the main grandstand.

WASHINGTON, D.C.

Grays, who featured Josh Gibson, a right-handed slugger who was the only batter able to clear Griffith's left field wall with regularity. In the 12 years they played at Griffith, the Grays won nine pennants, six more than the Senators did in their 50 years there.

The Senators moved to Minnesota and became the Twins in 1961, but a new Senators franchise immediately sprung up to take their place.

The new team played a year in Griffith Stadium before moving to RFK Stadium in 1962. The new stadium was better suited to football with its "formal, pretentious, martial, classically antiseptic, and cold style," which historian Philip Lowry said made it seem "designed by Stalin." Fans apparently agreed, and low attendance prompted the Washington franchise to relocate to the Dallas-Fort Worth area in 1972.

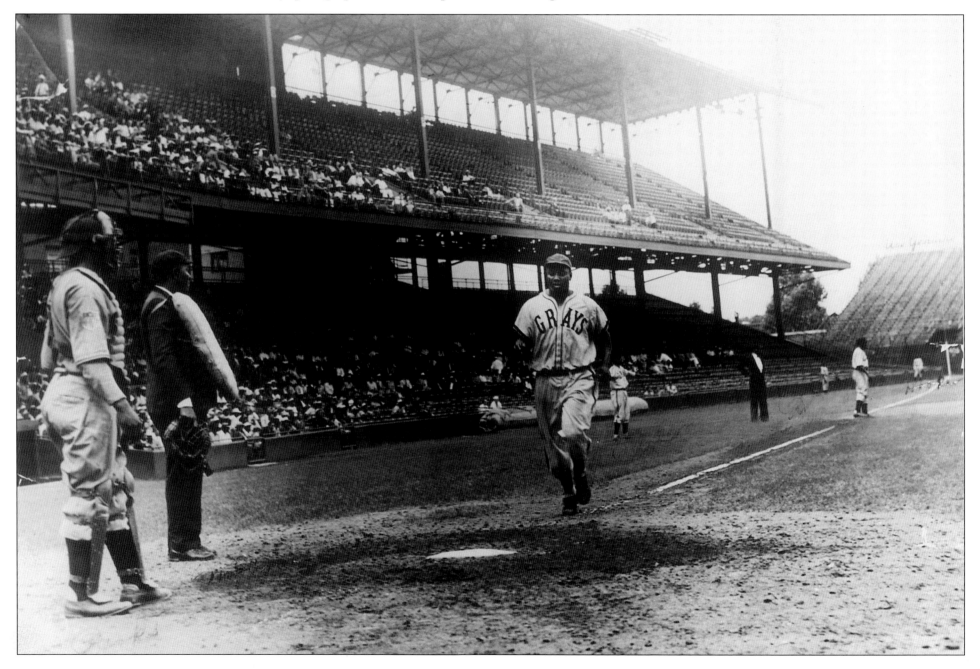

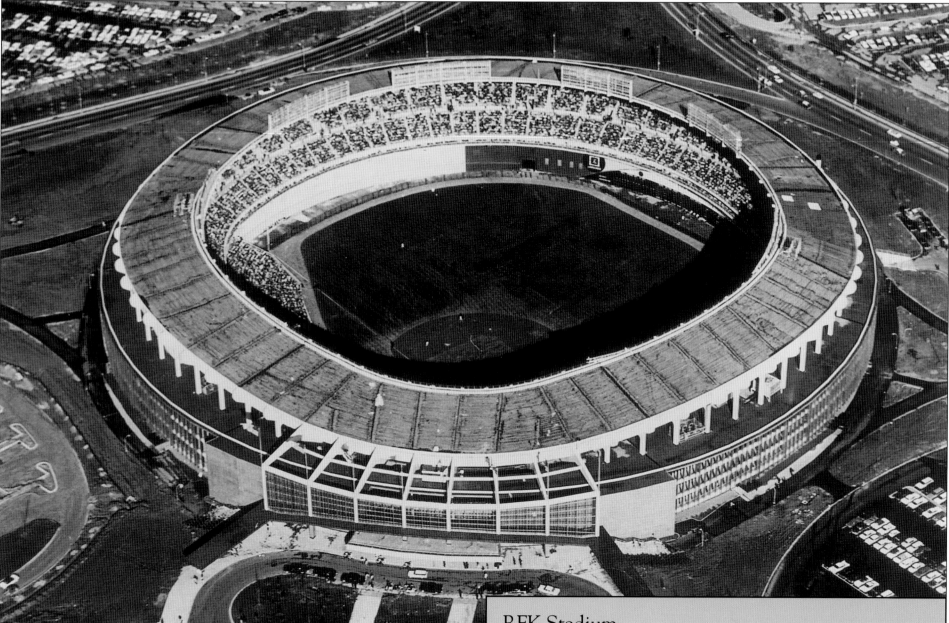

Above: As a typical 1960s cookie-cutter park, RFK Stadium's harsh appearance led one writer to quip that it was "designed by Stalin."

Left: Josh Gibson crosses home plate at Griffith Stadium. His Homestead Grays played some home games here and some at Forbes Field in Pittsburgh.

RFK Stadium

Opened: October 1, 1961
Home to: Washington Senators (American League) 1962–1971
Capacity: 43,500 (1962)
Greatest Moment: July 19, 1982—In an old-timers game, 75-year-old Hall of Famer Luke Appling hits a Warren Spahn pitch into the left field stands, becoming possibly the oldest person to homer at a major league ballpark. He gets a standing ovation.

"EXTRA INNINGS"

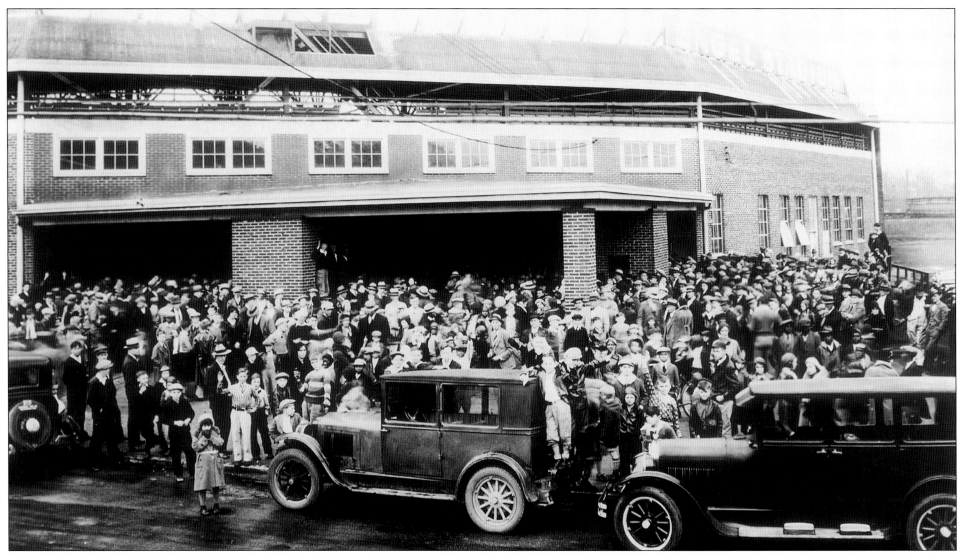

Though it never hosted major league baseball, Engel Stadium in Chattanooga, Tennessee was home to the minor league Chattanooga Lookouts for 70 years, from 1930 through 1999. The park was also home for the Chattanooga Choo-Choos, a black semipro team that Willie Mays played for briefly in the 1940s. The Lookouts moved to new BellSouth Park for the 2000 season, but Engel Stadium still stands.

History was made at Roosevelt Stadium in Jersey City, New Jersey on April 18, 1946, when Jackie Robinson—whose middle name was Roosevelt—became the first African-American to play minor league baseball since 1916. Robinson had one of the greatest debut games ever, collecting four hits, smashing a three-run homer, and stealing two bases as his visiting Montreal Royals defeated the Jersey City Giants. In 1956 (the year this photo was taken) and 1957, Roosevelt Stadium was the site of 15 Brooklyn Dodgers home games, as the team contemplated its move away from Ebbets Field.

Although Louisville had several major league teams before 1900, the minor league Louisville Colonels played here for most of the twentieth century. Their home ballpark was Parkway Field, built in 1923. This historic stadium was also home to various Negro League teams, including the Louisville White Sox and Louisville Buckeyes. The stadium structure was torn down in 1961, but the playing field still remains where it has always been. It is now owned by the University of Louisville, which uses the field for its college baseball games.

Yale Field in New Haven, Connecticut was built in 1927, and has housed Yale University's baseball team since the days when they were coached by ex-Red Sox star Smoky Joe Wood. In 1947 and 1948, Yale played in the first two College World Series ever held, led by first baseman and team captain George H.W. Bush. This stadium was home to one of the most memorable college baseball games ever played, a 1981 NCAA tournament pitchers' duel that saw Yale's Ron Darling throw eleven no-hit innings before losing to Frank Viola and St. John's in the twelfth inning, 1–0. Today Yale Field is the home of the Double-A New Haven Ravens, seen here playing in a 1999 game.

Cooperstown's Doubleday Field was supposedly built on the site of Elihu Phinney's cow pasture, where Abner Doubleday was said to have invented the game in 1839. The Doubleday story turned out to be a hoax, but Doubleday Field has seen much genuine history since it opened in 1939. Every year two major league teams battle in the Hall of Fame Game, an exhibition contest held on Hall of Fame weekend. The park has hosted Babe Ruth, Honus Wagner, Willie Mays, and virtually every other great player of the last 70 years. This photo was taken during the 1951 Hall of Fame Game. The Brooklyn Dodgers' Duke Snider plays center field in the foreground.

The release of the film *Field of Dreams* in 1989 prompted a revival of baseball nostalgia, including renewed interest in the game's historic ballparks. The Field of Dreams was a real baseball field constructed in Iowa for the filming of the movie, and this photograph was taken from the cornfield from which Shoeless Joe Jackson and the other ghostly players emerged. The film's catchphrase—"If you build it, he will come"—proved prophetic, as more than 700,000 fans have made the pilgrimage to Dyersville, Iowa where the field still stands. Admission is free and visitors are encouraged to play catch on the field, making it perhaps the ultimate ballpark experience.

INDEX